THE
ART DECO
STYLE

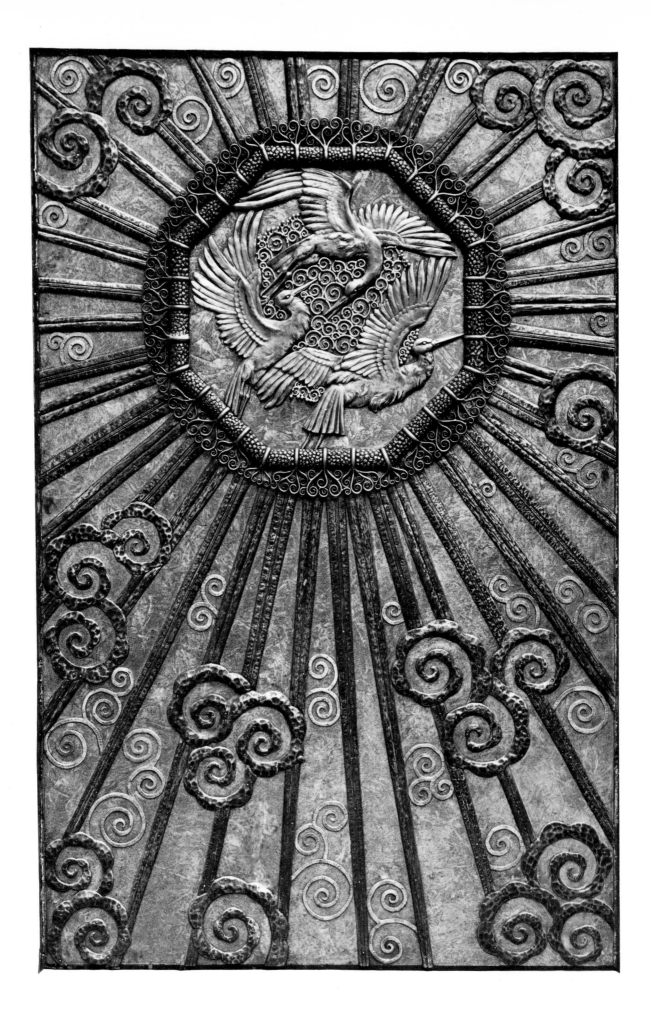

THE ART DECO STYLE

Yvonne Brunhammer

ST. MARTIN'S PRESS · NEW YORK

ACKNOWLEDGEMENTS

We wish to thank Maria de Beyrie, Félix Marcilhac, Christolfe, Maurice Périnet, Mr and Mrs Robert Walker, and the Editions Graphiques Gallery for kindly providing material for this book. Thanks also go to the following contributors of illustrative material: Allo Photo 224, 227; Archives L'Illustration 17, F. Harand 18, 19, 21, Rep 20, 24, 28, 29, 68, 73–75, 122, F. Harand 123–126, 128, 132, 187–191, 193–196, 198, 200, 216, 217, 221–223; Agence 'Top' Guillemot 55–57, 138–140, 152, 179–181; Guillot 231; Hinous 58; Boudot Lamotte 9, 14, 42, 49, 93, 159, 162, 164, 165, 184; Chadefaux et Basnier 48, 50, 62, 63, 76, 77, 79, 80, 86, 88, 95, 96, 99, 100, 102, 106, 112, 117–119, 127, 129–131, 133, 142–144, 147, 150, 166, 170, 173, 175, 185, 197, 199, 205–214, 218–220, 232, 241, 253, 265–270, 272–274, 276, 286, 298, 300, 306, 307, 320, 343–349, 354, 358–360, 366, 367; Jean Collas 30–32; Fondation Le Corbusier 33–36; Günther Meyer 215, 243–246, 335–341; Lucien Hervé 183, 342; Pierre Jahan 42–47, 51, 134, 141, 151, 153, 154, 157, 158, 160, 167, 172, 203, 204, 228, 229, 234, 275, 299, 301; Kollar 238; Knut Günther 7, 11, 84, 94, 103, 120, 318, 319, 322; Larousse 53, 54, 137; Yves Machatscheik 236, 264; Musée des Arts Décoratifs, Paris 3–6, 8, 10, 13, 16, 37–41, 52, 58, 60, 61, 69–72, 85, 101, 104, 105, 149, 161, 163, 182, 186, 192, 201, 202, 225, 242, 249, 252, 254–259, 277, 280, 283–285, 287, 291–294, 297, 302–305, 350–353, 355, 365; Sartony 281, 282; Sully-Jaulmes 59, 64, 81, 108, 113, 121, 142, 148, 168, 169, 171, 174, 176–178, 230, 233, 239, 240, 247, 248, 288, 333, 361, 362; Victoria & Albert Museum, London 1; Doumic 135, 136.

Front cover: GOLDSCHEIDER, VIENNA *Tragedy*, glazed pottery mask, c.1922. (Editions Graphiques Gallery, London)

Frontispiece: EDGAR BRANDT *Les Cigognes d'Alsace*, wrought-iron and bronze panel.

First published in the United States of America in 1984 by
St. Martin's Press, 175 Fifth Avenue, New York, NY 10010

Library of Congress Catalog Card Number 83-51369
ISBN 0-312-05224-3

First published in France by Baschet et Cie Paris
Translated from the French by David Beeson

Printed and bound in Hong Kong

CONTENTS

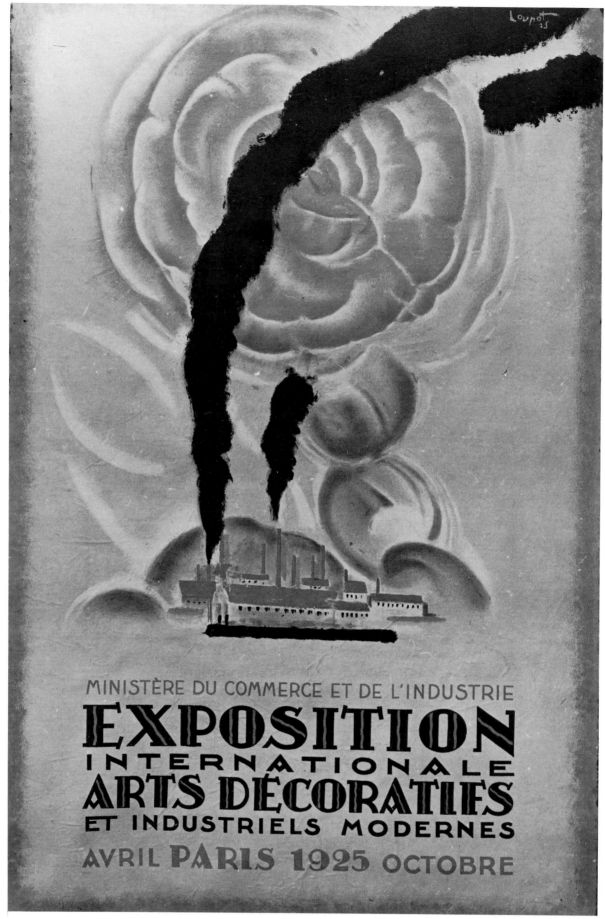

2 CHARLES LOUPOT Poster for the 1925 Exhibition. (Bibliothèque des Arts Décoratifs, Paris)

THE ORIGINS OF ART DECO

In the twentieth century, world exhibitions play the role which had previously belonged exclusively to monarchs whose name or date would become associated with the style of the period. It is this which gave Art Nouveau, which represented the rupture with the Greco-Latin world in the last quarter of the nineteenth century, a name based on the Paris Exposition Universelle of 1900 — the 1900 style. And hence, 25 years later, the year of the Exposition Internationale des Arts Décoratifs et Industriels Modernes, once more in Paris, became the symbol of all those tendencies which between 1909 and 1930 combined to define the style of the period.

In both cases, the exhibition represented an evaluation. It coincided with the high point of expression of the style; the moment when, having sown the seed of its own decline, it was already giving birth to the reaction to it. Thus the plan to organise an exhibition of decorative art in Paris was the outcome of the 'failure' of the 1900 Exhibition. That, at least, was how contemporaries saw it. The solution offered by the artists themselves was the formation, in 1901, of the Société des Artistes Décorateurs in which may be found the leading figures of Art Nouveau: Hector Guimard, Eugène Gaillard, Eugène Grasset, Albert Dammouse, alongside some younger men who were to contribute to the creation of the 1925 or Art Deco style: Emile Decoeur, Paul Follot and Maurice Dufrêne. In the same way, the Union des Artistes Modernes in 1930 brought together the 'modern' artists who emerged from the 1925 confrontation: Robert Mallet-Stevens, Pierre Chareau, Jean Puiforcat and the 'innovators' who announced the style of the decades to come: René Herbst, Eileen Gray and Charlotte Perriand, whose main concern was mass-production.

'We want this exhibition,' wrote the scheme's reporter, Roger Marx, in 1907, 'to be international because competition is an active stimulant. We also want it to be modern so that any reminiscence of the past is ruthlessly excluded, because a social art derives its interest and justification only from the degree to which it adapts itself rigorously to the times in which it appears . . . It should mark the end of that contempt to which the machine has been condemned . . . ' Since the London Exhibition of 1851 and further still since the first Exhibition of the Products of French Industry which opened on August 26 1798, the same words have reflected the same needs, and expressed the same concerns — the need to create something new, to distinguish one's period by an art which is original but which at the same time speaks to everybody, the need to reconcile art with industry, a concern with the development of science and the fear of being over-taken by the remarkable energy represented by industry. If every one of the numerous exhibitions with which the nineteenth century and the first quarter of the twentieth was strewn in France and abroad, represents a failure, the reason must be sought in the absence of commitment in their planning and in their execution.

This analysis is confirmed by the 1925 Exhibition. Initially intended for 1915, then 1916, adjourned because of the war in 1922 and 1924, it finally opened in April 1925 amidst great rejoicings — the rejoicings of the Années Folles after the black and bloody years of the war which had ended the pomp of the Belle Epoque. It reflected a world which could not, dared not or did not wish to make choices. 'It is not, in our opinion, the organisers of the 1925 Exhibition who are to blame for its aesthetic failure, but the principles themselves on which the event was based,' wrote Waldemar George in Amour de l'Art. 'By substituting the expression "exhibition of contemporary activity" for "art exhibition", our Esprit Nouveau friends have stated clearly that the modern creative spirit is not limited to plastic and applied art alone. Their faith in decorative art distorted the spirit of the whole exhibition.' The idea had been expressed and the debate was organised around it. 'I should like first of all to know who linked the two words, art and decorative. It is a monstrosity. Where there is genuine art, there is no need for decoration,' declared the architect, Auguste Perret, in an interview he gave to Marie Dormoy. For the advocates of the Esprit Nouveau movement, Amédée Ozenfant and Le Corbusier, the problem was no longer posed: 'decorative art means implements, beautiful implements'. This marvellous freedom allowed Le Corbusier to recognise the worth of Art Nouveau, in contrast to the decorators of the 20s. 'Around 1900 Art Nouveau appeared and suddenly the old clothes of an old culture were shaken out.' In addition, Le Corbusier re-established the value of the 1900 Exhibition: ' . . . A superb effort, considerable courage, great boldness and a genuine revolution were all displayed there.'

The style which emerged from the 1925 Exhibition as a whole, with all its claims, its antagonisms, its defects, was marked beyond a doubt by the year 1925 but also by the notion of Art Deco, evoking contradictory images in which varnished rosewood is found side by side with nickelled steel tubes, the cubist rose with constructivist geometry and the intense multicoloured blaze of the Ballets Russes and the Fauves with the subdued tints of the Cubists and Le Corbusier's use of whitewash.

Sources

The contradictions are old. They go back to the middle of the nineteenth century, when William Morris (1834-1896) set out to overcome the mediocrity and backward-looking character of the industrial products on show at the exhibitions in London, in 1851 and 1862 and in Paris, in 1855 and 1867, by renewing hand-made work and the tradition of the craftsman-artist. Following in the tracks of Morris and Co., other groups of painters and architects set out to create an environment in which aesthetic and social qualities were combined. If Morris rejected machines which he regarded as responsible for the production of archaic junk, certain groups such as the Arts and Crafts Movement recognised the need to work hand-in-hand with the industrial world.

The English movement was to a great extent a forerunner whose repercussions extended well beyond the Art Nouveau style. Thus William Morris' ideas and the renewal of domestic architecture — Richard Norman Shaw's garden cities and Voysey's functional homes — gave rise to the aims of the Deutscher Werkbund. This was an association of artists, industrialists and designers, founded in 1907 by the German architect, Hermann Muthesius (1861-1927) and 'concerned with giving manual labour its dignity back by ensuring the concerted action of art, industry and craftsmen by a campaign of propaganda and education and by the assertion of a common will'. The basis was laid for a current of ideas which, by way of the Bauhaus and the declarations of faith of the Esprit Nouveau, were to lead to the designs of the 60s.

From England too, there arrived an Art Nouveau stripped of all adornment, based on straight lines and cubes, which prefigured Purism, Neo-Plasticism and Constructivism. Its chief exponent was the architect, Charles Rennie Mackintosh (1868-1928) and its setting was the city of Glasgow. The annual exhibition of the Wiener Secession in 1900 revealed the close relationship between Mackintosh and the Glasgow school, and the tendencies expressed by the Viennese school, particularly with the painter Gustav Klimt and the architect Josef Hoffmann. Through Hoffmann and the art studios he opened in 1903 we see the combination of the two British currents; the technical organisation of the Arts and Crafts Movement and the supremely refined taste of Mackintosh.

It was in Vienna, in 1908, that the first, violent protests against decoration exploded. By publishing his pamphlet, *Ornamentation and Crime*, Adolf Loos (1870-1933) declared himself in favour of the lessons gained through contact with architects of the Chicago school and took to task the aesthetic tendencies of Viennese art. The declaration of faith is clear: 'As culture develops, the ornamentation of common objects disappears.' The peremptory, incisive tone, the polemical and colourful language, were of just the kind to appeal to Le Corbusier who saw in Loos one of the precursors of the new spirit. In 1921 he wrote: 'In 1900, at the time when enthusiasm for Art Nouveau was already in full flood, during that period of excessive decoration, of stormy intrusions of Art into everything, Mr. Loos, a clear and original thinker, was beginning to protest against such tendencies. One of the first to have felt the importance of industry and the contributions it could make to aesthetics, he began to assert truths which still seem revolutionary or paradoxical today.' Following in the footsteps of Louis Sullivan who, as early as 1892, recommended the abandoning of decoration, Adolf Loos campaigned for a purist architecture from which Le Corbusier was directly to inherit.

Europe in the first decade of the twentieth century was overrun by converging or contradictory tendencies which took advantage of the development of transport and the appearance of varied and rapid means of communication. Juxtapositions were made immediately, frontiers were abolished in the quest for a life style appropriate to the twentieth-century world. Whether one was for or against decoration, for or against industry, it was around a certain art of living that discussion and research were orientated. Pre-occupations centred, inevitably, around the social aspect, even when the result directly opposed it. Having set itself the aim of integrating art with social life, Art Nouveau had revealed itself to be, in the final analysis, an exaltation of individualism.

Suspicious of mechanisation confused with the imitation of the past, France came up against the same contradictions at the end of the nineteenth century as Europe generally. Art Nouveau was the expression, ranging from the very good to the very bad, of an ambiguity. The leaders of the trend, Hector Guimard and Emile Gallé, produced, in the name of a social and industrial art, an elitist art which had practically nothing to do with industry. As soon as industry took over the forms and decoration of Art Nouveau with the aim of popularising them, the result was deplorable. Its only achievement was to disgust a public which was already suspicious and which took refuge in antiques.

Tony Garnier's project for a Cité Industrielle (1901-1904) brought an extraordinarily young and revolutionary air to the disorientated world of art. In a project carried out at the Villa Medici he devised the concept of an urban complex which supplied the essential solutions to the problems of the modern city. The forms were geometrical, the raw material selected was reinforced concrete which, in 1901, had only ever been used for technical construction. The first concrete structure building in Paris was completed in 1903, on the rue Franklin and was built by Auguste Perret.

The Development of the Art Deco style in Europe

Drawing on the contrary currents of Art Nouveau, Art Deco emerged simultaneously in the capitals of Europe, in studios and art schools inspired by architects. The Art Nouveau period had laid stress on the close relationship that links architecture to decorative art. Guimard in France, Horta and van de Velde in Belgium, Mackintosh in Glasgow and Gaudi in Barcelona, had successfully demonstrated that a house, an architectural unit, should be conceived as a whole, in which interior depends strictly on exterior and vice versa. Engaged to build a block of flats on the rue Lafontaine — the Castel Béranger — Hector Guimard (1867-1942) had taken responsibility for all its fittings, from the carpet rods on the stairs to the bell pushes, by way of the slightest detail of room furnishings and equipment. His successors followed his example of conceiving of a house as a whole, but rejected his individualistic method, and hence with few exceptions, Art Deco was based on teamwork.

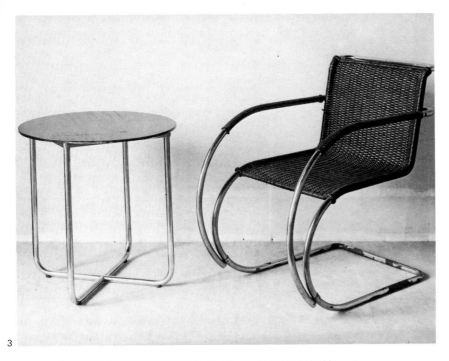

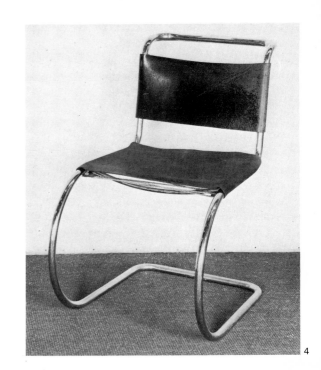

3

4

3 LUDWIG MIES VAN DER ROHE Nickel-plated tubular steel table with black lacquer top. The tubular steel chair with cane upholstery was made for the Weissenhof Exhibition in Stuttgart, 1927. (Bauhaus-Archiv, Berlin)

4 LUDWIG MIES VAN DER ROHE Chrome tubular steel chair with black leather upholstery, manufactured by Thonet Brothers, 1927. (Salon des Arts Ménagers, Paris)

5 WALTER GROPIUS Magazine storage shelves in cherrywood made at the Bauhaus ,1923. (Bauhaus-Archiv, Berlin)

6 GERRIT RIETVELD Berlin chair painted black and grey, 1923. (Stedelijk Museum)

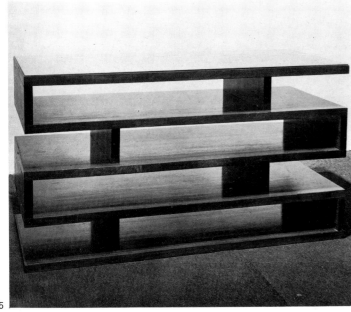

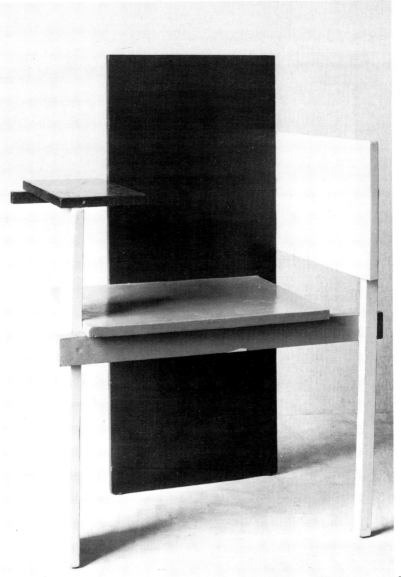

5

6

The Wiener Werkstätte

Founded in 1903 by Josef Hoffmann (1870-1956) and Koloman Moser (1868-1918), the Wiener Werkstätte united artists from different disciplines. The aim was to '. . . intervene whenever the struggle is engaged against outdated or ossified art forms and to replace them by forms adapted to their uses; logical, economic forms, corresponding to aesthetic needs'. The result was attained to the extent that production rejected historical references, adopted a decorative range treated with elegant clarity, attached a high priority to straight lines, geometric forms, a linear framework and pure colours. This was a luxurious art form which received its brightest expression in the Palais Stoclet in Brussels (1905-1908) where Hoffman succeeded in reconciling his nationalist notions with his extreme refinement.

Art Deco, with its favourite themes and colours, was fully present in the work of the Wiener Werkstätte before the First World War. If the Austrian pavilion of the 1925 Exhibition contributed nothing to Hoffmann's work, left to one side by the currents of the 20s, Gio Ponti, founder of the review, *Domus*, in Milan, made no mistake when in 1935 he stressed the importance of the Viennese artist's work in an article entitled 'Il Gusto di Hoffmann'. When he created the Wiener Werkstätte, Hoffmann had, indeed, established 'the base, the pivot and the experimental bench' of the renewal of decorative art in Austria, whose repercussions were to spread throughout Europe. They extend a long way down the years — hence silver cutlery designed in 1903 by Hoffmann was not only the source of the silverwork of such artists as Jean Puiforcat, for instance, but also prefigured the best French cutlery of the 70s.

The Deutscher Werkbund

If Viennese workshops knew nothing of the industrial world, this was not at all the case of the Deutscher Werkbund which essentially set out to link artists and industrialists. The strength of Muthesius was that he was able to attract the best representatives of different disciplines and artists of the calibre of Richard Riemerschmid, Hans Poelzig, Josef Hoffmann and Henry van de Velde. From 1912 to 1915, the Werkbund published a yearly journal detailing the year's achievements which bear witness to the fruitful contacts between industry and creativity.

In 1910, the Salon d'Automne in Paris threw open its rooms to the achievements of those who in France were called the 'munichois'. The confusion amongst decorators was such that they feared an exhibition which they regarded as essentially German. Although the critic attached to the review *Art et Décoration* praised 'the intelligent co-operation of businessmen and artists' that such an exhibition implied and deplored the fact that there was no such development in France he nevertheless devoted much time to criticising the 'heaviness' of the whole, the colours whose '. . . overstated values underline the dryness of the forms; black furniture on a bright yellow background, for instance . . . ' and the choice of such hard, crude tones as '. . . violent sea blue, ash grey, yellow, mauve and violet'. The participation of the Werkbund produced a new and important element — a unity in the conception of furniture. Alongside the impoverished forms and the old-fashioned colours inherited from Art Nouveau

which persisted on the whole in the French contributions, the rigorous forms of Paul Wenz's or Richard Riemerschmid's furniture, Oscar Niemeyer's and Bruno Paul's beautiful materials, even the colours which were so sharply criticised, all laid the foundations for the questings of Art Deco.

Muthesius' position became more clearly defined with the passage of time. In 1914, he defended his standardisation and came up against van de Velde's opposition in the name of the artist's individuality. In the same year, the Werkbund organised an important exhibition in Cologne in which Hoffmann, van de Velde — with his famous theatre — Behrens, Gropius and Taut all participated. Two buildings stand out from an epoch-making ensemble: the office and garage of a modern factory executed by Walter Gropius and Adolf Meyer and Bruno Taut's Crystal Pavilion. Well disseminated in Germany, the Werkbund's theories became international and organisations of the same type were set up in Austria (1910), Switzerland (1913), Sweden and England (1915).

Interrupted by the war, the Werkbund's activity took off again as soon as peace returned. The principal event was the exhibition of interiors organised in 1927 at the Weissenhof, near Stuttgart, in which foreign architects invited by the association's vice-president, Ludwig Mies van der Rohe (1886-1969), took part, such as Le Corbusier, J.J.P. Oud, Mart Stam and the Italian Gruppo 7. The theories of Muthesius, his modern building principles and his faith in standardisation found full expression there. They mingled with the teachings professed since 1919 by the Bauhaus in Weimar, established in 1926 in new buildings designed by Gropius in Dessau. Mies took charge of it in 1930 while Gropius was responsible for the Werkbund's display in the Salon des Artistes Décorateurs in Paris, with three of his former Bauhaus colleagues — Marcel Breuer, Herbert Bayer and Laszlo Moholy-Nagy. Grouping together the leading exponents of European architecture, the Weissenhof exhibition offered a complete picture of possibilities in building, as much on the technical level as on that of social and aesthetic considerations. As far as furniture is concerned, two chairs mark a historic date and remain classics of furniture to this day: Mies van der Rohe's Weissenhof-Sessel fitted with woven rushes and Mart Stam's chair with its leather lined back and seat. Both are based on tubular steel frames and have no back legs.

The Werkbund's display in 1930 made it possible to judge its progress since its foundation. Based on William Morris' aesthetic experiments and social theories, it was able rapidly to opt for the modern, scientific and industrial world. The experience of war, the lesson of the Socialist Revolution and Muthesius' open personality had enabled it to reach exemplary heights by grouping together the best artists, and on an international level by attracting all the avant-garde architects in Europe. It presented a picture of continuous advance up to the advent of the Nazis. 'From one stand to another,' wrote André Salmon in *Art et Décoration* in 1930, 'the continuity of effort is unmistakable. Toiletry or table objects, office equipment or furniture itself, there is nothing that would not be at home in a Gropius furniture setting and there is not a single object which a traveller would be unable to find, from tomorrow onwards, in some German shop window.' The aim Muthesius set himself 20 years earlier was attained and

confirmed by Moholy-Nagy: 'The greatest stress is to be laid not on the isolated masterpiece, but on the creation of a kind of general value, the progress towards standardisation.'

The Bauhaus

'Architects, sculptors, painters, we must all return to our trade! There is no "professional art". There is no difference of kind between the artist and the craftsman. The artist is merely an inspired craftsman . . . Let us therefore form an association of a new kind, an association free of that class distinction which· raises a barrier between craftsman and artist. Let us all together plan and execute the architecture of the future, in which painting, sculpture and architecture will be indissolubly linked, and which, under the hands of millions of workers, will one day grow skywards; the crystal symbol of a new faith.' It was in these terms that Walter Gropius (1883-1969) announced the foundation of the Bauhaus in 1919, the union of the Kunstgewerbeschule and the Weimar Academy to the direction of which he succeeded Henry van de Velde (1863-1957). The message was clear in Germany, all the more so in that it took the direction already adopted in Muthesius' work.

Teaching was based on the study of forms and colours, and on practical craftsmanship in specially adapted workshops for sculpture, glasswork, photography, metalwork, furniture making, pottery, typography and weaving. Through lack of funds and premises, Gropius was prevented from opening a department of architecture at Weimar but from 1927 one was operated at Dessau under the direction of the Swiss architect, Hannes Meyer (1889-1955).

The activity of the Bauhaus from its foundation in 1919 to its closure by the Nazis in 1933 is of great importance. Its role was considerable and the men who inspired it were almost all exceptional figures; not only the architects who in turn directed it — Gropius, Meyer, Mies van der Rohe, but the artists and painters who took charge of the workshops such as Klee, Itten, Kandinsky, Feininger, Moholy-Nagy and Schlemmer. The opportunities available to students and teachers to complete prototypes destined for use in industry was certainly the institution's most remarkable achievement. Some of them remain faultless even today and continue to be produced — the chairs designed by Marcel Breuer (b. 1902) for example. His Wassily armchair designed in 1925, produced in 1926 by Standard Möbel in Berlin is today manufactured by Knoll and the chair without back legs produced by Thonet in 1928 is also manufactured today by Knoll. Breuer chose metal tubing after initial experiments with wood furniture in which the method of assembly remained apparent. 'I chose metal deliberately . . . in order to obtain the qualities and framework of modern life. The heavy padding of a comfortable chair is replaced by tightly fitting upholstery and by a few light and supple tubes. The metals used, particularly aluminium, are remarkably light while remaining nonetheless strong and furthermore the sleigh shape increases its handiness.' Some other examples were metal and glass objects designed by Marianne Brandt and Wilhelm Wagenfeld such as teapots, tea glasses, ashtrays and lamps.

The Bauhaus' products, particularly during the Weimar period, bear a distinct family resemblance to each other.

Shapes are simple and geometrical, based on a respect for and knowledge of the material used, as a function of the desired goal: the use of the object. The choice of colours was the outcome of fundamental theoretical considerations.

The extent of the Bauhaus' influence was considerable. Paradoxically the political circumstances surrounding its closure, by obliging teachers and students to leave Germany, increased the influence of its doctrine throughout the world. France of the Art Deco period missed it however. The reasons are political, nationalistic and ideological for the aims of the Bauhaus were in complete opposition to the wishes of post-1914 French society — those of perpetuating for as long as possible a way of life which the French dimly realised would abandon them very soon. The Esprit Nouveau group were however an exception for Le Corbusier had become well acquainted with the Werkbund's way of thought in 1911 while on a study trip organised by the Ecole d'Art de La Chaux-de-Fonds.

The De Stijl movement

Architecture and decorative arts are more or less consequences of the great currents that revolutionised painting in Europe between 1905 and the First World War. If Expressionism, to the extent that it represented a refusal of the classical tradition and official eclecticism, influenced the artists of the Werkbund and Bauhaus in their early days, Piet Mondrian's Neo-Plasticism inspired the work of a number of Dutch, Russian, Swiss and Alsatian architects, painters and sculptors grouped around Théo van Doesburg, founder of the review *De Stijl* (1907). Oud, van der Leck, Vantongerloo, César Doméla, El Lissitsky, Rietveld, van Eesteren, Jean Arp and Sophie Taueber-Arp had in common an attempt to find a synthesis of all the arts on the basis of the Neo-Plasticist doctrine: a doctrine 'which consists of the exclusive use of right angles in horizontal-vertical positions and of the three primary colours to which are added the "non-colours", white, black and grey', (Michel Seuphor). Their activity encompassed all forms of plastic expression including painting, sculpture, architecture, interior decoration, furniture, theatre, dancing and films.

The Shröder House in Utrecht (1924) built by Gerrit Rietveld (1888-1964) gave the clearest expression to the architectural notions of De Stijl as the correspondence between external and internal architecture, mobility of interior space due to movable partitions and a global and generous conception of architecture as a synthesis of the arts worked out in close collaboration with prospective residents. The group's activity was not limited to Holland. Van Doesburg took part in fitting out the interior of the Villa Noailles built by Robert Mallet-Stevens at Hyères (1923). He also worked on the Aubette cabaret in Strasbourg with Jean Arp and Sophie Taueber-Arp.

In 1917 van Doesburg designed the prototypes of chairs made of chromed steel tube, covered in leather. Rietveld had anticipated him in this field with the production, also in 1917, of the famous Red-Blue chair, whose wood form and bold colours present a vigorous construction. In 1925, neither De Stijl nor the Bauhaus were called upon to represent Holland at the Exhibition of Decorative Art.

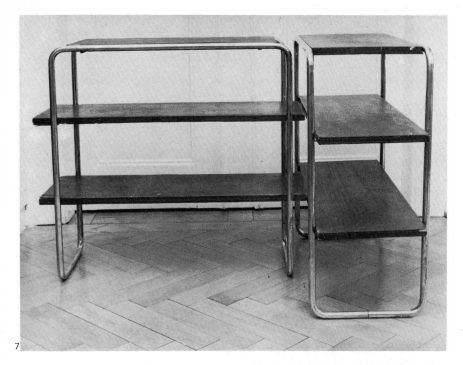

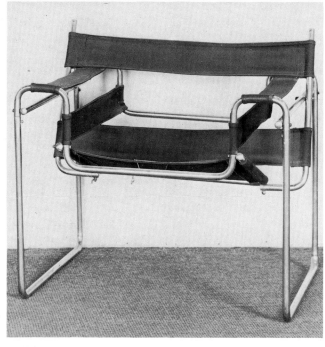

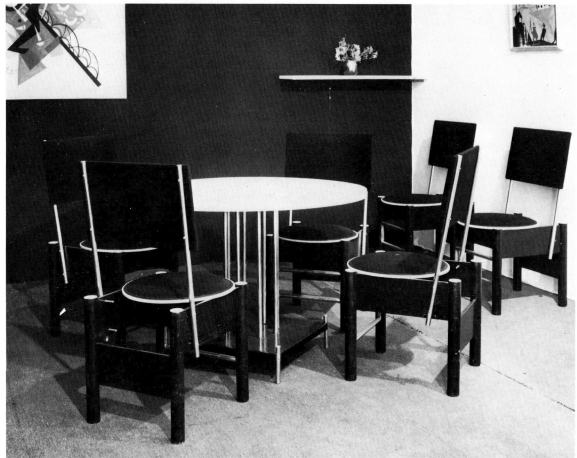

7 MARCEL BREUER Tubular steel sideboard with lacquered shelves manufactured by Thonet. (Collection Knut Günther)

8 MARCEL BREUER The Wassily chair of nickel-plated steel tubing, 1925, manufactured a year later by the Standard Möbel in Berlin. (Bauhaus-Archiv, Berlin)

9 MARCEL BREUER A dining-room suite made at Dessau for Kandinsky and according to the artist's specifications, 1926. (Collection Mme N. Kandinsky)

10 JOSEF HOFFMANN Bent wood and leather chair made for the dining-room of the Purkersdorf Sanatorium, near Vienna, c.1903-1906. (Musée des Arts Décoratifs, Paris)

11 MARCEL BREUER Chrome tubular steel and lacquered wood desk, c.1926. (Collection Knut Günther)

12 Folding table with painted top made in Germany or Holland, c.1925. (Collection Maria de Beyrie)

13 GERRIT RIETVELD The Red-Blue chair in painted beechwood, 1917. (Musée des Arts Décoratifs, Paris)

14 PETER BEHRENS Desk and chair in pale wood and amaranth, c.1900-1905. (Kunstgewerbemuseum, Hamburg)

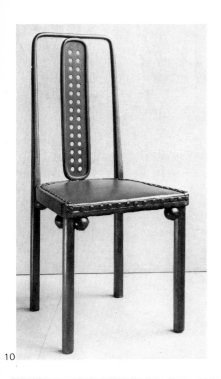

10

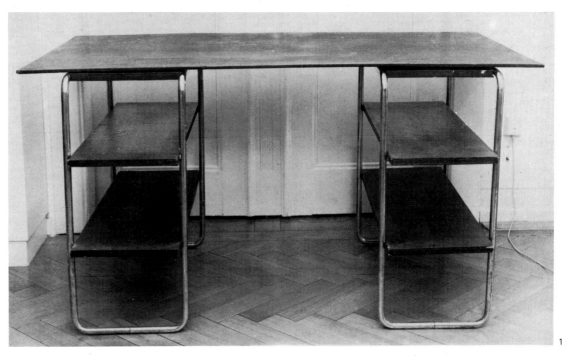

11

2

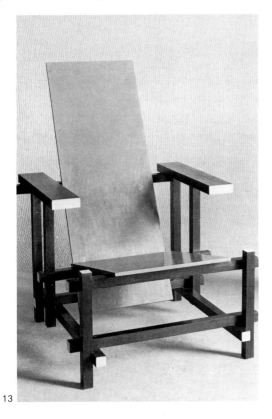

13

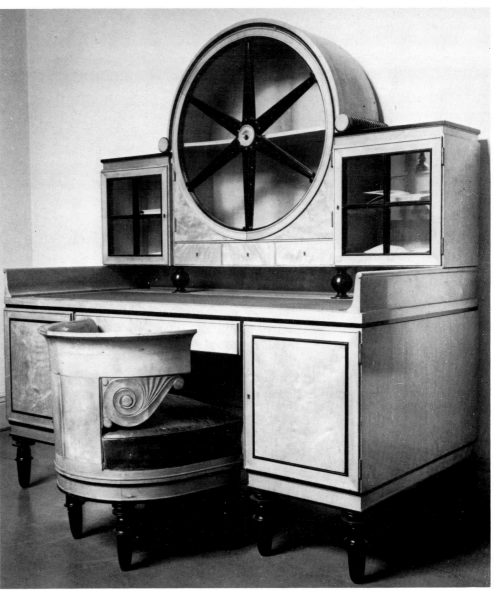

14

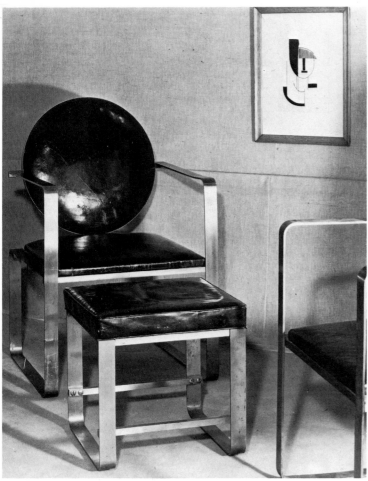

15 Steel and black patent leather chair, one of a pair designed at the Bauhaus, c.1930. The gouache on the wall, dated 1930, is attributed to Otto Freundlich. (Collection Maria de Beyrie)

Russian Constructivism

The Constructivist theories of Naum Gabo, Antoine Pevsner and El Lissitsky inspired the Russian architects of the 20s with a 'veritable technological mystique'. This current was expressed by the Russian pavilion by Konstantin Melnikov at the 1925 Exhibition, as well as by the stage sets on show in it. The faculty of architecture at Moscow University whose teaching was close to that of the Bauhaus, concerned itself more with architecture than with decorative art or the production of objects made with industry in mind. With the exception of a chair made of metal tubing, with a moulded seat, the work of Vladimir Tatlin and Casimir Malevitch's designs for dinner services for the Leningrad State pottery, the objects presented on the whole reflected a pronounced taste for folklore.

Art Deco in Italy

Up to the First World War, Italy merely followed in the wake of other nations — their Liberty style having been inspired by Belgian and French Art Nouveau. From 1909 onwards until the war, interest began to be directed towards Central Europe and those two foci of dynamism, Vienna and Munich. From this confused period when decorative art hesitated between the purely decorative tendency of d'Annunzio and foreign currents from Austria, Wagner's school and Bavaria, one figure stands out — Antonio Sant'Elia (1888-1916). This visionary architect, impressed by the great American cities, conceived the design of a Città Nuova, presented in Milan in 1924 with the plans for a modern metropolis designed by his friend Mario Chiattone. The text accompanying the exhibition's catalogue proposes a renewal of architecture breaking totally with tradition. Its aspirations and the tone in which they are expressed are similar to the theories of the Futurist movement which Sant'Elia was persuaded to join by Filippo Marinetti. The manifesto of Futurist architecture was published in *Lacerba*, the group's review: 'We are no longer sensitive to monumental, massive, static form . . . our spirit has been enriched by a taste for light, practical forms, for the provisional, for rapidity . . . We must invent the Futurist town as a whole in the image of an immense bubbling work-site, full of life, mobile, dynamic in every way and the Futurist house in the image of a gigantic machine.' The language was new and the concepts revolutionary, heralding Le Corbusier's famous formula promulgated in 1921 that a house 'is a machine for living'. A victim of the war in 1916, Sant'Elia's work had no time to develop independently of the major European countries. It represented a new spirit in a country which until then had been utterly backward-looking, paralysed by narrow nationalism.

The revival of the decorative arts remained a primary concern. They were included in the exhibition of modern art of the Biennale di Venezia but in the form of craftsmanship and on a regional level only. Graphic art and posters were in the forefront due to the work of Marcello Dudovitch and Aleardo Terzi. The Neapolitan chain of confectioners, Mele, commissioned the graphic firm, Ricordi, to produce their advertising posters: a unique experience of co-operation between art and industry in Italy before 1914 resulting in designs rich in quality. The productions staged by the Ballets Russes in Rome in 1911 revealed a previously unknown world of sumptuous colour but failed to excite the same dynamic enthusiasm which was shaking France at the same period.

The war did nothing to change a situation which, if anything, worsened, revealing a patriotism which was later expressed in Fascism. Italy was practically torn in two between opposing camps, one basing its nationalism on the adulation of ancient Rome and the other young, modern, turned towards Europe and the satirical work of the illustrator, Sergio Stefano. Movements began to be formed, salons to be organised, with the aim of establishing genuinely Italian forms of architecture and the decorative arts. The most important organisation was that of the Novecento Italiano, an association of architects who wished to present themselves as modernists while at the same time adhering to the neo-classical aesthetic which had its roots in Fascism. One of their number, Giuseppe Terragni, separated himself from them by creating the Gruppo 7 in 1927 with six other architects, nearly all of them Milanese. Their aim was to devise functional architecture and forms independent of neo-classicism, but in the national tradition.

Interest in the decorative arts inspired Italy to open the first international exhibition essentially devoted to them. Organised in the Villa Reale at Monza in 1923, it was a biennial occasion which later became triennial and was

moved to Milan in 1933. The apparent impossibility of escaping from the nation's regional subdivisions which enclosed artistic and craft work within their limits, gave to the Italian contributions a traditional, folkloric character, in stark contrast with most of the foreign displays open to the main European currents. The work of certain poster painters, Enrico Saccheti and Sepo Nizzoli, stood out from the general mediocrity, as did Guido Ravesi's sumptuous cloths from Como, Alfredo Ravasco's jewellery from Milan, Venini's and Cappellin's blown glass from Murano. The Richard-Ginori earthenware and porcelain factory drew its inspiration from the architect, Gio Ponti, who envisaged Italian forms undergoing their revival within classical and ancient traditions, while at the same time attaching a due importance to those men who had played a key role in the European revival — Josef Hoffmann for instance. In 1928, Ponti founded *Domus* in Milan, the first review in the world to devote itself equally to architecture, art and the decorative arts. Its role in the formation of Italian bourgeois taste was crucial and remains so today.

Art Deco in Scandinavia

The 20s was not a period of revival in Scandinavia, nor one in which it took an active part in the search for original art forms genuinely independent of the past.

Swedish architecture passed through two phases: the first, pre-1914, took the form of a nationalist, realist current and the second, after the war, was neo-classical. More interesting was industrial building which had its roots in an upsurge of industrial activity. Decorative art was, on the whole, heavily marked by national traditions and the influence of styles

from the past. Exceptions are glasswork and ceramics for there we find a genuine desire for innovation, to be integrated into the modern world and to use its techniques. The Orrefors glassworks launched itself simultaneously into the industrial manufacturing of cheap glasses and the creation of exceptional items in cut and engraved crystal based on models made by two artists attached to the firm, Simon Gate and Edward Hald. Similar concerns influenced research and production in the Gustavsberg and Rörstrand factories.

The Danes contributed to the Art Deco style in the two fields of artistic craftsmanship which were traditionally theirs: porcelain and goldwork. The Royal Copenhagen Porcelain factory produced enamelled porcelain, white or flambé porcelain, glazed stoneware and earthenware. The range of techniques used by Bing and Gröndahl was equally as broad: soft paste, enamelled porcelain, porcelain decorated in matt enamel, sculpted porcelain by Mrs Jo Hahn Locher and stoneware and statuary by Kai Nielsen and Jean Gauguin, the son of Paul Gauguin. If a marked oriental influence can be seen in the earthenware produced by both factories, decoration in the Art Deco style was adopted for the porcelain. Alongside Christian Fjerdingstad, who supplied models to Christofle in Paris, Georg Jensen (1866-1935) was the most noted goldsmith of the period. One of the first before the 1914-1918 war, his efforts were directed towards enhancing the quality of his craft once more, after the lowering of standards due to machine production. He personally designed and produced some elegant and refined pieces, with hammered surfaces and added sculpted details. Jensen also produced work from models by artists such as the painter Johan Rohde, a friend of the Pont-Aven group.

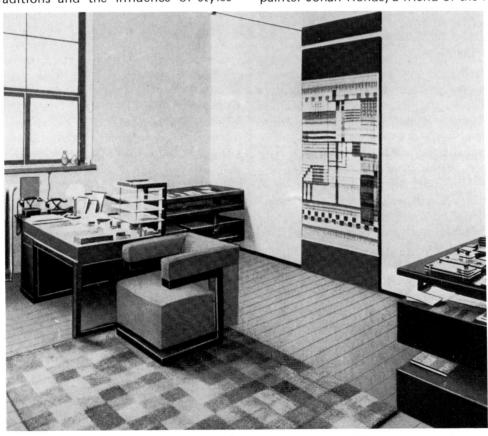

16 WALTER GROPIUS Office at the Bauhaus in Dessau, 1926.

ART DECO IN FRANCE

Consecrated in Paris on the occasion of the 1925 Exhibition, Art Deco found its chosen land in France where it also encountered its antithesis, in the tendency defended in the Esprit Nouveau movement by Amédée Ozenfant (1886-1966) and Le Corbusier (1888-1966) and in the group of innovators grouped together round René Herbst in 1930 to found the U.A.M., the Union des Artistes Modernes.

The failure of the 1900 Exhibition was sharply felt by decorative artists. In 1901, they founded a society dedicated to breaking the indifference of a public whose interest had been drawn once more towards the furniture and objects of the past, whether false or genuine and encouraged to indulge this taste by antique dealers and industrialists. The entirely backward-looking position of industrialists obliged decorators to establish direct contacts with their customers. In France this was achieved through the annual salon organised from 1907 onwards in the Pavillon de Marsan, the Salon d'Automne in the Grand Palais, the Salon des Artistes Français and the Société Nationale which opened departments of decorative art, through the exhibitions of applied art organised by the city of Paris in the Musée Galliera and abroad through any international exhibitions.

From 1901 to 1910, the objective as far as furniture and decoration were concerned was to escape the 'obsession with the curve'. The main aim was 'cheapness'. Certain decorators such as Mathieu Gallerey and Maurice Dufrêne, used machines in order to achieve their aim. Ornaments, the glory and charm of Art Nouveau, were questioned, but this questioning was more theoretical than real. There were certain exceptions, however, like Francis Jourdain who was already designing furniture in which even the mouldings had been suppressed and who concerned himself only with establishing a balance of weight. This was a transitional period, a thankless period in which craftsmanship came into conflict with theory, in which carpenters were in opposition to architects with the appearance of Lucet's 'American Combined', sofas integrated with bookcases and convertible into beds. Their 'cheap' furniture was definitely a failure and became associated with kitchen furniture. The result was dismaying, to the extent that a cheap furniture competition that opened in 1908 on the occasion of the Third Furniture Industry Salon contained a Louis XVI bedroom suite.

At the same time as in Germany and Austria the problem of the home and of interior decoration was being completely rethought in realist terms as a function of the technical, economic and social context. French decorators remained isolated, cut off from industry which turned its back on them and deprived them of any important architectural work. The few buildings by Auguste Perret, Tony Garnier and Henri Sauvage are exceptions. Official architecture remained completely backward-looking, dominated by the standards of the bourgeoisie of the nineteenth century.

The Ballets Russes and their influence

In 1909, Paris discovered Sergei Diaghilev's Ballets Russes and through them, a form of spectator art whose unprecedented unity was achieved by a close collaboration of dancing, music and painting. The painter's role in them was exceptional; he became not only organiser of the programme but of the posters, decor, props and costumes and found himself in a sense determining the 'brand image' of the production. It was he who determined the history of the ballets to the extent that only these aspects — the programmes, posters and costumes have survived. In 1909, the Ballets Russes' brand image was colour. Its oriental splendour literally invaded the stage. Diaghilev's painters — all Russian — used colours in a way that could not be more different from the pale range inherited from the first years of the century, and from the greyness of the realist school's presentations of Parisian street scenes. The productions that followed on each others' heels until the outbreak of war — *Schéhérazade, Le Spectre de la Rose, Thamar, L'Oiseau de Feu, Petrouchka, L'Après-midi d'un Faune, Le Sacre du Printemps, Le Coq d'Or* — constituted a series of events which progressively changed not only the notions of the French stage, but also fashion and the decorative arts.

Paul Poiret

In 1909, Paul Poiret (1879-1944) reigned over Paris fashions and over the circles of society he dressed, bringing fashionable people and artists together at his famous parties. Some of these artists he employed — Paul Iribe who left us his impression of the 1908 collection in *Les Robes de Paul Poiret racontées par Paul Iribe*, Georges Lepape whose charming watercolours published in 1911 in *Les Choses de Paul Poiret* allow us to gauge the evolution of the couturier's style, towards freer, more colourful fashions, and Raoul Dufy, to whom he presented a cloth printing workshop in 1911.

In his memoirs published in 1930 under the title *En habillant l'époque,* Poiret admits to having been 'deeply impressed by the Ballets Russes'. He modestly adds this astonishing sentence: 'I would not be surprised if they had exercised a certain influence on me.' After which, he defends himself spiritedly against the suggestion that he had been

affected by Léon Bakst's success: 'It must however be made entirely clear that I already existed, and that my reputation was established well before M. Bakst's.'

It is however undeniable, and this in no way detracts from his great talent and considerable achievements, that the Oriental vogue brought to France by Diaghilev influenced Poiret's colour scheme and the styles of his dresses. Not to speak of the famous Persian Party, that 'Mille et deuxième nuit' which brought together 300 'Persians' one evening, on June 24 1911.

In 1912, Paul Poiret founded the Ecole Martine, thus adding a further string to the already well endowed bow of his activities. Trips to Austria and Germany, in the course of which he met Klimt, Hoffmann and Muthesius, visiting workshops and schools beyond the Rhine, made him aware of the problems of artistic creativity and education. His methods paralleled those of the Wiener Werkstätte. The students, young girls of around 12 years of age, chosen from working class backgrounds, painted from nature, in the country or at the Botanical Gardens. 'They brought me some charming things,' he recounts in his memoirs, 'fields of ripe wheat in which daisies, poppies and cornflowers blazed out; or baskets of begonias, clumps of hortensia, virgin forests through which charging tigers leapt, the whole treated with an untamed and natural touch that I wish I had the words to describe.' Those works would then become the cloths, rugs and wallpapers sold in the Maison Martine, opened a few months later. 'My role,' explains Poiret, 'was to stimulate their work and their taste without ever influencing them or criticising them, in order to leave their sources and their inspiration pure and intact. To tell the truth they exerted a far greater influence on me than I on them, and my only talent was for choosing which of all their works were most suitable for reproduction.' The childlike style of drawing and the popular imagery of the 'Choses à la mode' of the Martine workshop produced in 1912 a new, young spirit which tended towards the direction of modern life and its taste for the ephemeral. Cubist chairs without ornament made from rare materials or painted wood, were also designed there, as were seats inundated with cushions, and weird and exotic lighting. This was vogue art but art which transcended itself and reached out towards the future.

Futurism/Fauvism/Cubism
On February 20 1909, *Le Figaro* published the Italian poet, Marinetti's *Manifesto of Futurism*. 'We proclaim that the world's splendour has been enriched by a new beauty: the beauty of speed. A racing car with its bonnet adorned with thick pipes like so many fire breathing serpents . . . a roaring car that appears to be flying on a hail of bullets is more beautiful than the *Victory of Samothrace* . . . We want to see museums and libraries demolished . . . ' The tone was aggressive, shocking in its desire to destroy the past in the name of the future. It belonged to that revolutionary ferment that was stirring the whole of Europe in the years leading up to the Great War. In the same period, France was divided between two families — the Fauvists and the Cubists. Opposed to Fauvism which exalted pure painting, sensation expressed in two dimensions without modelling or chiaro-

scuro, stood Cubism which discarded decoration in favour of analytic, realist and objective vision of form. Futurism, Fauvism and Cubism are the aesthetic roots of the French 20s, of Art Deco as of the Esprit Nouveau. Both defined themselves in relation to Cubism for Art Deco borrowed its geometric forms as in Iribe's cubist rose and the Esprit Nouveau laid claim to its analytic and objective view of form. Both drew also on Fauvism, from which they took the notion of speed, the Ballets Russes and Paul Poiret. Although united by aesthetic links and by their contemporaneity, Art Deco and the Esprit Nouveau were opposed to each other on the ideological, political plane and established systems of thought in which luxury was contrasted with a kind of ascesis.

Art Deco
Speed, the machines that created it, pure colour, geometry — all these constituent parts of the jigsaw puzzle were in their allocated places as early as 1909. Few however, were those who could assemble them at that time, such was the confusion that still reigned. Hostility towards Art Nouveau — a typically French phenomenon — prompted an upsurge of nationalist feeling which was reinforced by the Deutscher Werkbund's display in the Salon d'Automne of 1910. The role of 'ensemblier' as opposed to decorator gained increasing importance in the creation of the new interior or ensemble. This ensemble was a combination of separate decorative elements which, when viewed as a whole contributed to the general unity. The ensemblier borrowed the fashion for brightly coloured cushions from the reds and greens of the Ballets Russes and took his dark, funereal tones from the Werkbund's violets and blacks. He also sought out painted wood, lacquer and exotic wood inlays. In 1925, just before the great pageant of the decorative arts, Guillaume Janneau, then Inspector of Fine Arts, felt he could justify this early period in the following terms: 'The designers of the first decade of this century understood that new forms are not born in the imagination of the artists but out of real needs hence a chair which is only a domestic implement cannot be designed in an ivory tower but in the apartment where the piece of furniture or implement will find its place.' In 1910, this attractive theory still had a long way to go to become reality. Hence the French section of the Turin International Exhibition where a study designed by the architect Plumet and the decorators Jallot, Gaillard, Süe, Huillard, Follot and Dufrêne was disparate and inconsistent. And all the more so as the German section, grouping together Paul, Behrens, Olbrich and the Scotsmen, Mackintosh and MacNair was remarkable for its unity of expression and intent.

A group of young artists tried at that time to break down the isolation in which each worked by founding an association of artists of different disciplines, which was to become in 1919, the Compagnie des Arts Français. Grouped around André Mare and Louis Süe, they set themselves the goal of creating a modern French style, based on reason and tradition. 'It is thanks to the new requirements of our taste and to a reaction to internal influence that we have subjected ourselves to French constraints,' wrote one of their number, Paul Véra in the review *L'Art Décoratif*. 'We are seeking those qualities of clarity, order and harmony which

distinguished the seventeenth century, and on the other hand to renew our links with a tradition which we see as having been brought to a close in 1848.' Inspired both by provincial French life and Louis-Philippe styles, the decorator . . . will borrow the themes for his variations from nature, whose fruit or flowers he will collect in a basket or weave into a garland . . . It is because of this that a garland of flowers or a basket of fruit will form the brand image of the new style . . .'

The future of the decorative arts took hold of public opinion to such an extent that the daily papers made the subject their own and the main department stores organised competitions. Plans were laid for an exhibition of modern decorative arts for 1916 but activity was brought to a temporary halt by the war. This produced fundamental social and economic transformations, felt very deeply by some while others pretended to ignore them, taking refuge in the illusion of a return to the easy life.

In 1917, Diaghilev once more began to stage the Ballets Russes, but with new composers; Satie, Auric, Poulenc, Milhaud, Falla and Western painters who represented modern tendencies; Picasso, Matisse, Braque, Derain, Laurencin, Gris, Ernst, Miró and Utrillo. In 1920, Rolf de Maré's Ballets Suédois took over this avant-garde role drawing on the talents of Picabia, de Chirico, and Léger. The participation of a painter in the designing of a production was by then taken for granted. The cinema too entered the field, making use of artists and offering them at the same time a new vision — the original view points of which advertising and posters were to make use.

The tendency of decorators to group together, to prefer collective work to individual effort, was becoming firmly established. Following in the tracks of the Compagnie des Arts Francais, the major department stores opened workshops in which every aspect of the decorative arts was studied in order to satisfy the varied requirements of customers: La Maîtrise with Maurice Dufrêne in the Galeries Lafayette, Pomone in the Bon Marché headed by Paul Follot, Primavéra in Le Printemps with M. and Mme Gauchet-Guilleré and Studium at the Magasins du Louvre with Kohlmann and Matet.

The Exhibition was dominated by these decorators, all of them traditionalists, whom Guillaume Janneau called 'contemporary' to distinguish them from 'modern'. It was such men as Süe et Mare, Ruhlmann, Groult, Iribe and Rateau who represented the Art Deco tendency in the 20s with its elegance, its slightly decadent charm and its warmth. But they did not take the step which would allow others to enter the modern world and invent its new image.

The Modern Movement and the Esprit Nouveau

The modern world that emerged from the war was more than ever that of the machine which Le Corbusier defended so passionately, and of speed which was progressively transforming human relations. Aircraft, trains and cars stimulated a new aesthetic inherited from Cubism. Their smooth and graceful forms inspired Le Corbusier's enthusiasm and he gave his architectural work names inspired by the brand name of cars — Maison Citrohan — as well as designing a cheap car that foreshadowed the Citroen 2 chevaux. Ruhlmann himself studied car body shapes and the Martel brothers worked on models for radiator caps.

'A house is a machine for living,' wrote Le Corbusier in *L'Esprit Nouveau* in 1921. Every one of his projects from that time on aimed at giving concrete expression to his profound convictions that housing had to be rethought along completely new lines and at imposing a modern vision of its uses. He felt that a house was as much a tool as all the other objects which contribute to human activity in the twentieth century — a tool adapted to the needs of the new man based on contemporary economic and technical possibilities. With this in mind, architects and decorators like Mallet-Stevens, Chareau, Eileen Gray and Jourdain concerned themselves with the reorganisation of the interior. Hence there appeared multi-purpose living rooms and studios but which showed an equal interest in the equipment of bathrooms and kitchens.

The 1925 Exhibition gave Le Corbusier his opportunity to state clearly and vigorously his attitude towards problems of furniture and decoration. 'Decorative art,' he wrote, 'is a vague and imprecise term representing all that concerns human limb objects. These correspond fairly exactly to thoroughly objective needs; seen as extensions of our limbs, they are adapted to human uses which are standard activities. Standard needs, standard uses, hence standard objects, standard furniture. The human limb object is an obedient servant who is discreet and self-effacing, leaving his master his freedom of action.' Le Corbusier replaced the word 'furniture' which represented 'accumulated tradition and outdated uses' with that of 'equipment'. Finally, following in the steps of Adolf Loos, he took decoration to task: 'Decorated objects were once rare and costly, today they are in huge supply and cheap. Simple objects were once cheap and in huge supply, now they are costly and rare . . . Today decorated objects have flooded out the shelves of the major department stores and are sold off cheaply to office girls. If they are sold cheaply, it is because they are badly made and their decoration hides the faults of workmanship and the poor quality of the materials used . . . Trinkets are always decorated and excessively so; luxury pieces are well made and clean-cut, pure and wholesome and their bareness reveals their good workmanship.'

In its diversity and its contradictions, the 1925 Exhibition of the Decorative Arts was therefore a precise mirror image of the prodigious creativity of a period which was hesitating between two cultures: one inherited from the nineteenth century, linked to the bourgeois system, to those aspects of tradition which make it restrictive technically and stylistically limited and not those aspects which are dynamic and exemplary and the other turned towards the future and deeply involved with the second Industrial Revolution.

17 SUE ET MARE La Rotonde in the Musée d'Art Contemporain.

18 EDGAR BRANDT The wrought-iron room of the Galerie de l'Ameublement.

19 EMILE-JACQUES RUHLMANN Boudoir from Ruhlmann's Pavillon du Collectionneur.

20 EMILE-JACQUES RUHLMANN Study from the Pavillon with a sculpture by Joseph Bernard.

21 EMILE-JACQUES RUHLMANN Dining-room from the Pavillon with wall-hangings by Léon Voguet, bas-relief by Pierre-Georges Jeanniot and rug by Gaudissart.

THE 1925 EXHIBITION

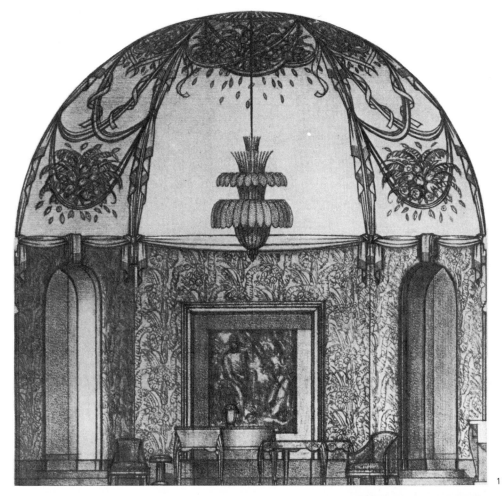

17

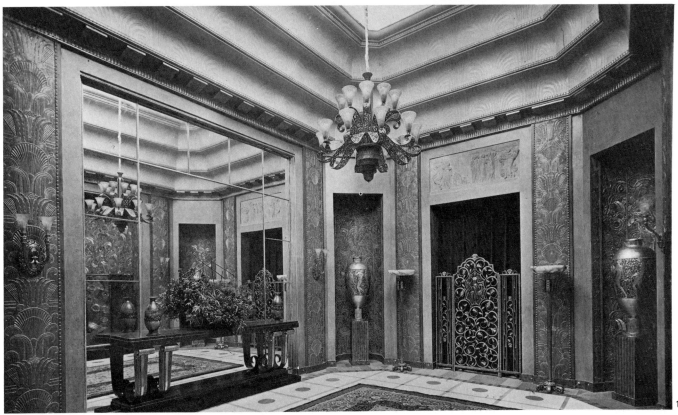

18

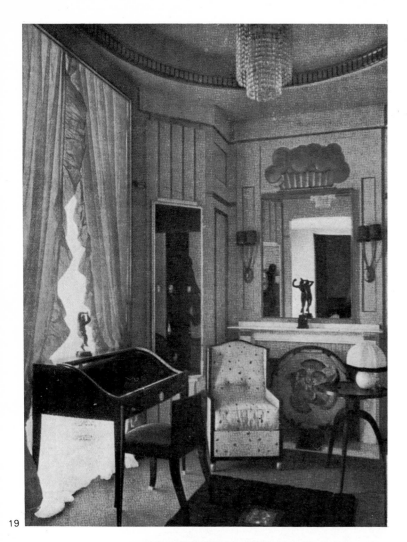

19

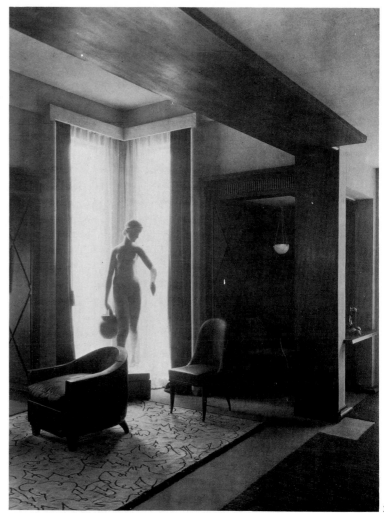

20

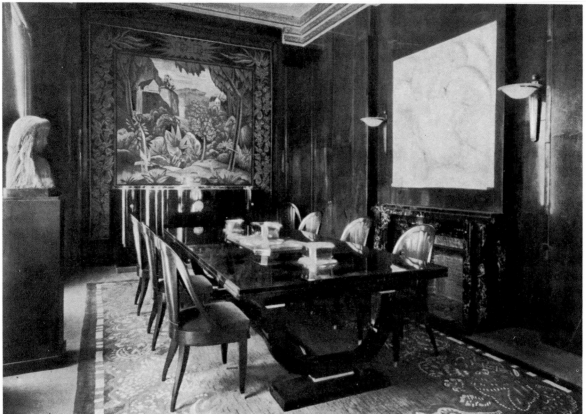

21

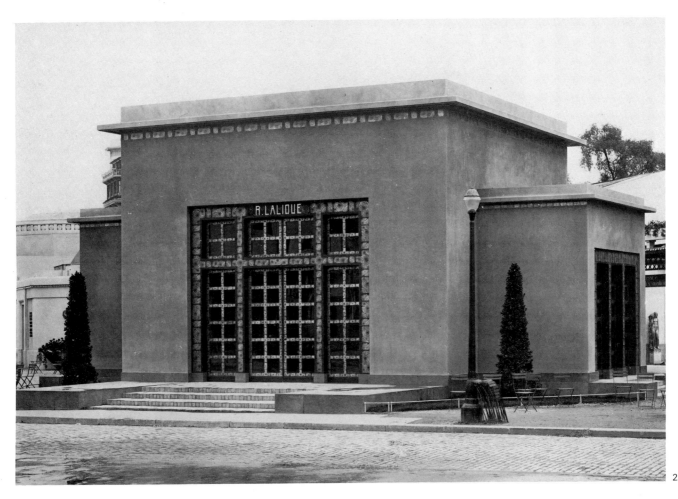

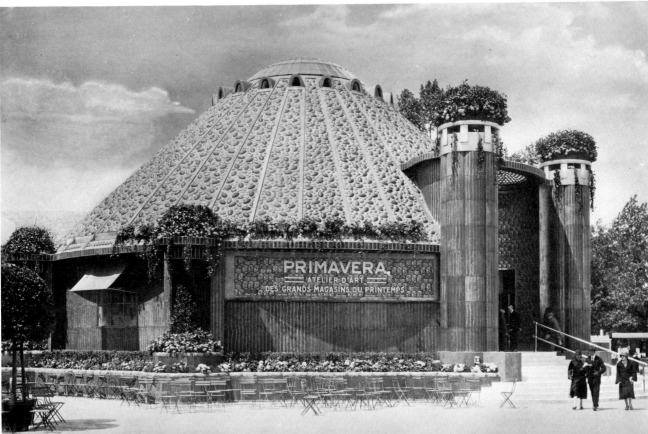

22 MARC DUCLUZAND The René Lalique pavilion with ceramic staircase by Lalique.　23 SAUVAGE and WYBO The Primavéra pavilion for the Grands Magasins du Printemps.

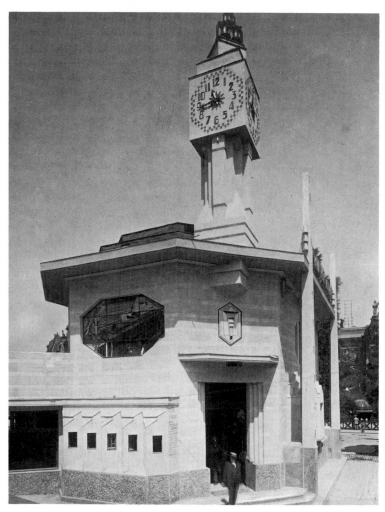

24 G. TRONCHET The Hôtel des Postes et Télégraphes with stained glass by Jacques Grüber.

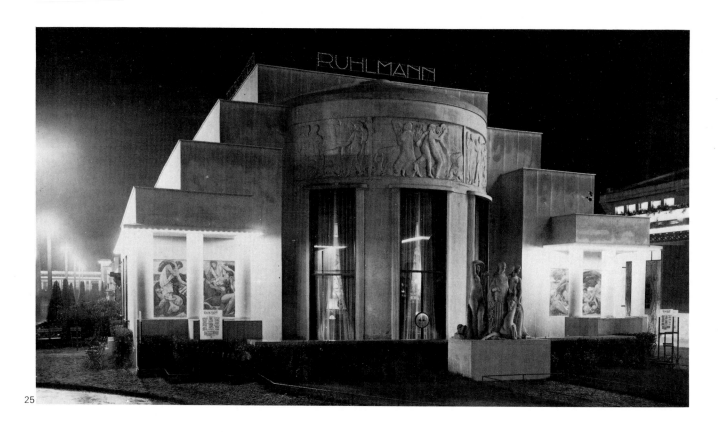

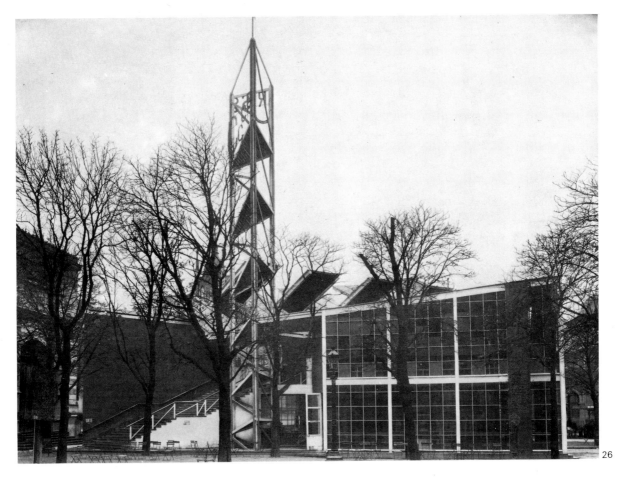

26

25 PIERRE PATOUT The Pavillon du Collectionneur. The door is by Edgar Brandt, the bas-relief by Joseph Bernard and the sculpted stone group *A la Gloire de Jean Goujon* by Pierre-Georges Jeanniot.

26 KONSTANTIN MELNIKOV The Russian pavilion.

27 LE CORBUSIER and PIERRE JEANNERET The *Esprit Nouveau* pavilion with sculpture by Jacques Lipchitz.

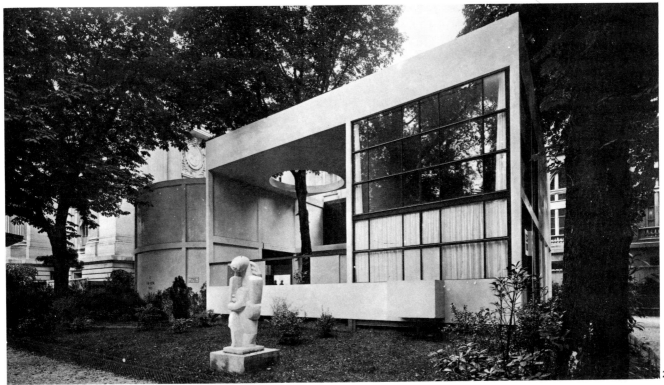

27

ARCHITECTURE

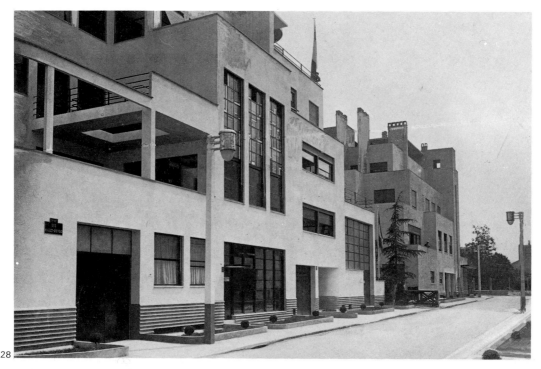

28

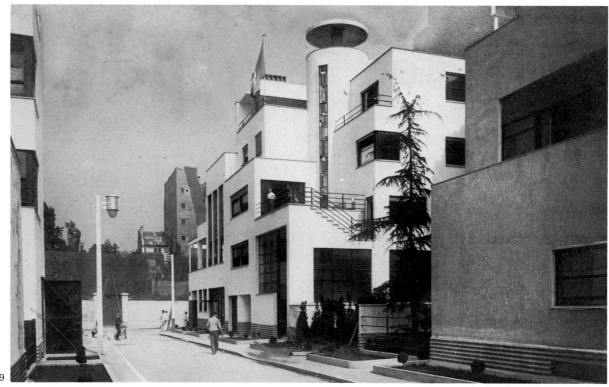

29

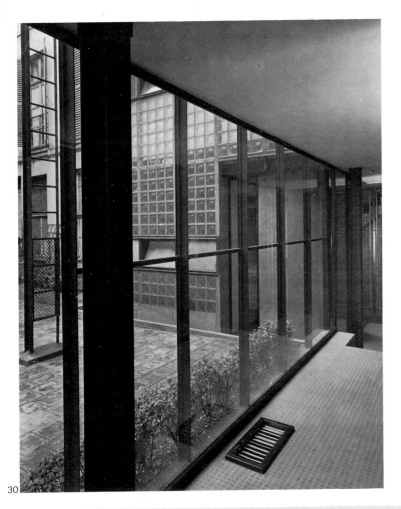

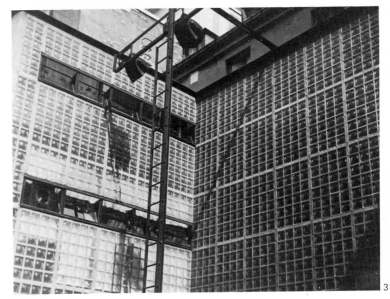

28 ROBERT MALLET-STEVENS The Martel brothers' and Reifenderg villas along the impasse Mallet-Stevens in Auteuil, built between 1925 and 1926.

29 ROBERT MALLET-STEVENS Another view of the villa belonging to the sculptors Jan and Joël Martel. The stained glass in the stairwell is by Louis Barillet.

30-32 PIERRE CHAREAU Three views of the Maison de Verre built between 1928 and 1931 for Dr and Mme Jean Dalsace, rue Saint-Guillaume, Paris, showing the novel use of glass slabs.

33-34 LE CORBUSIER Two views of the Villa Stein at Garches, built in 1927.

35 LE CORBUSIER The roof terrace of the Villa Savoye in Poissy built between 1929 and 1931.

36 LE CORBUSIER The La Roche house, Paris, designed in 1923 for Le Corbusier's friend, Raoul La Roche. Nowadays it houses the Foundation Le Corbusier.

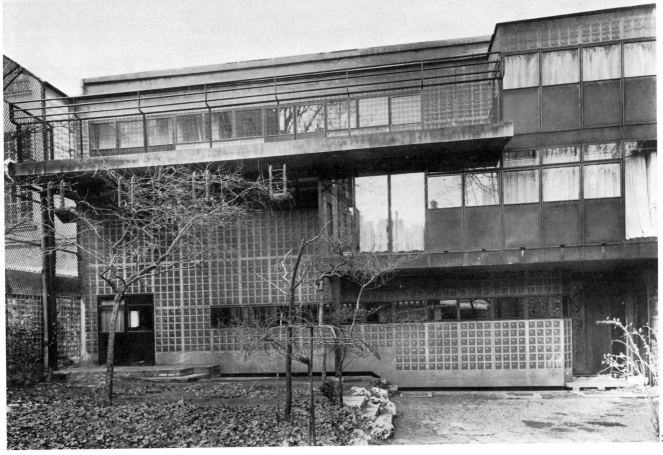

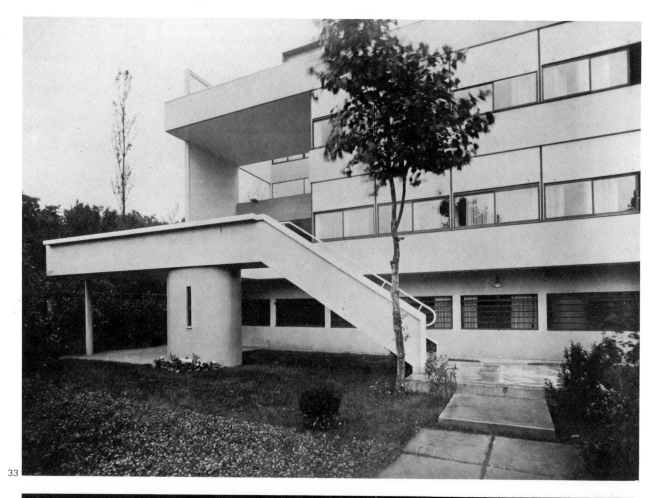

33

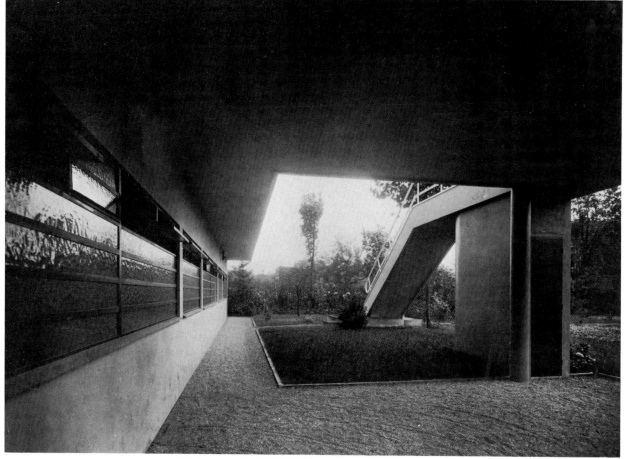

34

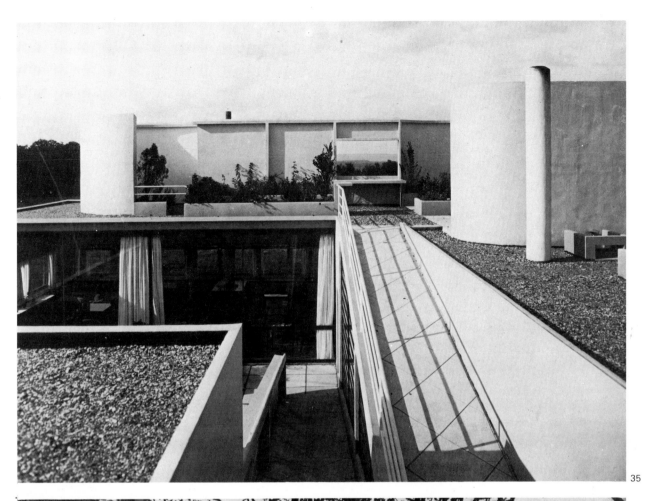

35

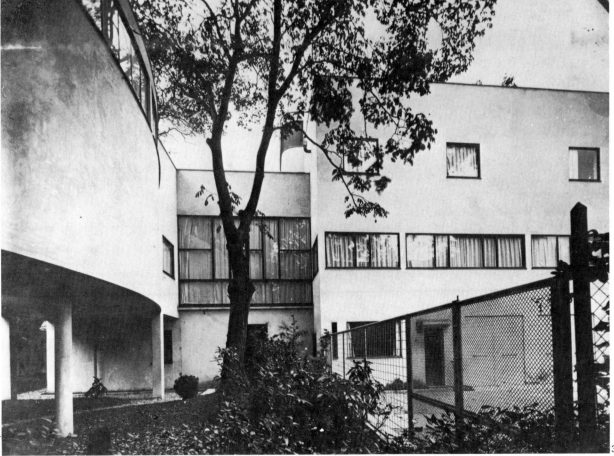

36

FURNITURE

THE TRADITIONALISTS

The 20s saw the last fine days of luxury furniture —hence their appeal 50 years later. It was the work of those whom we could call, with Guillaume Janneau, the 'contemporaries', or better still, the 'traditionalists'. Most were decorators or cabinet-makers, striving to wipe out memories of the disastrous mass-production which characterised the second half of the nineteenth century. But rejecting the 'decadent' principles of Art Nouveau they laid claim to a tradition which extended back to Louis-Philippe or even to the eighteenth century. Hostile to forms of decorative art foreign to France, they were aggressively French. Because of the 'patriotism of the Germans and the English' as Paul Véra wrote in 1912, these decorators refused to follow their guidance and set themselves the task of 'continuing the French tradition'. This state of mind was symptomatic of the pre-1914 desire to preserve that bourgeois universe which was beginning to be seriously questioned and, later, after the armistice, to forget the four bloody years through which they had passed, by clinging on to a form of civilisation which was already historically condemned. The specific problems of the modern interior concerned them very little. Their main aim was to furnish apartments very close to those of the nineteenth century. With only minor exceptions, their types of furniture are identical to those of previous centuries. Their goal was not innovation but the production of exceptional pieces of high quality, impeccable technique, with selected and very varied materials. They preferred exotic and richly coloured woods such as rosewood, mahogany, ebony, either solid or in veneer, to the native woods made fashionable around 1900 by Art Nouveau. Light coloured woods were chosen for their patterned grains, knotted elm for instance. When the wood's grain or shading was not sufficient, it would be carved, inlaid or overlaid with other woods of contrasting colours, or even with ivory, mother-of-pearl, tortoiseshell or metal. Two materials were particularly popular: sharkskin, which was known as galuchat, in its natural state or dyed, and above all, lacquer. Handles or drawer-rings were made of ivory, bronze or cloth. Shapes varied from designer to designer but as a general rule, despite a certain Cubist influence, they were supple, gentle, curved and were made not only for the pleasure of the eye but also the well-being of the body. The tendency towards geometric shapes was more apparent in decoration where the rose became cubist and flowers were angular and interwoven. One decorative theme predominated — the garland or basket of flowers or fruit which became the most representative symbol of the movement, just as Paul Véra had hoped as early as 1912.

The traditionalists were many in number and not all their work is equally interesting. Amongst those who progressively adopted the new style, Paul Follot (1877-1941) most deserves to be mentioned. A student of Grasset's, influenced early on by English styles and by pre-Raphaelitism, Follot retained from his experience of Art Nouveau a taste for frequently abundant, carved decoration. Around 1909-1910, he began to seek a 'tranquil architecture', choosing beautiful materials and refined techniques — inlays, lacquers, bronze — taking great care of special effects and contrast of colour. In 1923, Follot took charge of Pomone, the artists' workshop at Bon Marché in Paris, for whom he designed a stand at the 1925 Exhibition. He was an ardent defender of the aristocratic tradition of luxury and was categorically opposed to what he called 'mass-production art'. This attitude was not shared by Maurice Dufrêne (1876-1955) who began his career at the Maison Moderne in 1901, a few years before Follot, and established the Maîtrise workshop at the Galeries Lafayette in 1921. Dufrêne was a partisan of the use of industrial methods in every field to which he turned his attention whether it was furniture, textiles, glasswork, ceramics or goldwork. His art, albeit complying with the fashion of the day, remained undefined and in the final analysis had nothing either to gain or lose from being 'popularised'. Clément Mère (1870-n.d.), another artist to emerge from the Maison Moderne, was a specialist in costly furniture in exotic woods and his cabinets, cases, desks and decorative work were governed by his professional training as a painter and in inlaying. The shapes he used are strict, classically geometrical rather than cubist, set off with inlaying in costly wood, carved ivory veneers, polished or embossed copper panels, veined or marbled lacquers or imitations of lacquers.

A taste for comfort, for an elegance reminiscent of the eighteenth century, dominated the work of Paul Iribe and André Groult. Iribe (1883-1935) played a crucial role in the years preceding the First World War. He belonged to the world of high-class fashion and had considerable influence on accepted tastes. His chairs engulf the sitter and are largely open in design. His furniture, finey curved but later straight, is veneered with amaranth, ebony, Brazilian rosewood or dyed sharkskin; its decoration is linear or flowered and makes use of colour contrasts. In 1912, after the remarkable sale of his eighteenth-century collection, the couturier, Jacques

Doucet, commissioned Iribe to furnish his new apartment in the avenue du Bois, marking the beginning of a system of patronage which would, after the war, channel the work of a group of young artists by allowing them to express themselves. André Groult (1884-1967) went still further than Paul Iribe in the cultivation of comfort and a sense of security, due to his profoundly baroque imagination. His masterpiece was without a doubt the stunning anthropomorphic chest of drawers for the Chambre de Madame in the Ambassade Française designed in 1925 by the Société des Artistes Décorateurs.

André Mare (1887-1932) was one of those young artists who, around 1911, turned to French provincial life in their search for a new way forward. He was at the same time a painter, working closely with Roger de la Fresnaye, and designed brightly illuminated book bindings on parchment. The furniture he exhibited in the 1913 Salon d'Automne was regarded as being shockingly cubist in tone. André Mare achieved his main aim by founding the Compagnie des Arts Français in 1919 with the architect, Louis Süe (1875-1968) in which artists from different but complementary disciplines worked together towards a common goal and around a common programme. With such painters and designers as Paul Véra, Gustave Jaulmes, Richard Desvallières, Charles Dufresne, André Dunoyer de Segonzac, Bernard Boutet de Monvel, Jean-Louis Boussingault and André Marty; the sculptor, Pierre Poisson and the glassworker, Maurice Marinot, the Compagnie was in a position to satisfy very varied requirements. It was not their aim to 'produce "fashionable" or revolutionary art, but rather to create ensembles that are straightforward, logical yet welcoming . . .' for their bourgeois customers. Inspired by shapes drawn from the Louis-Philippe period, Süe et Mare's furniture is distinguished by its deep curves, set off with carved decoration of garlands of flowers and fruit or palm leaves and by their preference for self-coloured veneers, contrasting woods and gilded bronze panels. The work of Jules Leleu (1883-1961) follows the trail blazed by André Mare and Louis Süe.

The work of Armand-Albert Rateau (1882-1938), a stranger to salons and artistic groups, is distinguished by his taste for classical antiquity and Oriental art. He made use of wood, particularly solid oak, bronze, with which he worked in the classical mode, and lacquer in gold, silver, yellow or brown. In 1920, Rateau was commissioned by Jeanne Lanvin to fit out her apartment and designed some remarkable furniture for her in green bronze sown with daisies and butterflies, supported by does and pheasants. This extremely ornate style evolved into a remarkable sobriety with the mahogany furniture designed for Dr. Thaleimer and Mlle Stern in 1929-1930. Many other names should be added to those mentioned: Léon Jallot, André Domin, Marcel Genevrière, René Joubert, Pierre-Paul Montagnac, Pierre Lahalle and Henri Rapin, all of whom contributed in their own way to enriching the history of Art Deco furniture.

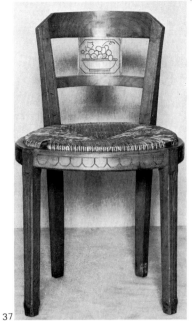 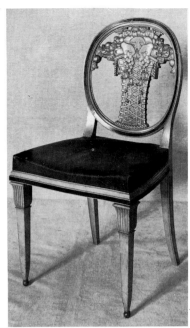

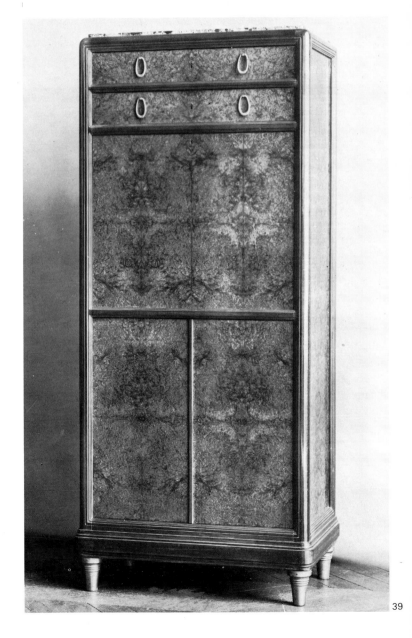

37 ANDRE MARE Waxed and carved cherrywood chair with straw seat, exhibited as part of a dining-room suite at the 1911 Salon d'Automne. (Musée des Arts Décoratifs, Paris)

38 PAUL FOLLOT Sycamore chair with a basket of fruit carved in ebony and amaranth on the back and upholstered in purple morocco leather, 1912. (Musée des Arts Décoratifs, Paris)

39 LEON JALLOT Writing desk in acacia, amaranth and amboyna with gilt-bronze feet, 1914. (Musée des Arts Décoratifs, Paris)

PAUL IRIBE

40 PAUL IRIBE Mahogany, shagreen and carved ebony cabinet, c.1912 from Jacques Doucet's original collection. (Musée des Arts Décoratifs, Paris)

41 PAUL IRIBE Mahogany easy chair with ebony inlay from Jacques Doucet's apartment, avenue du Bois, 1913. (Musée des Arts Décoratifs, Paris)

42 PAUL IRIBE Writing desk and swivel chair in wood veneer inlaid with flower patterns, c.1912-1919. (Private Collection)

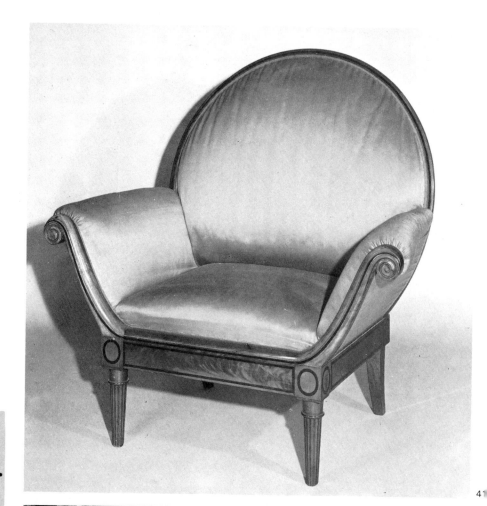

41

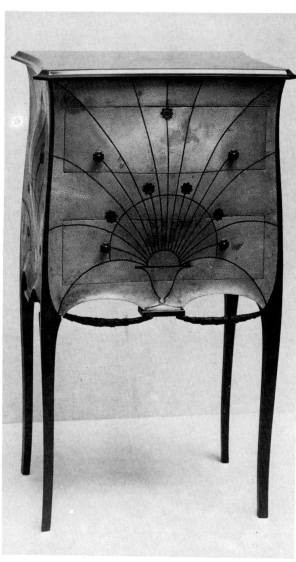

40

42

PAUL FOLLOT

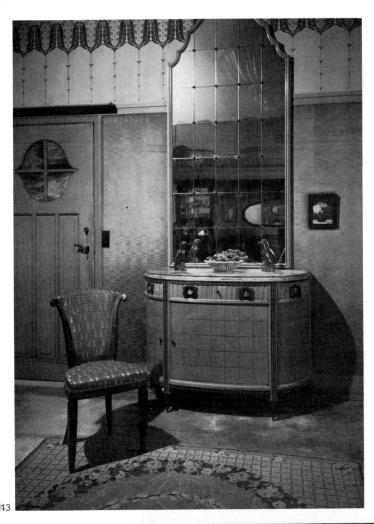

43 PAUL FOLLOT Sycamore commode with inlaid ebony and ivory threads and silvered bronze handles, amboyna chair and rug with Follot's stylised rose.

44 PAUL FOLLOT Detail of a small amboyna chest of drawers with inlaid motif.

45 PAUL FOLLOT Meuble de collectionneur, carved and gilded on sheet metal with amaranth shelves. The standard lamp is of carved wood.

46 PAUL FOLLOT Commode in ultramarine lacquered wood with carved gilt motif.

47 PAUL FOLLOT Flecked maplewood piano with amaranth and mother-of-pearl strands, 1906.

Photographs taken in the private home designed by Paul Follot which has since become a museum. Fondation Hellen Follot Vendel.

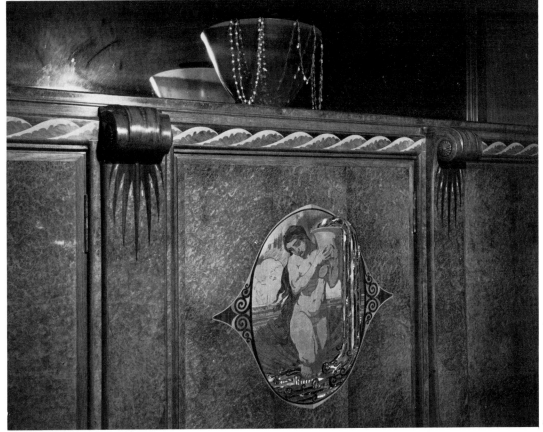

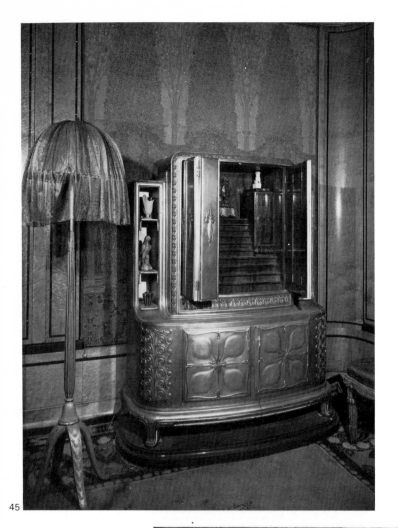

45

46

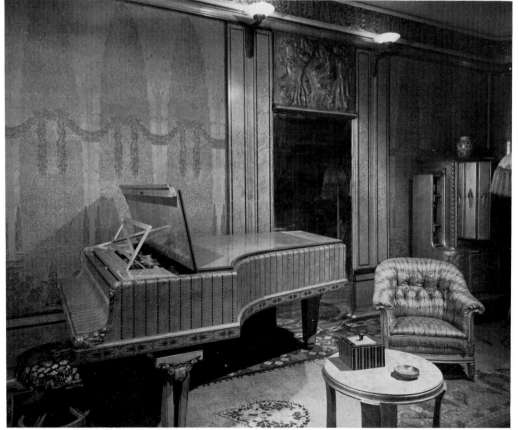

47

PIERRE LAHALLE

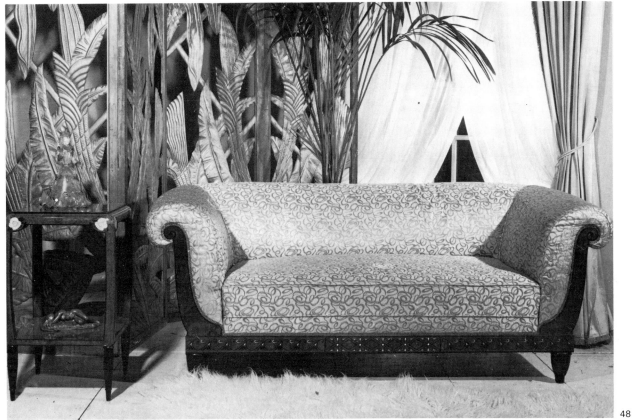

48

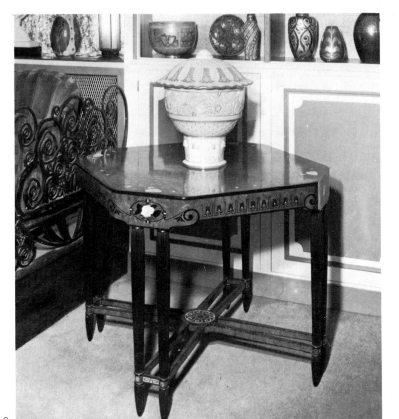

9

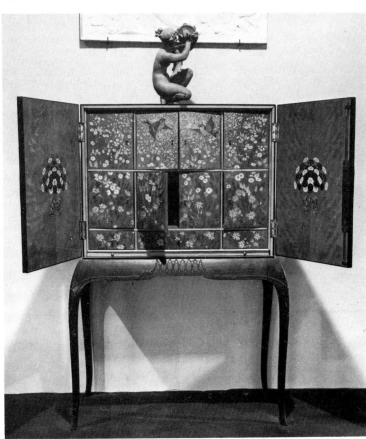

50

48 PIERRE LAHALLE Alcove sofa in wood veneer and occasional table in burr-walnut, c.1920. (Turlure Décor)

49 PIERRE LAHALLE Lacquered wood writing desk painted with birds and flowers on curved legs, 1919-1920. (Collection Mme Lahalle)

50 PIERRE LAHALLE Inlaid table with twin legs jointed by a cross-piece, c.1920. The porcelain lamp is by Henri Rapin and the ceramics by Jean Mayodon and André Methey. (Christofle and Private Collection)

ANDRE GROULT

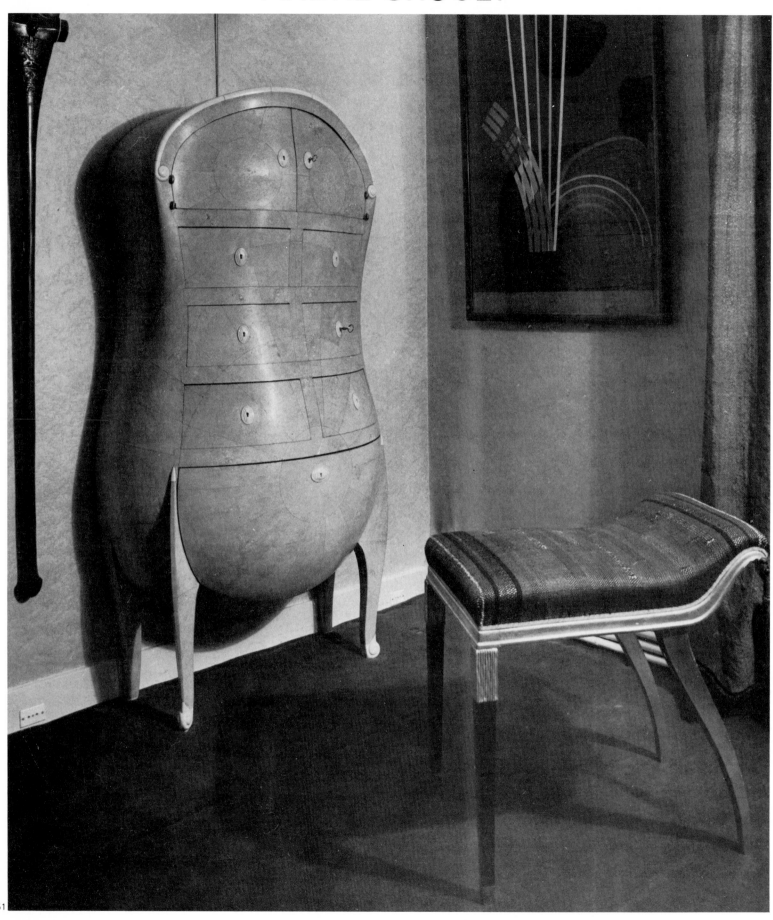

51

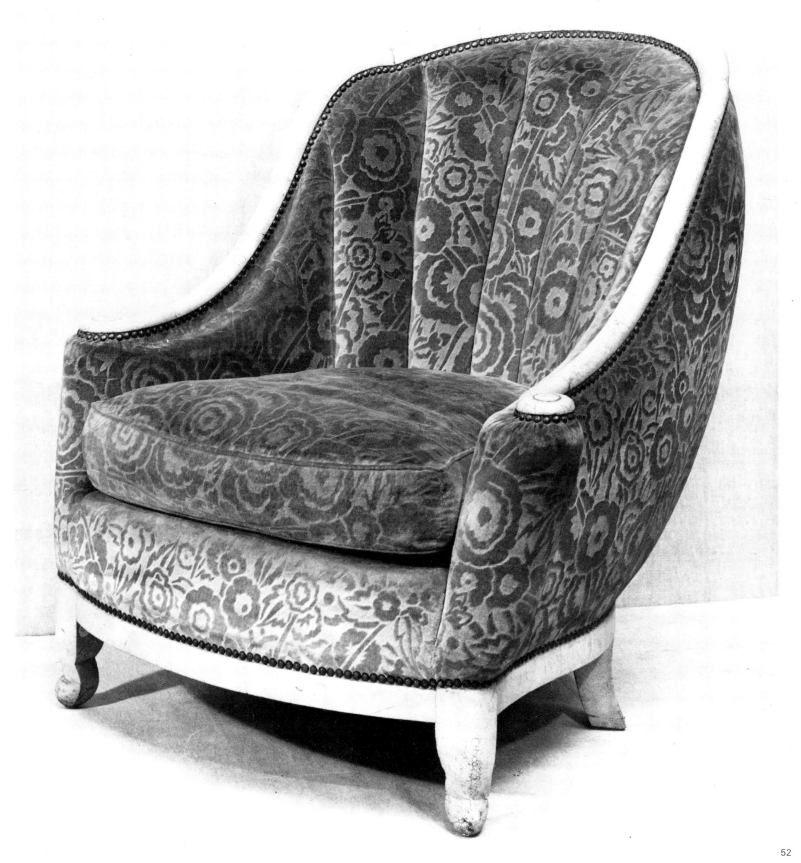

51 ANDRE GROULT Cabinet covered in shagreen with ivory lockplates, also exhibited in the Chambre de Madame. The gilt and lacquered wood stool with sabre-shaped legs was designed by Ruhlmann, c.1922 and upholstered by Rachel Leflers, a colleague of Paul Poiret. (Collection Manoukian, Paris)

52 ANDRE GROULT Beech gondola chair covered in white shagreen and upholstered in velvet by the Maison Delaroière et Leclerq which was part of the Chambre de Madame in the Pavillon de l'Ambassade Française. (Musée des Arts Décoratifs, Paris)

ARMAND-ALBERT RATEAU

53 ARMAND-ALBERT RATEAU Low table in patinated bronze with marble top from Jeanne Lanvin's home, rue Barbey-de-Jouy, Paris, 1920-1922.

54 ARMAND-ALBERT RATEAU Dressing-table designed for Jeanne Lanvin between 1920 and 1922. The reversible mirror is illuminated by lights fixed inside the daisies or marguerites (in honour of Lanvin's daughter, Marguerite) and the chair is of cherrywood.

55-56 ARMAND-ALBERT RATEAU Bathrooms with yellow Sienna marble bath and stucco bas-relief and gilt-bronze wash basin with reversible circular mirror supported by two curved branches attached to a base in the shape of two facing pheasants. (Musée des Arts Décoratifs, Paris)

57 ARMAND-ALBERT RATEAU Jeanne Lanvin's dining-room with sliding door of carved wood lacquered in pale yellow and brown and table, made from a heavy slab of marble resting on two fluted legs, which is surrounded by gilt wood chairs. The bronze standard lamps have a green patina and a curtain of pearls decorated with daisies covers the mirror.

54

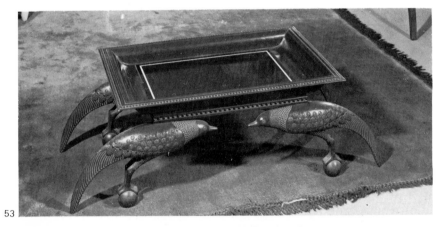

53

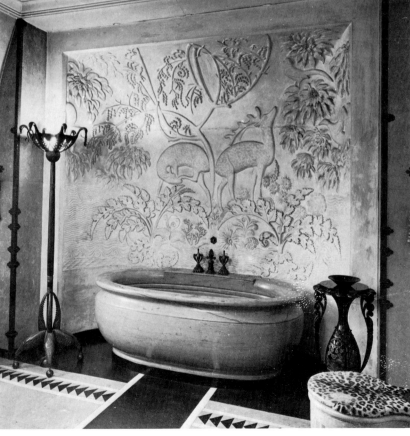

55

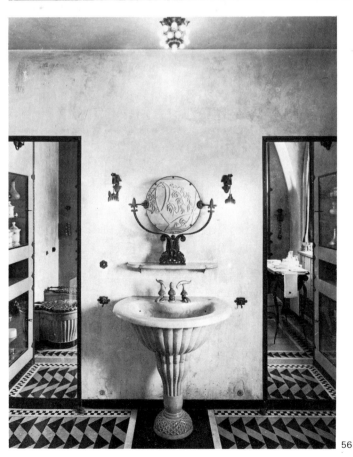

56

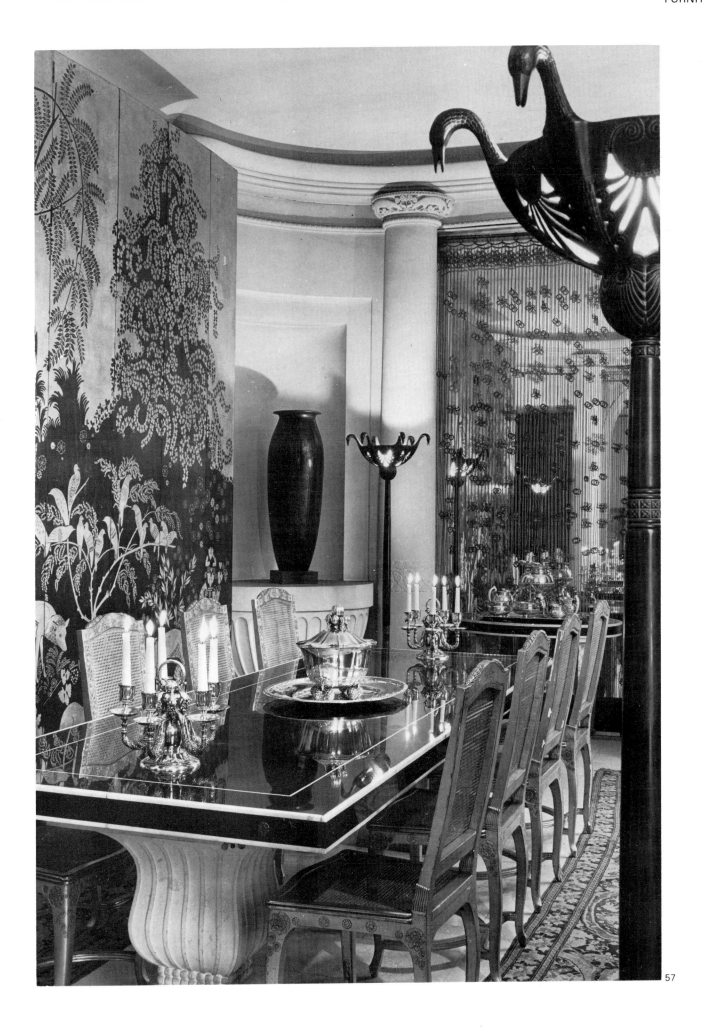

57

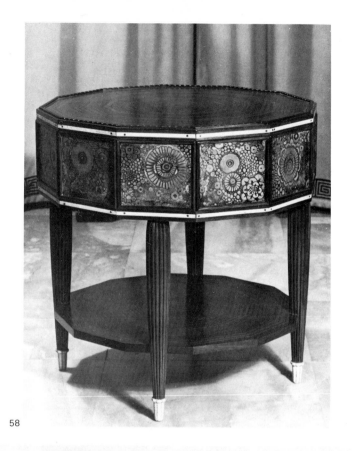

58

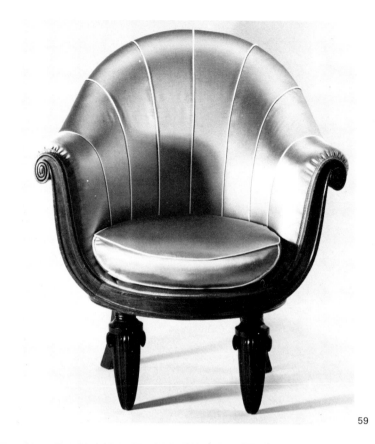

59

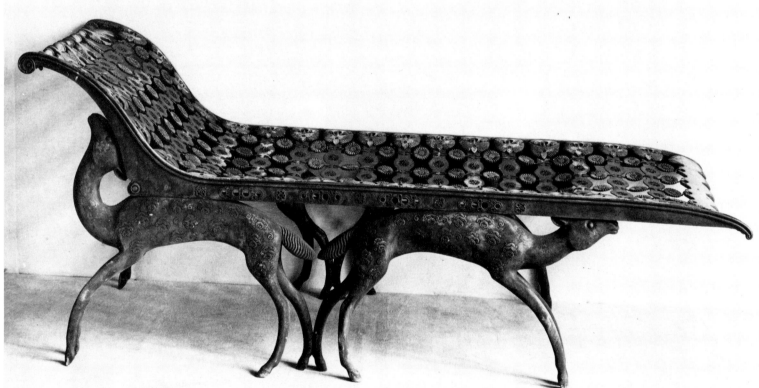

60

58 MAURICE DUFRENE Small octagonal table with tapering legs and ivory inlay. (Collection Souillac, Paris)

59 MAURICE DUFRENE Gondola armchair. (Collection Félix Marcilhac, Paris)

60 ARMAND-ALBERT RATEAU Chaise-longue from Jeanne Lanvin's boudoir with a supple base consisting of rows of daisies, supported by four does, the whole piece in green patinataed bronze, 1920-1922. (Musée des Arts Décoratifs, Paris)

61 ANDRE DOMIN and MARCEL GENEVRIERE (DOMINIQUE) Chair of varnished Brazilian rosewood with trapezoidal seat and back rest, c.1925.

62 DOMINIQUE Amboyna veneer writing desk supported by two legs joined to the base. (Private Collection)

63 DOMINIQUE and ALFRED PORTENEUVE Low table, gondola chair and alcove bed with side tables in exotic wood, c.1925-1930. (Private Collection)

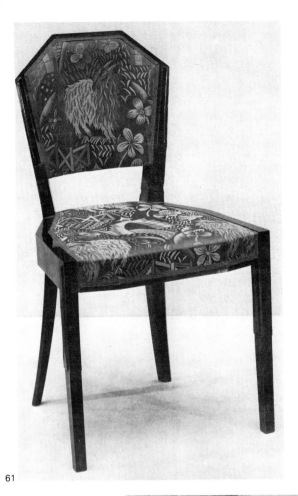

61

62

63

JULES LELEU

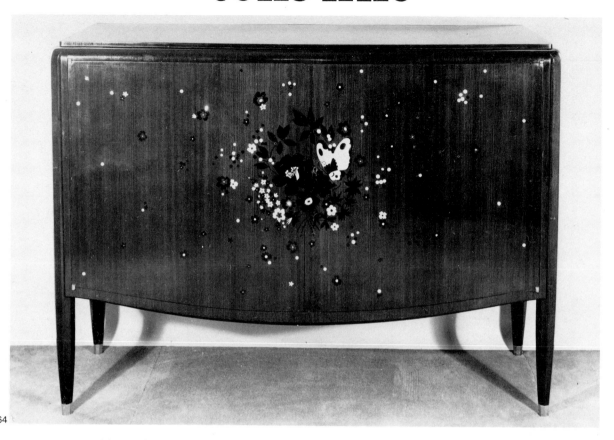

64

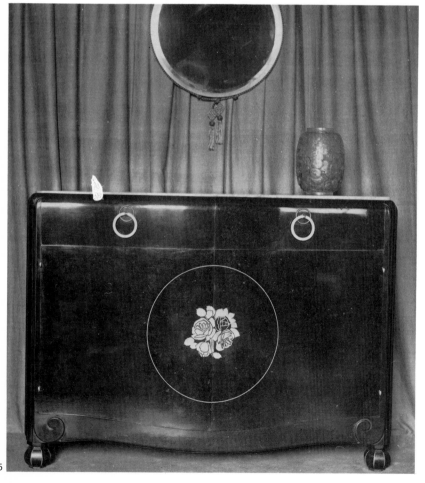

65

66

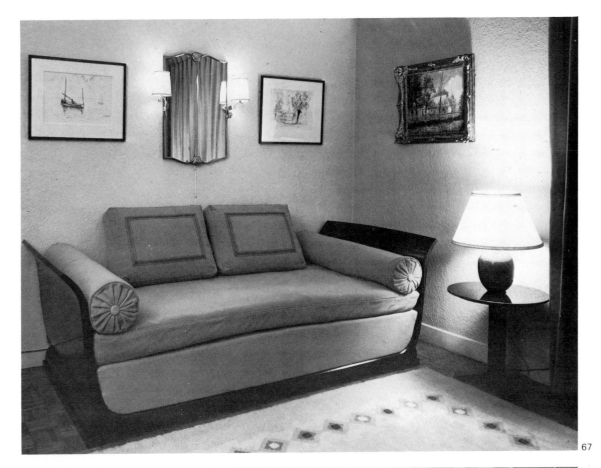

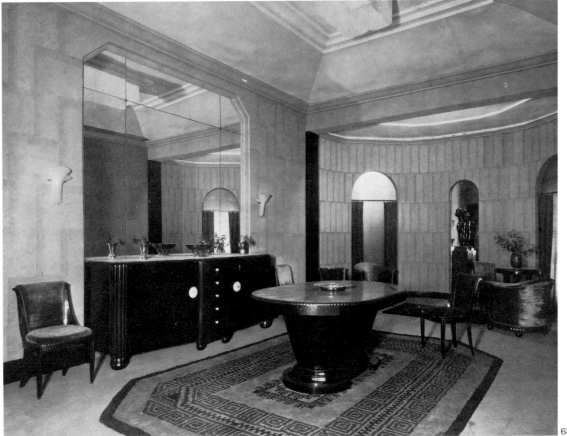

64-66 JULES LELEU Three commodes, one of which was exhibited at the 1925 Exhibition. The style and form are reminiscent of eighteenth century pieces although the floral decoration, particularly far left, is geometrically Art Deco in style.

67 JULES LELEU Restoration style divan with two bolster-shaped armrests.
68 JULES LELEU Dining-room for the 1925 Exhibition with oval table and large ebony sideboard.

CLEMENT MERE

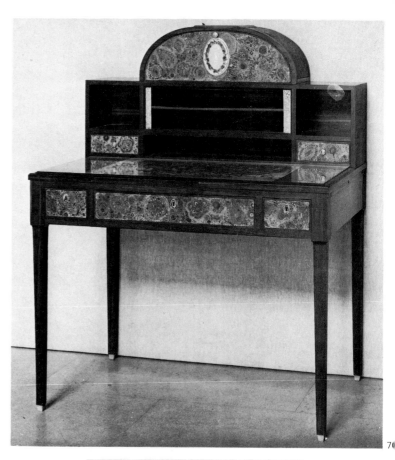

69

70

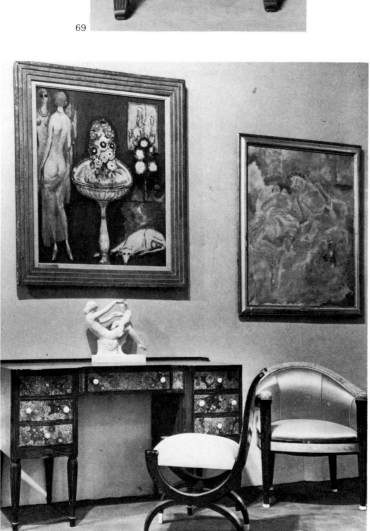

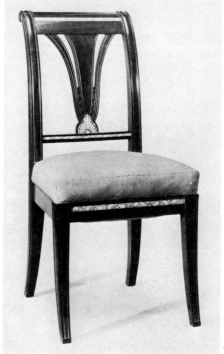

71

72

69 CLEMENT MERE Carved Brazilian rosewood firescreen inlaid with ivory, c.1925. (Musée des Arts Décoratifs, Paris)

70 CLEMENT MERE Small lady's writing desk with a set of pigeon holes in macassar ebony, lacquered leather and ivory, c.1925.

71 CLEMENT MERE Flat desk with two sets of drawers in Brazilian rosewood and lacquered leather. The seats are by Clément Rousseau, 1921. (Private Collection, Paris)

72 CLEMENT MERE Brazilian rosewood chair. (Musée des Arts Décoratifs, Paris)

SUE ET MARE

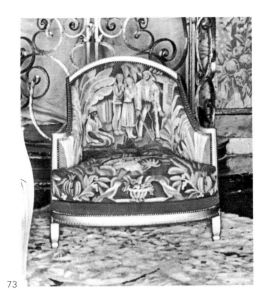

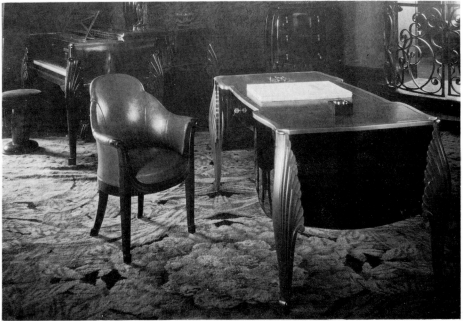

73

74

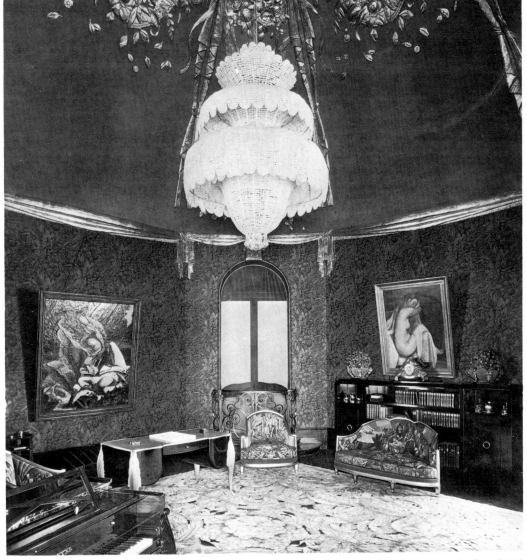

75

73-75 SUE ET MARE Three views of the Rotonde, the principal room in the Musée d'Art Contemporain designed by the Compagnie des Arts Français for the 1925 Exhibition. The desk now in the Metropolitan Museum, New York, is of bronze and Gabonese ebony and the armchair of macassar ebony. The gilt-wood sofa and chair are upholstered after Charles Dufresne, the piano is by Pleyel and the rug from the Maison Lauer.

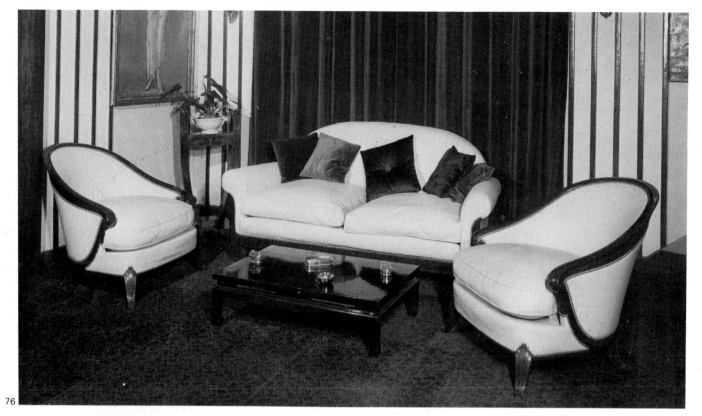

76

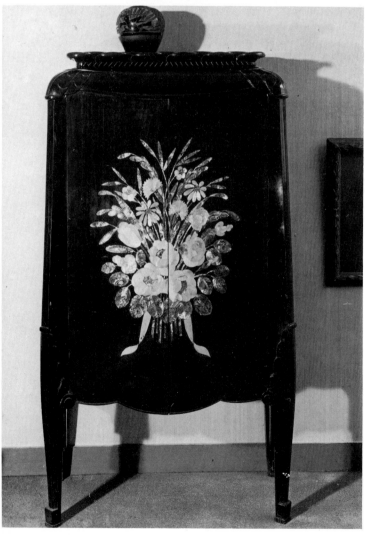

77

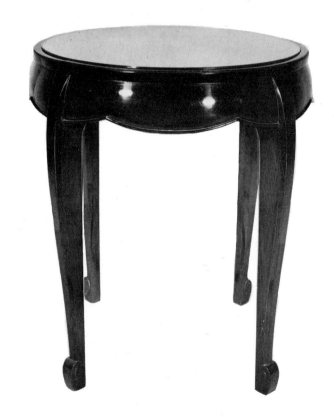

78

76 SUE ET MARE Drawing-room suite consisting of a sofa 'à l'escargot' and two gondola chairs with large cushions, c.1925. (Private Collection)

77 SUE ET MARE Macassar ebony cabinet inlaid with a spray of flowers in mother-of-pearl and silver, c.1925. (Foulk Lewis Collection, London)

78 SUE ET MARE Occasional table with four curved legs in exotic wood c.1925. (Collection Félix Marcilhac, Paris)

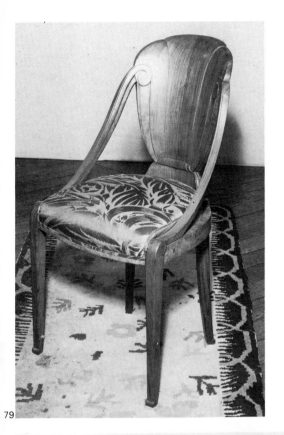

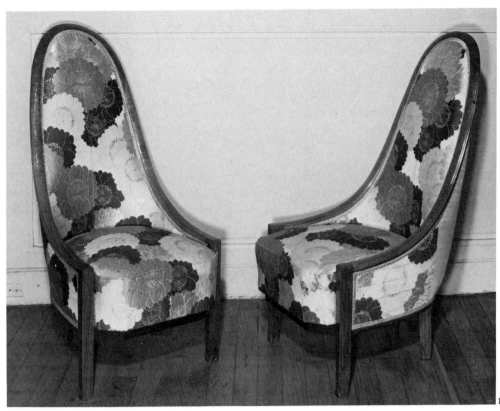

79

80

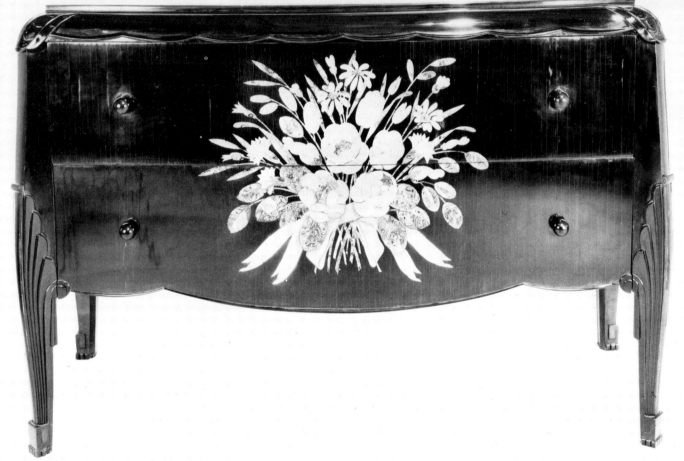

81

79 SUE ET MARE Brazilian rosewood gondola chair, the back attached to the sides of the seat by two curved supports with scroll-shaped ends, c.1923. (Musée des Arts Décoratifs, Paris)

80 SUE ET MARE Pair of gondola chairs with rounded high backs and straight legs, c.1920-1925. (Collection Manoukian, Paris)

81 SUE ET MARE Inlaid chest of drawers. (Collection Félix Marcilhac, Paris)

EMILE-JACQUES RUHLMANN

In the same way as Riesener alone represents the cabinet-maker's craft during the reign of Louis XVI, so the name of Emile-Jacques Ruhlmann (1879-1933) symbolises a certain conception of Art Deco furniture in France, bound up with high quality, elegance and technical and formal refinement. Ruhlmann exhibited for the first time in the 1913 Salon d'Automne and established himself firmly from the very beginning as the primary exponent of luxury furniture. After the war, he founded the Etablissements Ruhlmann et Laurent which produced furniture and objects designed by him until his death.

Trained as a cabinet-maker, Ruhlmann cultivated veneers in such costly and warm woods as amboyna, amaranth, violet wood and ebony, overlaid with ivory and fine materials such as morocco leather and sharkskin. His simple and elegant forms, delicately rounded are very far from being opposed to tradition. They are based on eighteenth-century tradition which he was able to transpose at that period better than any other artist. As early as 1913, Ruhlmann was making use of slender legs with cut faces whose highly extended curvature sometimes continued the shape of the uprights of the piece of furniture. At the 1925 Exhibition he presented the Pavillon du Collectionneur created with the architect, Pierre Patout, and a group of artists and ensembliers drawn from amongst the best including Bernard, Bourdelle, Despiau, Pompon, Jallot, Jourdain, Rapin, Puiforcat, Brandt, Decoeur, Lenoble, Dunand, Décorchemont, Legrain and Bastard. At the end of his life he began to use chrome and silver in his furniture work.

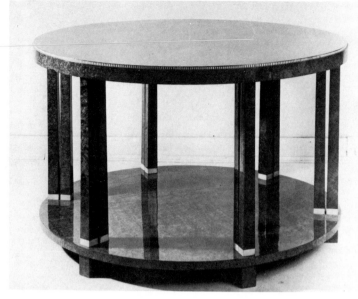

82

82 EMILE-JACQUES RUHLMANN Low circular table supported by six amboyna and ivory legs, c.1928. (Collection Félix Marcilhac, Paris)

83 EMILE-JACQUES RUHLMANN Small macassar ebony and ivory writing desk, the insides of which are lined with leather. The legs are long and tapering and the handles formed from ivory rings with tassels. (Galerie du Luxembourg, Paris)

84 EMILE-JACQUES RUHLMANN Lady's desk in macassar ebony with an amboyna top inlaid with strips of ivory in a diamond pattern and tapering legs, 1921. The macassar ebony chair is inlaid with ivory dots. (Collection Knut Günther)

85 EMILE-JACQUES RUHLMANN Amboyna cabinet. (Musée des Arts Décoratifs, Paris)

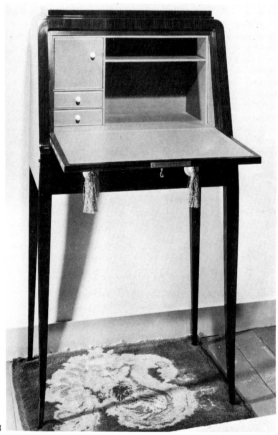

83

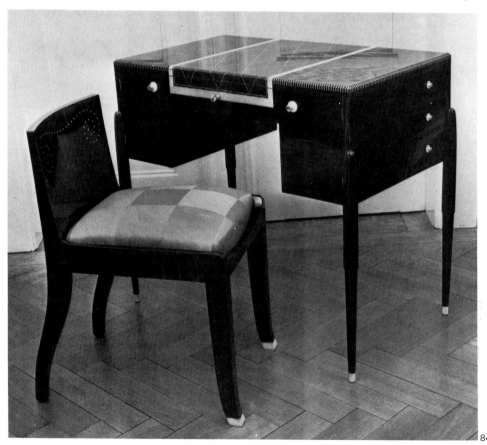

84

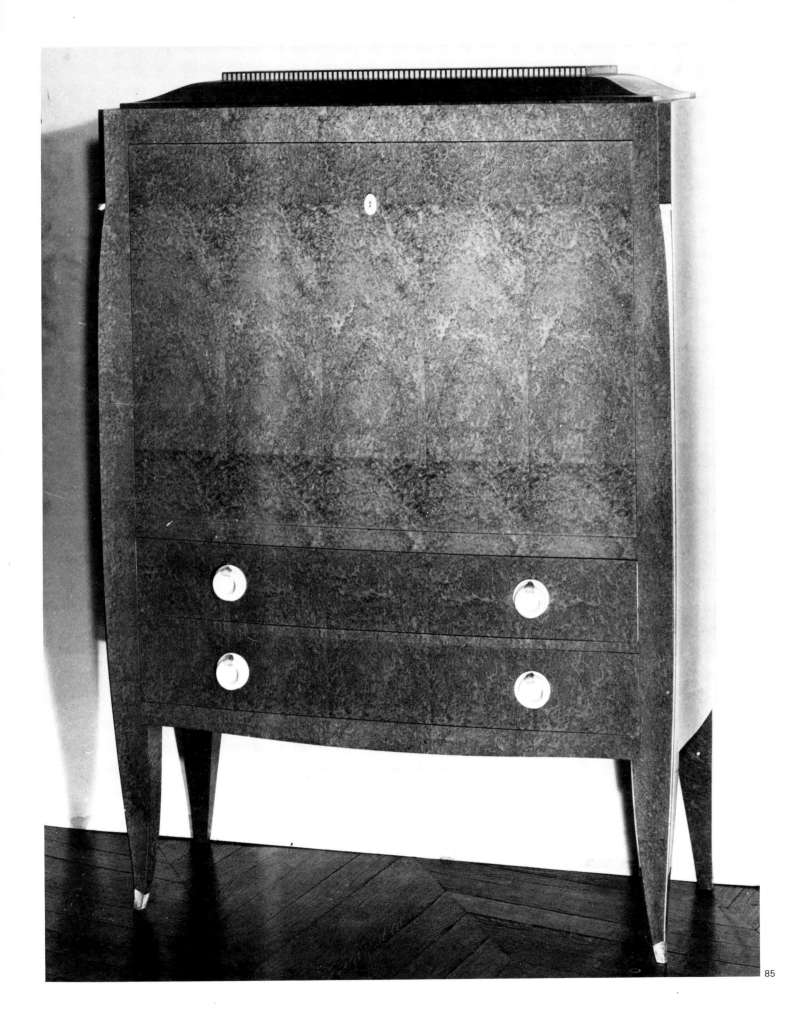

85

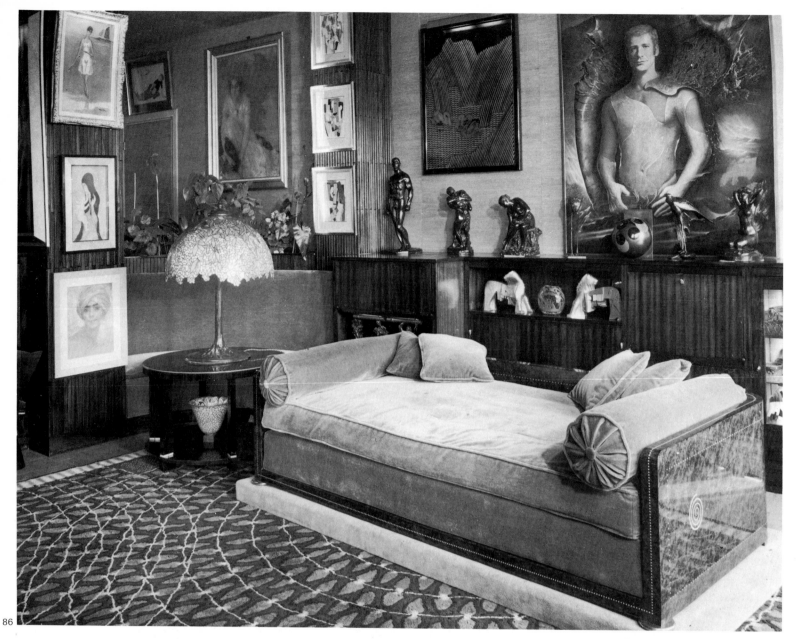

86

87

86 EMILE-JACQUES RUHLMANN Amboyna divan inlaid with a line of dots. (Collection Alain Lesieutre, Paris)

87 EMILE-JACQUES RUHLMANN Boat-shaped bed, the two sides of which are linked by an ivory strip highlighting the curve, 1922. (Collection Maria de Beyrie)

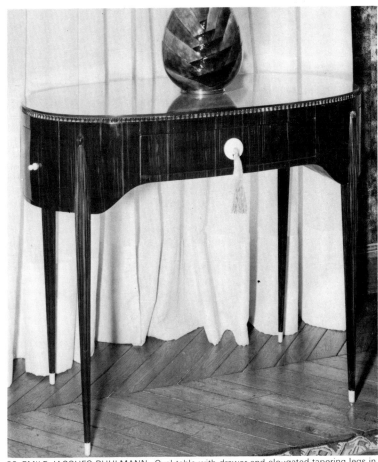

88 EMILE-JACQUES RUHLMANN Oval table with drawer and elongated tapering legs in macassar ebony and ivory. (Private Collection)

89 EMILE-JACQUES RUHLMANN Amboyna corner cupboard, the door of which is decorated with a diamond-shaped motif in ivory. (Collection Maria de Beyrie)

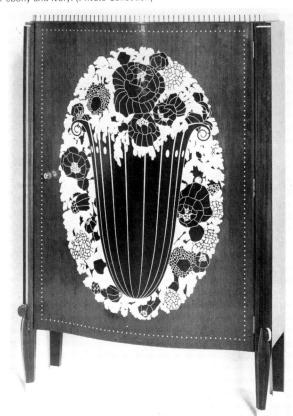

90 EMILE-JACQUES RUHLMANN Small amaranth cabinet with gently curving door filling the entire front section. The central motif of a flower-filled basket is inlaid with ivory and macassar ebony, 1923. (Musée des Arts Décoratifs, Paris)

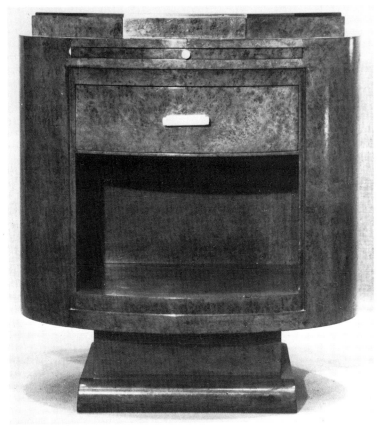

91 EMILE-JACQUES RUHLMANN Amboyna bedside table, c.1929-1930. (Collection Maria de Beyrie)

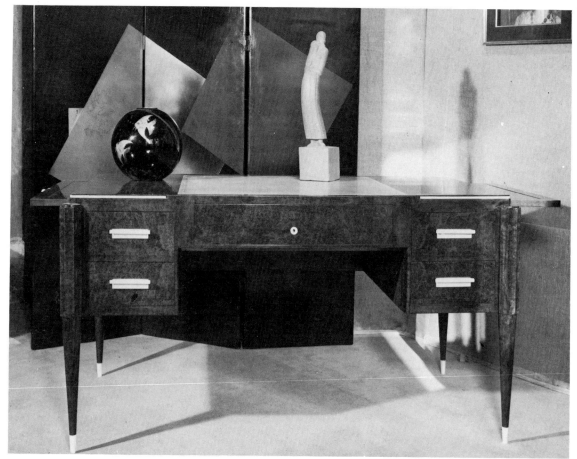

92 EMILE-JACQUES RUHLMANN Large flat desk with five drawers and writing slides at the sides, c.1925–30. (Collection Maria de Beyrie)

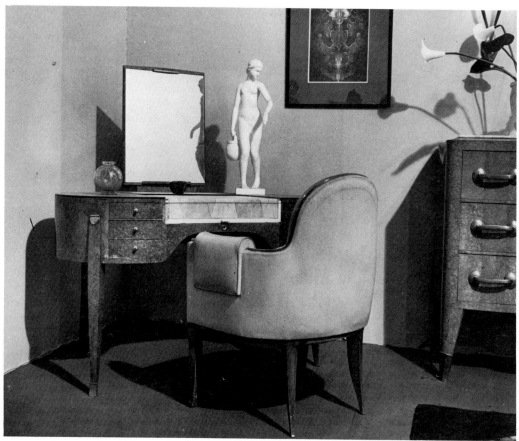

93 EMILE-JACQUES RUHLMANN Amboyna dressing-table and chair forming part of a bedroom suite, 1929. (Private Collection)

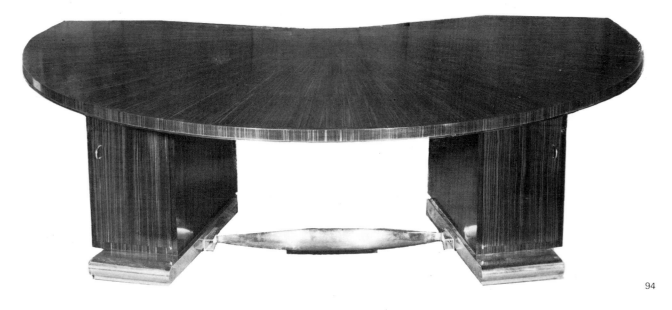

94

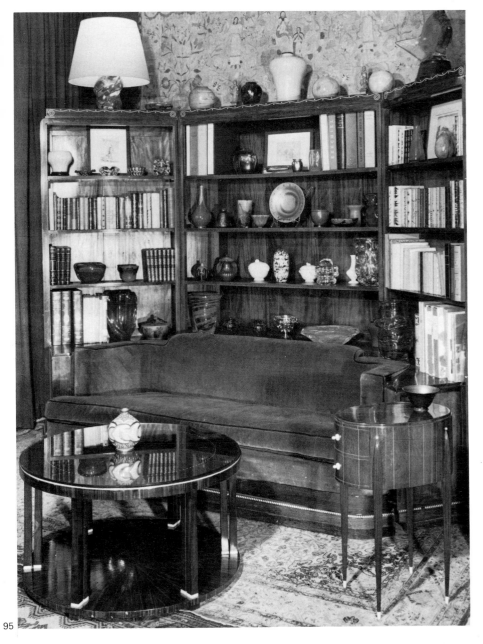

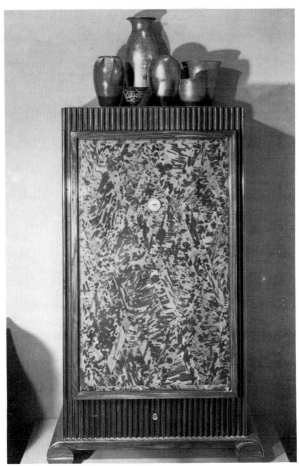

96

94 EMILE-JACQUES RUHLMANN Large kidney-shaped desk in macassar ebony and chrome metal designed for the president of the Syndicat des Soieries in Lyon in 1932. (Collection Knut Günther)

95 EMILE-JACQUES RUHLMANN Alcove sofa surrounded on three sides by a bookcase. Circular table with twin legs and side table with fluted tapering legs. (Private Collection)

96 EMILE-JACQUES RUHLMANN Small macassar ebony bookcase, the door panel of which is decorated in shell on a red lacquer base. Dinanderie vases by Dunand and Linossier. (Collection Jean-Pierre Badet)

95

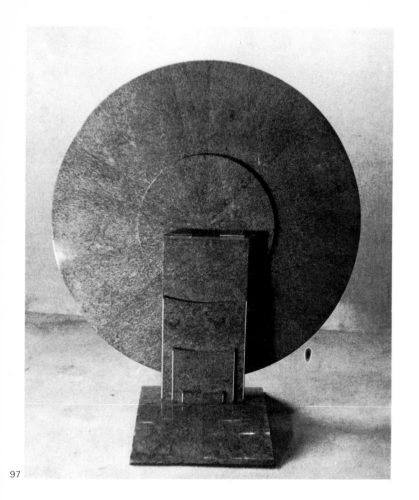

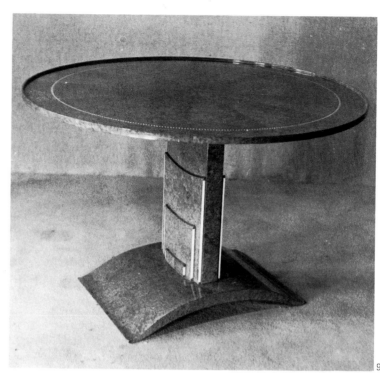

97-98 EMILE-JACQUES RUHLMANN Circular amboyna and ivory table with folding top and arched foot, c.1927-1930. (Collection Maria de Beyrie)

99 EMILE-JACQUES RUHLMANN Dining-room table and gondola chairs. The armchair is upholstered in a magnificent Art Deco patterned fabric and in the foreground is the identical Rateau table from the Lanvin collection. (Collection Alain Lesieutre, Paris)

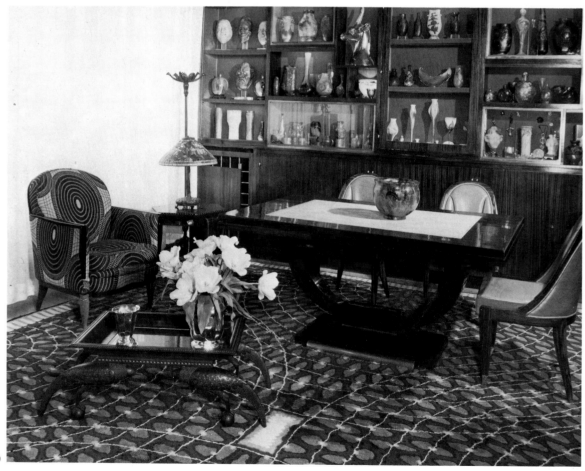

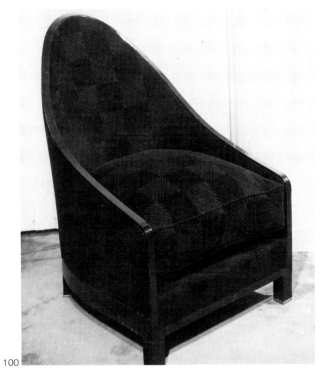

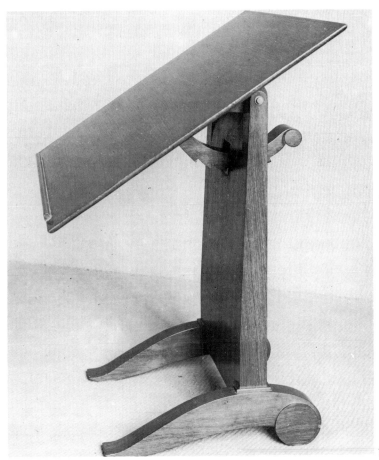

100

101

100 EMILE-JACQUES RUHLMANN Gondola chair with velvet removable cushion.

101 EMILE-JACQUES RUHLMANN Brazilian rosewood print table known as the *Cla Cla* due to the sound of the wooden ratchet, 1928. (Musée des Arts Décoratifs, Paris)

102 EMILE-JACQUES RUHLMANN Macassar ebony veneered table with ivory handles and feet, c.1923. (Private Collection)

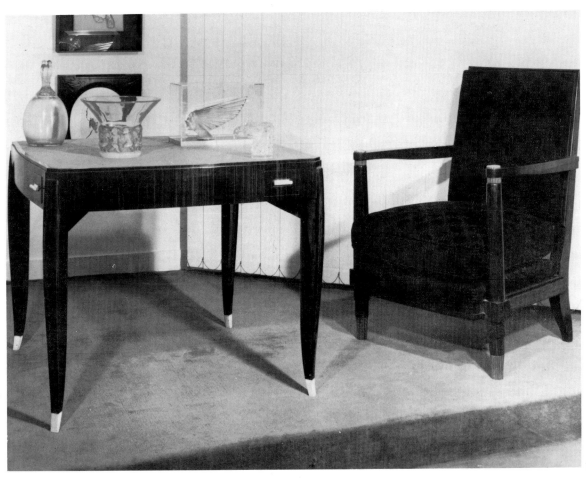

102

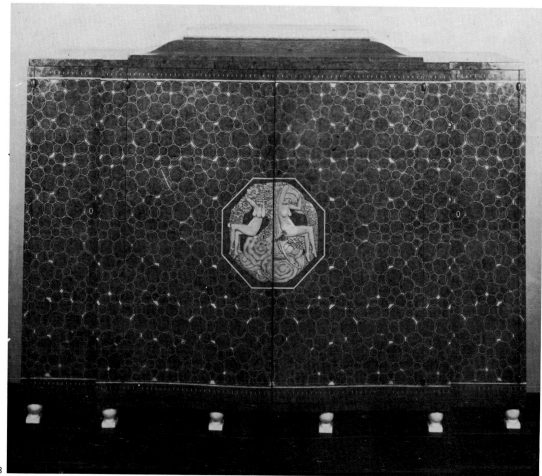

103

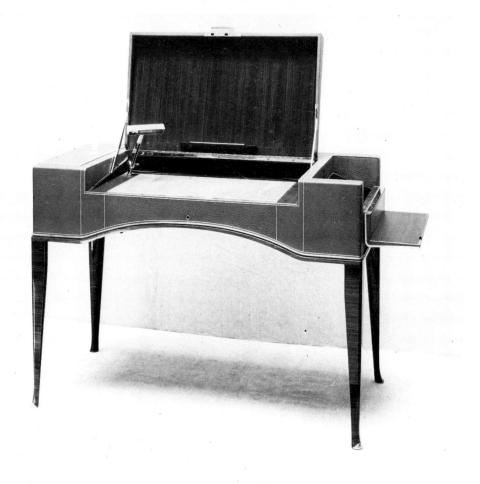

104

THE DESIGN OF RUHLMANN'S FURNITURE

How Ruhlmann designed his furniture

In 1924, Léon Moussinac wrote the preface to *Croquis de Ruhlmann* with 54 plates of designs which taught much more about the cabinet-makers' art than all dissertations on it. They were not finished working drawings but rapid jottings, so precise however that the piece in question was easily identified.

After the sketches came the more elaborate stage — the plans, elevations, profiles and sides. Each model was numbered and at the moment of execution given a letter which marked its place in the series. Several years could therefore separate the first model from its successive realisations. A certificate, numbered and signed in Ruhlmann's own hand, which accompanied the piece when it was sold, now makes it possible to date it very exactly.

103 EMILE-JACQUES RUHLMANN Cabinet veneered in amboyna and inlaid with over a thousand interlaced circles of ivory. The central octagonal motif representing night and day is of lacquered wood by Foucault. (Collection Knut Günther)

104 EMILE-JACQUES RUHLMANN Small desk in macassar ebony, ivory and leather. (Musée des Arts Décoratifs, Paris)

105-106 EMILE-JACQUES RUHLMANN The designs for the chiffonier no. 1527 and the finished article of macassar ebony and ivory. The tapering legs extending up the sides of the piece characterise Ruhlmann's work between 1920 and 1925.

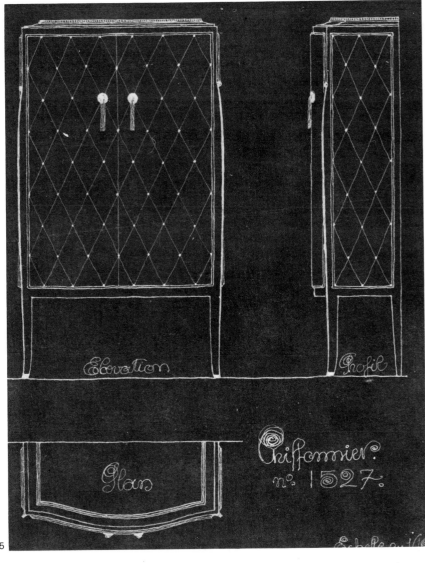

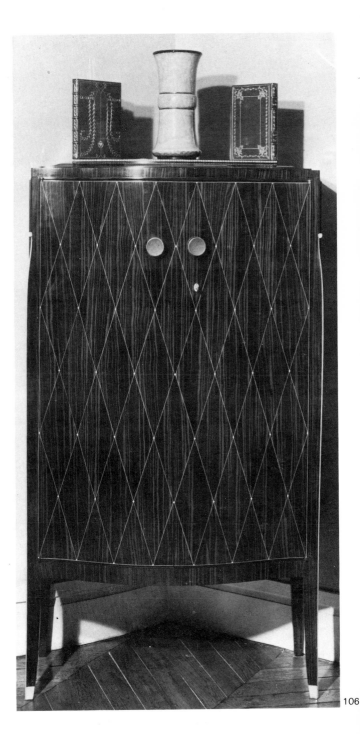

105

106

55

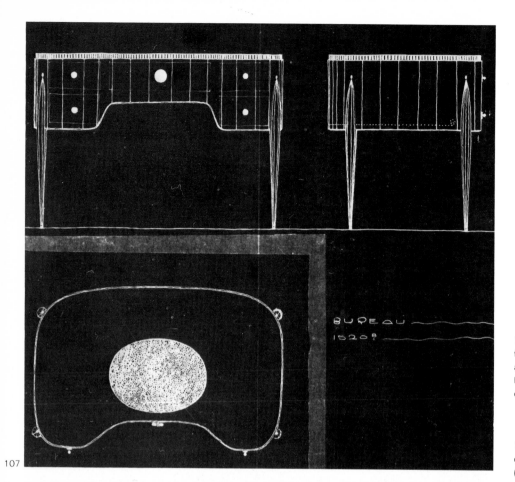

107

108

10

110

107-108 EMILE-JACQUES RUHLMANN The designs and the finished desk with the addition of a raised section with pigeon holes and drawers surrounding the circular leather top of three sides. The legs are inlaid with threads of ivory in line with those on the upper part of the piece. (Galerie du Luxembourg, Paris)

109-110 EMILE-JACQUES RUHLMANN Design and armchair with deep square seat and large cushion following the slope of the base. (Collection Jean-Pierre Badet)

111-112 EMILE-JACQUES RUHLMANN A cabinet with its plan, elevation and profile. The bronze motif of a crouching woman encircling the lock with her hands was executed exactly according to the design.

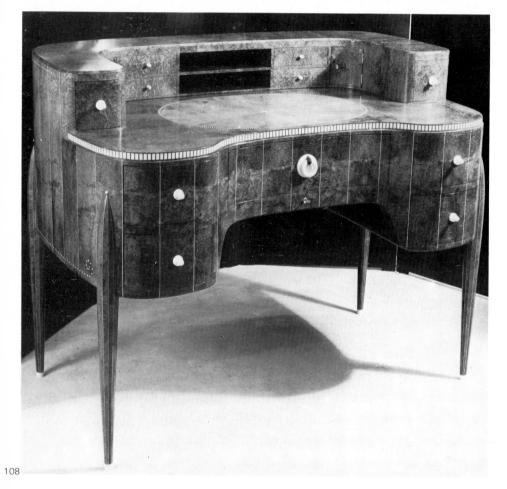

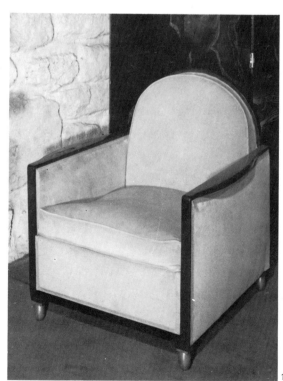

MEUBLE 2.036

0.96

1.42

0.60

0.56

ECHELLE 1/10

111

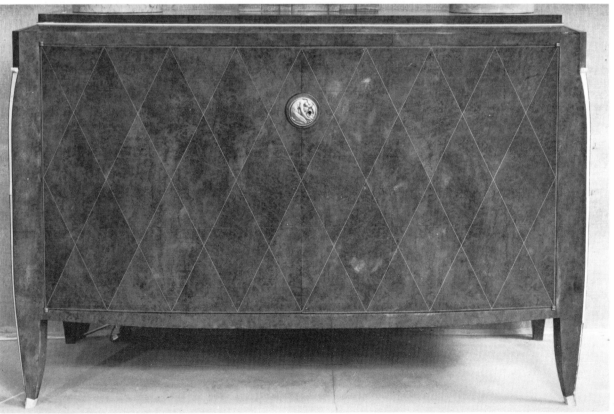

112

113

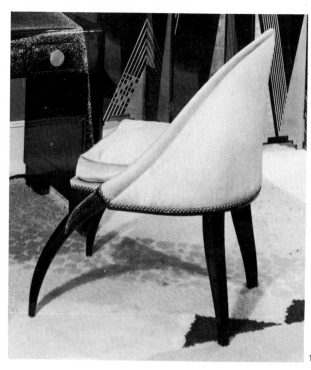

113-114 EMILE-JACQUES RUHLMANN Dressing-table chair made according to Ruhlmann's designs with black lacquer work inlaid with eggshell by Dunand, c.1927. (Private Collection)

115-116 EMILE-JACQUES RUHLMANN Dressing-table retaining the severe lines of the original drawing but which is softened by the delicate charm of the inlaid motif and the elegant mirror nestling in its semi-circular macassar ebony frame. (Galerie du Luxembourg, Paris)

115

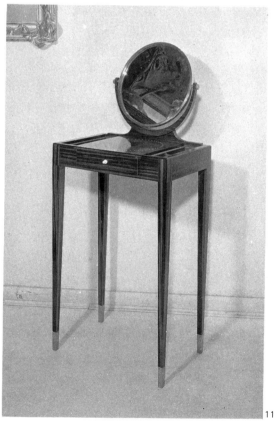

116

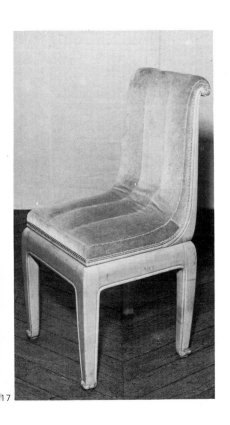

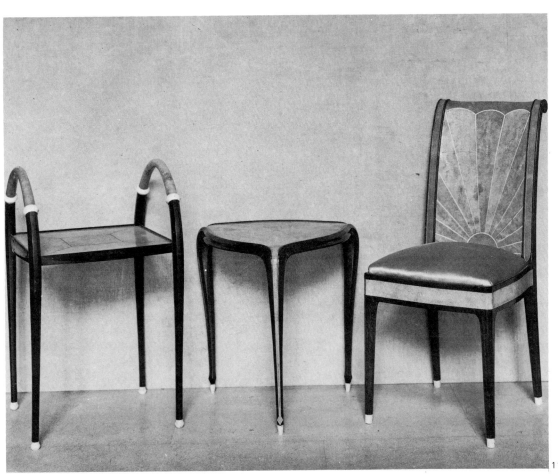

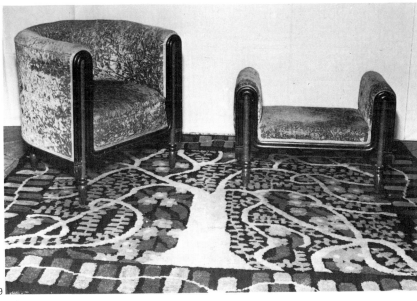

117 ATELIER MARTINE Sycamore chair upholstered in pale green velvet with legs and back terminating in scrolls. (Private Collection)

118 CLEMENT ROUSSEAU Magazine table, three-legged table and chair in ebony, Brazilian rosewood and shagreen, c.1921. (Musée des Arts Décoratifs, Paris)

119 ATELIER MARTINE Armchair and stool in amboyna and stained pearwood and upholstered in green velvet, c.1912. (Collection Mme Heilmann-Letrosne)

120 ALAVOINE Writing desk with folding panel in walnut and shagreen applied in a geometric pattern. (Collection Knut Günther)

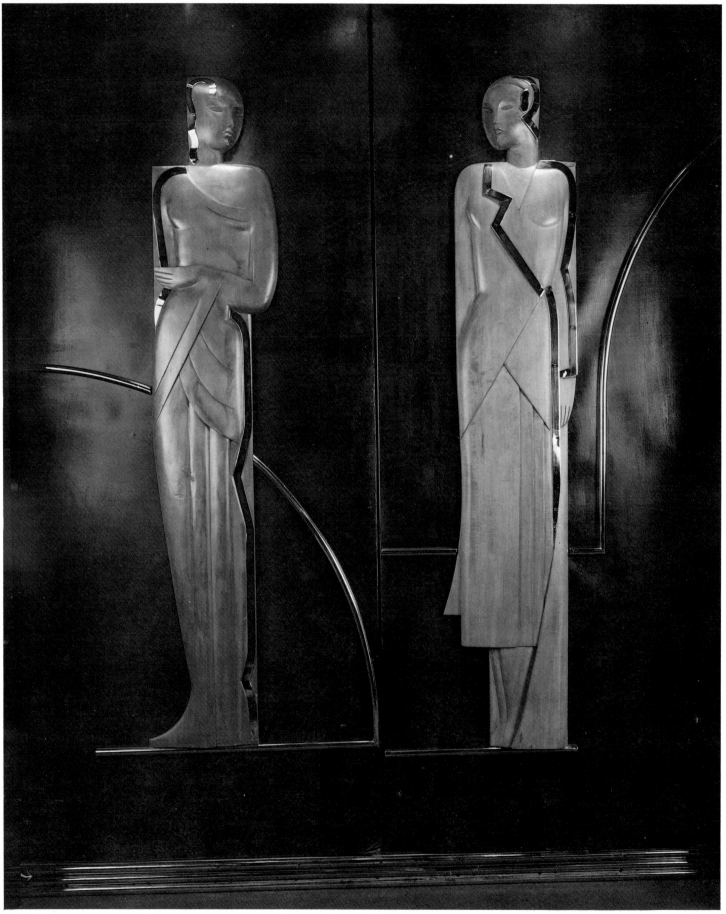

121 Two tall female figures carved in wood by an unknown sculptor on a pair of lacquer doors. (Collection Félix Marcilhac, Paris)

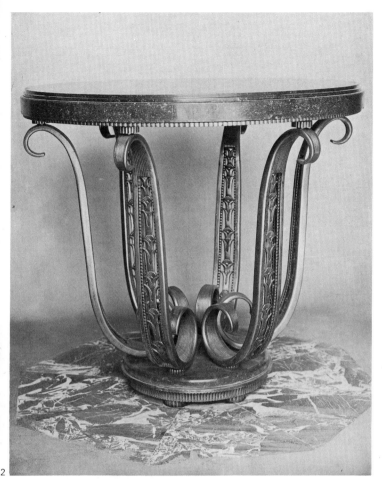

WROUGHT-IRON WORK

Art Deco rediscovered metal such as bronze and wrought-iron and its possibilities in furniture work.

Bronze, with a greenish patina to make it appear old, was Rateau's favourite raw material and was used to make tables, chairs, mirrors, lamp stands and fire-dogs. It is a luxury material, requiring specialist craftsmen for its use.

Wrought-iron was, in 1925, primarily the work of Edgar Brandt (1880-1960), the Parisian of Alsatian origin who had begun to work brilliantly with the metal when he was only 15. In the 1925 Exhibition, his work was everywhere, on all the stands. Its presence gave to frequently dark or colourful or particularly ornate ensembles an indispensable dimension — that of the transparency and precision of gilded, silvered, polished metal, married with bronze, marble and lacquers. Brandt's work formed an essential part to everybody's contribution, from Ruhlmann's Pavillon du Collectionneur to Henri Rapin and Tony Selmersheim with their Salon de Réception in the Ambassade Française.

122 EDGAR BRANDT Wrought-iron table with marble top exhibited in the Pavillon de l'Intransigeant at the 1925 Exhibition.

123 EDGAR BRANDT Console in silvered wrought-iron made by the Société des Artistes Décorateurs and exhibited in the Pavillon de l'Ambassade Française.

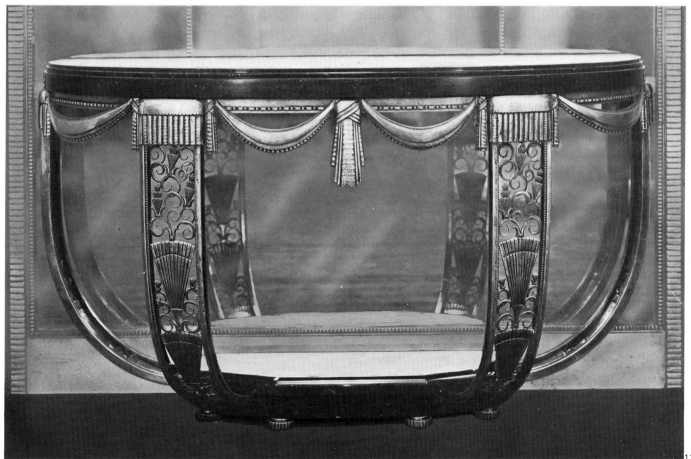

123

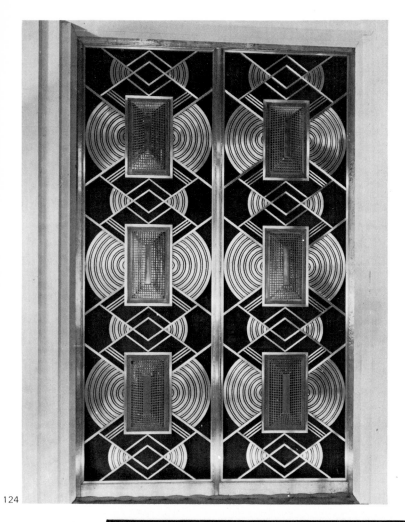

124

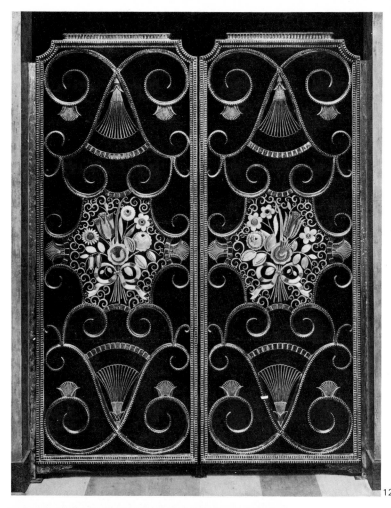

12

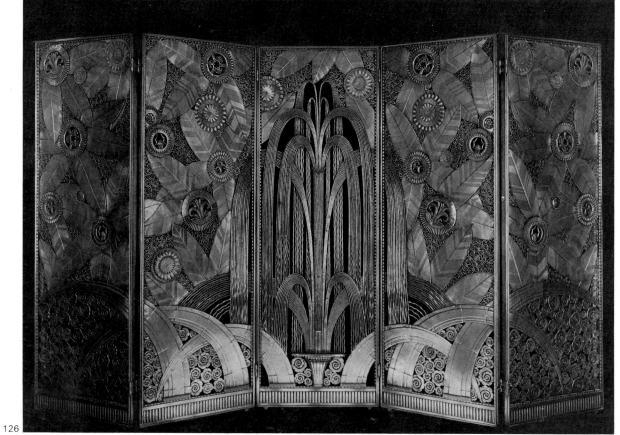

126

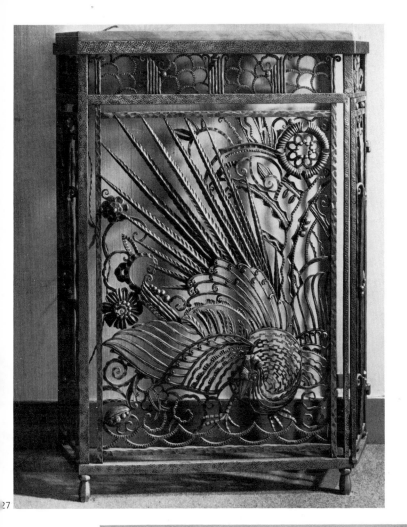

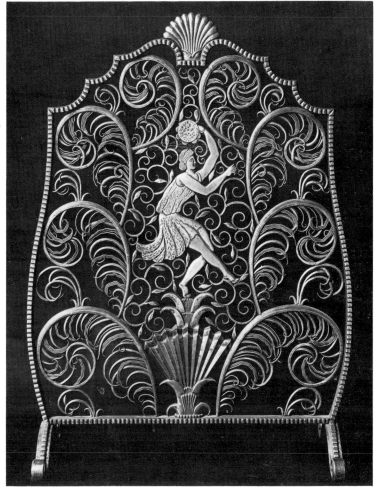

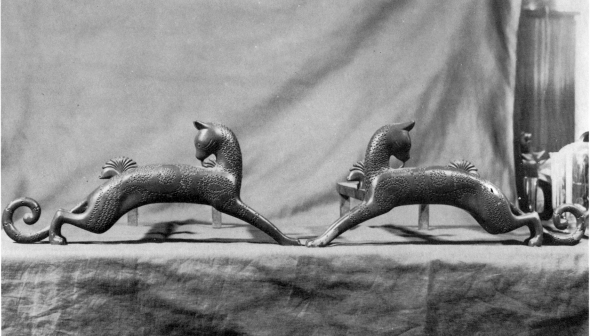

124 RAYMOND SUBES Stainless steel grill in which cabochons of Lalique glass are set.

125 EDGAR BRANDT *Les Bouquets*, a patinated and gilded wrought-iron door exhibited at the 1925 Exhibition.

126 EDGAR BRANDT One of Brandt's major pieces, the wrought-iron screen *l'Oasis*, heightened with gold and exhibited at the 1925 Exhibition. The fountains and waterfalls incorporated within the screen are a frequently recurring theme in Art Deco imagery.

127 PAUL KISS Wrought-iron radiator guard, c.1925-1930. (Private Collection)

128 EDGAR BRANDT Wrought-iron screen entitled *Les Plumes* and exhibited at the 1925 Exhibition.

129 ARMAND-ALBERT RATEAU Fire-dogs in patinated bronze identical to those in Jeanne Lanvin's bedroom, c.1920-1922. (Collection Jean-Pierre Badet)

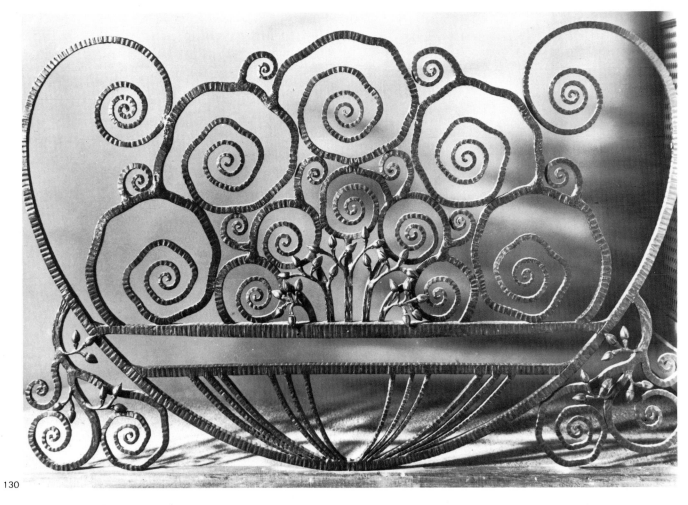

130

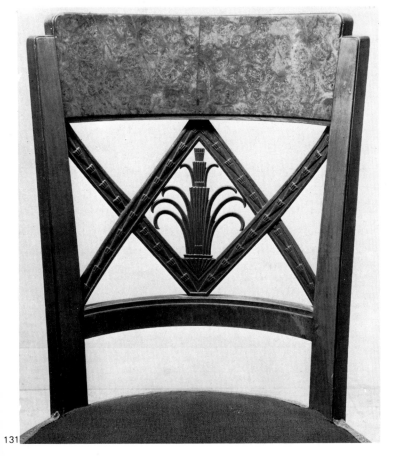

131

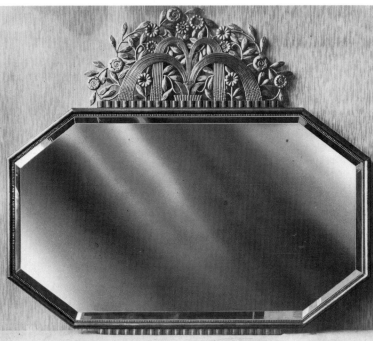

13

130 EDGAR BRANDT The central motif of a wrought-iron grill, c.1925. (Private Collection)

131 EDGAR BRANDT Fountain motif in wrought-iron in the centre of this fretwork chairback.

132 EDGAR BRANDT *Les Jets d'eau*, a wrought-iron mirror from the Pavillon du Collectionneur designed and furnished by Ruhlmann at the 1925 Exhibition.

133 GEORGES LAPAPE A Poiret gown from the album, *Les Choses de Paul Poiret*, 1911. (Bibliothèque des Arts Décoratifs, Paris)

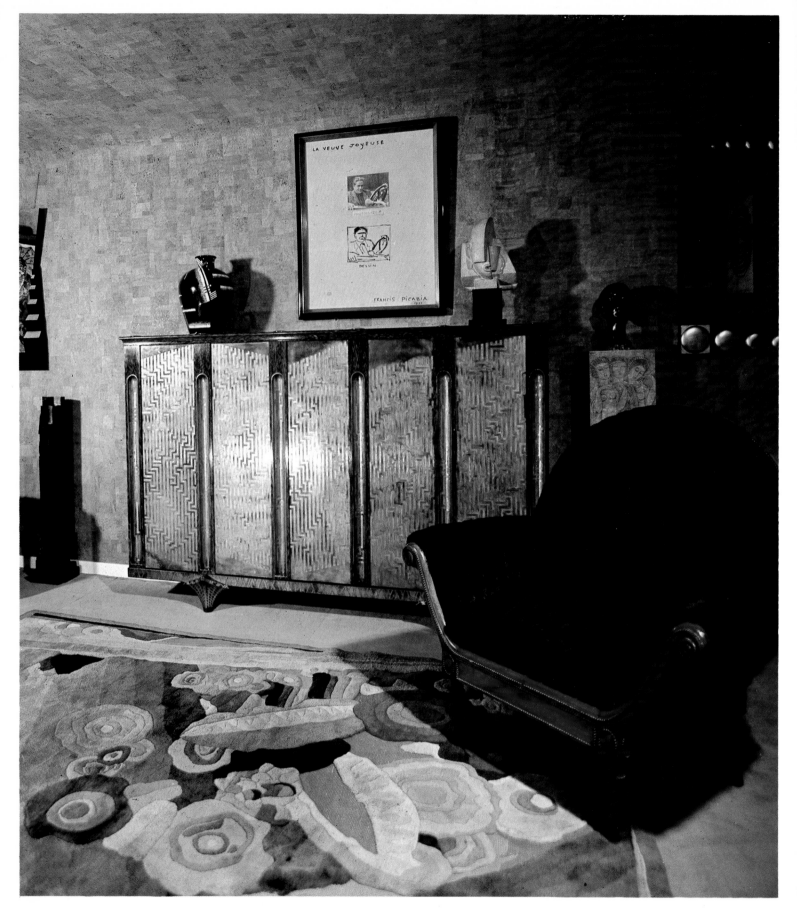

134 Mahogany chair by Paul Iribe, 1912, and in the background a palmwood bookcase by
Eugene Printz, c.1925 with carved doors by Jean Dunand. The vase with eggshell decoration
is also by Dunand and the stone bust by Josef Csaky, 1920. (Private Collection)

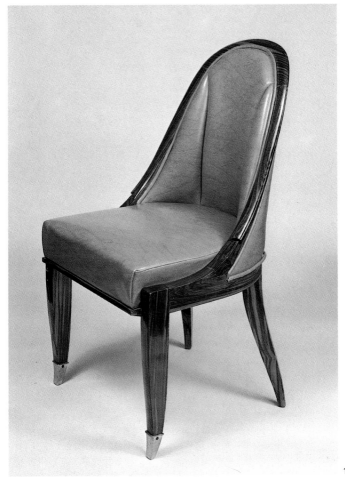

135

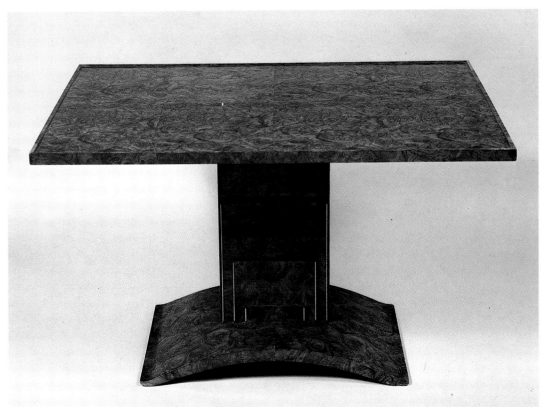

136

135 EMILE-JACQUES RUHLMANN Dining-room chair in macassar ebony, upholstered in leather, 1930. (Collection Alain Lesieutre, Paris)

136 EMILE-JACQUES RUHLMANN Low table in burr walnut and ivory, 1930. (Collection Alain Lesieutre, Paris)

137 FELIX DE MARLE Neo-plastic furniture in painted wood made for de Marle's studio in Becon in 1926. (Private Collection, Paris)

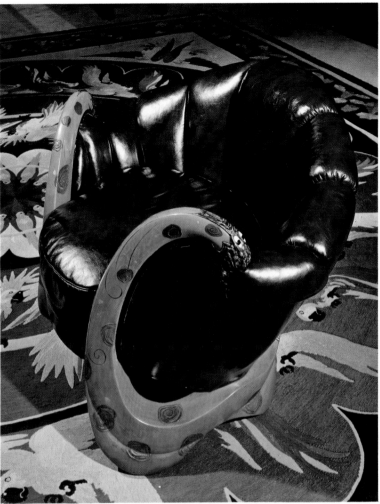

138 EILEEN GRAY Round black lacquer table with red and silver ornamentation, c.1914-1920, from Jacques Doucet's Studio. (Collection Maria de Beyrie)

139 EILEEN GRAY Carved red lacquer and leather armchair, the base and arms of which are in the shape of snakes, c.1910-1914. (Collection Yves Saint-Laurent)

140 EILEEN GRAY Bronze-green and white lacquered table with lotus blossom feet, commissioned by Jacques Doucet for the Oriental room of his Studio, c.1914. (Collection Maria de Beyrie)

139

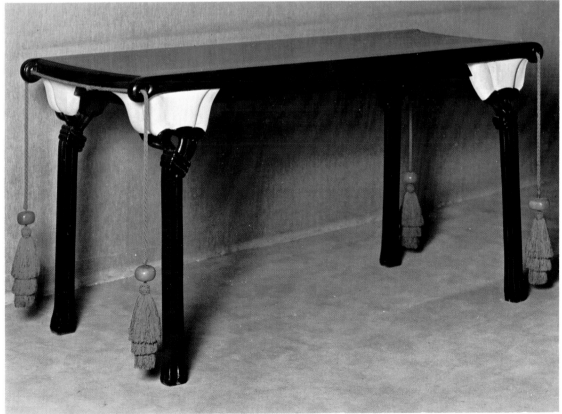

140

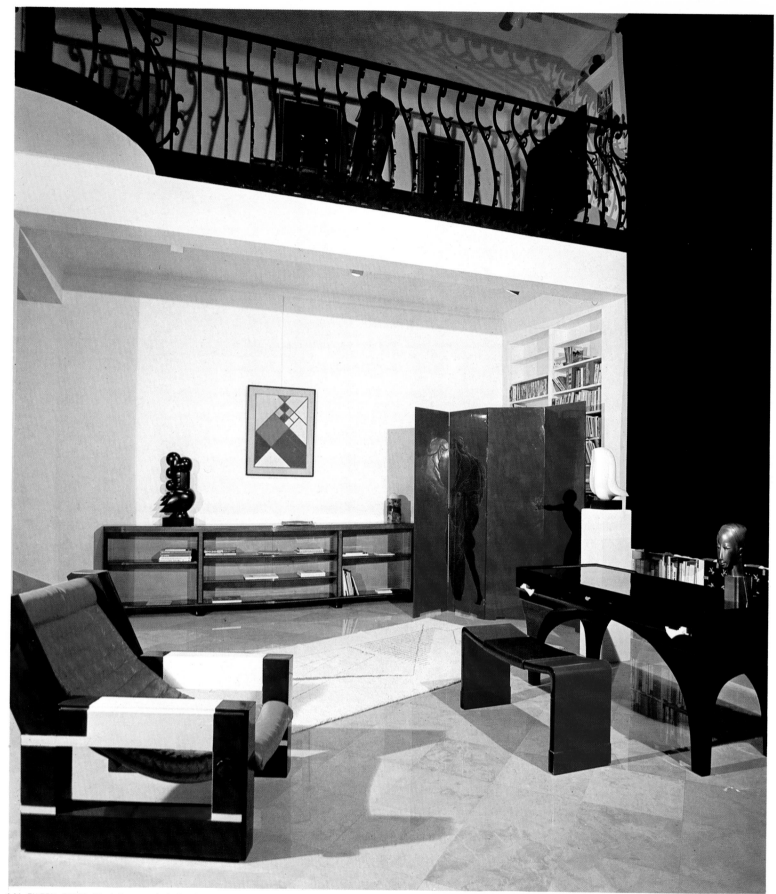

141 EILEEN GRAY Black lacquer desk lined with red lacquer, with ivory handles and matching stool upholstered in leather, designed for Mme Mathieu Lévy, c.1920-1922. The low bookcase in three sections is of black and gold lacquer, c.1913. The screen, *Le Destin*, is ornamented on one side with classical figures carved in bronze-green and silver lacquer on a red background and on the other with a 'rayonniste' design. It is signed and dated 1923 and was acquired by Jacques Doucet. The mahogany and parchment armchair in the foreground is by Legrain. (Private Collection, Paris)

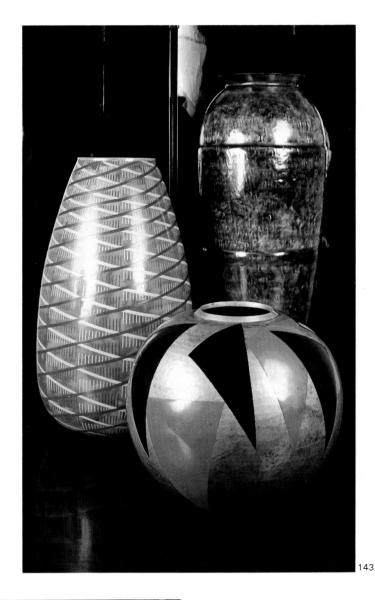

143

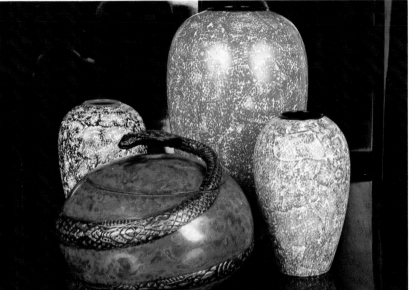

144

142 JEAN DUNAND Lacquer panel. (Collection Alain Lesieutre, Paris)
143 JEAN DUNAND Two copper vases covered in a coat of mottled snuff-coloured lacquer,
c.1925. The pewter vase in the foreground has geometric designs in red and black lacquer,
c.1928-1930. (Private Collection)

144 JEAN DUNAND Carved and embossed copper snake encircling a chinese red lacquer
sweetmeat box. Three eggshell vases in black and red contrasting lacquer, c.1925. (Private
Collection)

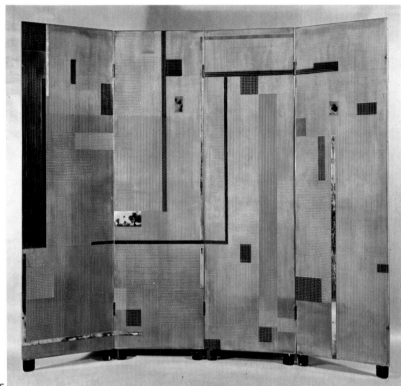

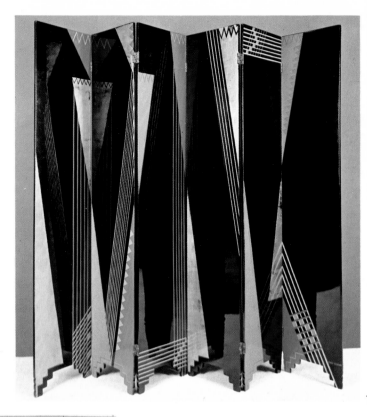

145

1

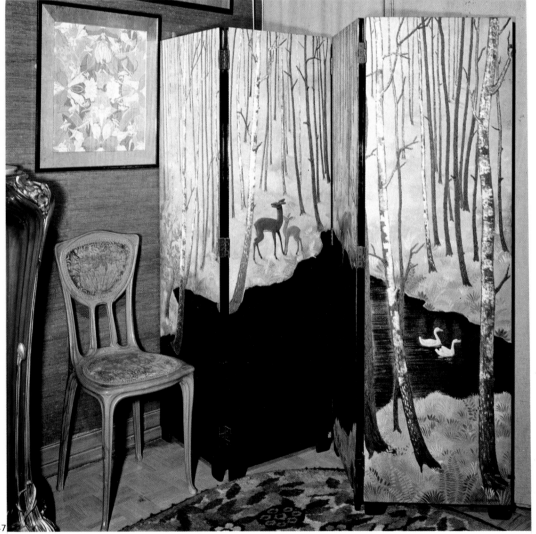

147

145 JEAN DUNAND Four-leaved screen in pale lacquer carved and decorated with black, red and silver lacquer, c.1922–1923. (Private Collection)

146 JEAN DUNAND Six-leaved screen with geometric 'Negro' design in red and gold lacquer on a black lacquer base, c.1925–1926. (Private Collection)

147 JEAN DUNAND Four-leaved screen, *La Forêt*, with polychrome lacquer design on a black base, c.1922–1925. (Collection Alain Lesieutre, Paris)

MODERNISM AND REACTION

On leaving his Louis XVI town house in the rue Spontini for an apartment in the avenue du Bois in 1912, the couturier Jacques Doucet attempted to reconstitute his living space on the basis of the paintings in his possession by Daumier, Degas, Manet, Monet, van Gogh and Cézanne. He chose the decorator Paul Iribe to furnish it for him; an artist who represented fairly well the transition from eighteenth-century art to the new style which was beginning to emerge. It was at this time that Doucet came to know Paul Iribe's assistant Pierre Legrain and Eileen Gray, a young Irishwoman who had been living in Paris since 1902 and who was using Japanese methods in her lacquer work.

After the war, Jacques Doucet's interest turned towards avant-garde art. Guided by the writers who worked for him as secretaries, André Breton and Philippe Soupault, he bought works by Picasso, Miró, Ernst, Picabia, Brancusi, Csaky and Miklos and made a collection of Negro art. In 1925, Doucet began to think in terms of an ambiance better suited to the spirit of his new purchases and from this was born the project for the Studio in the rue Saint-James in Neuilly designed by Paul Ruau. Pierre Legrain (1889-1929) who had been designing mock-ups of bindings for him since 1917, was put in charge of decoration and furniture. Legrain was a man of the 20s who understood Cubism and Negro art and the furniture he designed for Doucet was deeply influenced by this double tendency. He explored the use of geometric, frequently angular shapes, rare or unusual materials such as palmwood, ebony, lacquer, metal, leather, parchment, sharkskin, silvered glass and waxed cloth. Wood was used according to its nature, as veneering or solid and carved. The habit of designing covers for bindings left him well qualified to design the fronts of pieces of furniture and had also taught him how to play with empty and solid spaces, with contrasts of material and colour. Legrain was more a painter than a cabinet-maker and thus his technical quality was far from being as good as the furniture of Ruhlmann, for example. His was an isolated form of art, which while being thoroughly modern, scarcely concerned itself with the problems of the modern interior or with the possibility of mass-production. Legrain's clientele was rich and worldy including Madame Tachard, Maurice Martin du Gard and the Vicomte de Noailles. One of his last pieces was a Pleyel piano whose glass casing leaves the internal workings visible.

Into the setting decorated by Legrain, Jacques Doucet put furniture by Rose Adler, Eileen Gray, Clément Rousseau and Marcel Coard. Born in 1889 in Paris, Coard was an architect and worked for a number of collectors. He based his furniture on geometric shapes and right angles but kept curves for seats. His work consists only of single pieces, for which he used the finest materials: exotic woods, ivory, lapis-lazuli and parchment.

The career of Eileen Gray (1879-1976) is a perfect example of continuous progress. 'My idea,' she said towards the end of her life, 'was to make things that belonged to their time: things that were possible but which nobody was doing.' Around 1910, having been trained in the use of lacquer, she began to work on decorative panels and screens then furniture, desks, bookcases and beds. They were all single pieces of high quality, reserved for a privileged clientele. That was her greatest regret, and from 1914 Eileen Gray devoted much thought to a kind of furniture which could be mass-produced and more widely sold. In 1922, she opened a decorator's shop in the rue du Faubourg Saint-Honoré, under Jean Désert's name, where she designed everything from furniture to lighting and carpets. This was the period in which she fitted out Mme Mathieu Lévy's apartment. In a delicate setting, luxury furniture revealing an interest in 'Negro art could be seen side by side with avant-garde work; for instance, a screen with mobile panels, which she later reworked in plexiglass. In 1926, Eileen Gray designed a functional chair based on the deck-chair. Between 1927 and 1929 she built and entirely fitted out her own house at Roquebrune with the help of the architect, Jean Badovici, in which the leitmotif is clarity, suppleness and comfort. Every space is polyvalent and the furniture is collapsible, made of tubular steel, glass, plate glass or painted wood.

Jean Dunand (1877-1942) approached furniture after the First World War, from the standpoint of a particular technique — lacquer work. He had used it earlier in order to improve the finish of his metal vases and had learnt the craft from the Japanese Sougawara, who had also taught Eileen Gray. In 1921, he exhibited his first pieces, furniture, screens and panels, at the Galerie Georges Petit, in the first exhibition of the Goulden, Jouve, Schmied group. His beautifully proportioned furniture consisting of straight lines and planes was all designed to take lacquer decoration. His repertoire includes low tables of every size, nests of tables, round tables and chairs. Dunand also did the lacquer work for furniture designed by other artists such as Legrain, Ruhlmann, Goulden and Printz. He used lacquer in its more or less natural colour or tinted with black or red and tortoiseshell. Eggshell overlays introduced a note of white in a fairly limited range.

Jean Dunand's work became virtually monumental art in his decorated panels and above all in his screens. He would create them from the designs of his friends, Jouve, Schmied and Lambert-Rucki or would himself design the decoration. Two tendencies appeared in consequence, one which was figurative, historic, anecdotic and the other geometric, kinetic even, long before that particular term was coined. Following the Chinese and Japanese example, Dunand used natural lacquers, transparent for the base, keeping coloured opaque lacquers for decoration. Decorations might also be painted, engraved or carved, in the Coromandel style, overlaid with horn, ivory, mother-of-pearl, stone or better still, gilded with powder or gold leaf.

Pierre Chareau (1883-1950), decorator and architect, belonged to that group of artists of the 20s who, while being

entirely modern, that is to say entirely dissociated from models drawn from the past, remained nonetheless committed to quality workmanship and hence to luxury work. His was a builder's view of furniture and he would submit it to the requirements of the whole ensemble, adapting it to precise functions. Chareau used mahogany, rosewood and sycamore for his furniture which was so well designed as to make decoration unnecessary. He was one of the first to attempt to find a plastic solution to the problems of children's rooms. But he was above all the designer of Jean Dalsace's Maison de Verre in the rue Saint-Guillaume in Paris, on which he worked with Bijvoët from 1928-1931. The house was made of iron and glass and was very revolutionary in design and aesthetics, consisting of a façade of glass tiles with concave lenses permitting internal lighting by means of external projectors, three levels linked into each other, sliding and revolving doors which served as cupboards at the same time and furniture which was at once functional and refined.

With the exception of Eileen Gray, the architects and decorators we have labelled 'modern' did not concern themselves with the needs born of the social and economic conditions that appeared after 1914. Francis Jourdain (1876-1958) was the first in France, and he even elaborated his position before the war, to concern himself with 'fitting out the increasingly limited space' imposed by the new living conditions '. . . A room can be very luxuriously fitted out if we empty it rather than fill it with furniture.' This view and his desire to produce cheap furniture intended for a popular clientele made Jourdain one of the leading figures in the reaction to modernism. Without the slightest trace of orna-

mentation or moulding, Francis Jourdain's furniture is made of solid wood in simple and geometric shapes. The architect, Robert Mallet-Stevens (1886-1945) made his name as a decorator in 1913 at the Salon d'Automne by exhibiting a hall and a music room which were astonishing for their bright colours, their purity and clarity, which did not however altogether avoid a certain dryness. He chose geometric shapes in new materials such as painted metal and painted or nickelled tubular steel. In 1930, Mallet-Stevens joined the Union des Artistes Modernes, the group founded by René Herbst (b. 1891). Rigorously opposed to all superfluous decoration, Herbst concentrated on prototypes of rational furniture.

Le Corbusier, Pierre Jeanneret and Charlotte Perriand went still further in this direction when at the 1929 Salon d'Automne they exhibited a design for household equipment conceived by Thonet. 'The interior design of a house,' wrote Le Corbusier, 'means the clarification, by means of an analysis of the problem of the various elements necessary to domestic uses. Replacing the vast amounts of much-bedecked furniture of every name and shape, we have standard "pigeonholes" incorporated into the walls or placed against them in every place or room where a precise daily task is carried out . . .' In rooms free of furniture 'there remain only chairs and tables. The study of chairs and tables leads to entirely new concepts, of a functional and not a decorative order; the "label" has been suppressed by the evolution of customs.' These chairs, chaises-longues, armchairs with hinged backs, club chairs, made of nickelled tubular steel are amongst the classics of contemporary furniture.

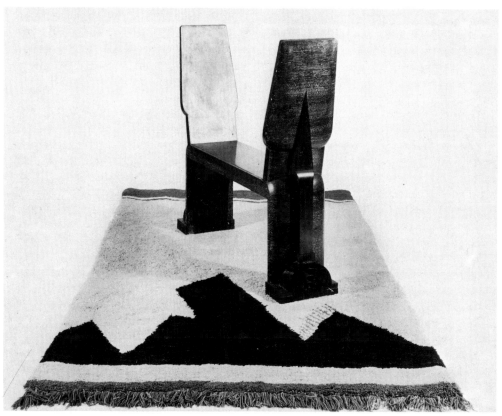

148 PIERRE LEGRAIN Small bench in stained oak with carved ebony motifs and gold lacquered back rests, showing the influence of African art, c.1922. The rug is designed by Marcoussis. (Private Collection, Paris)

PIERRE LEGRAIN

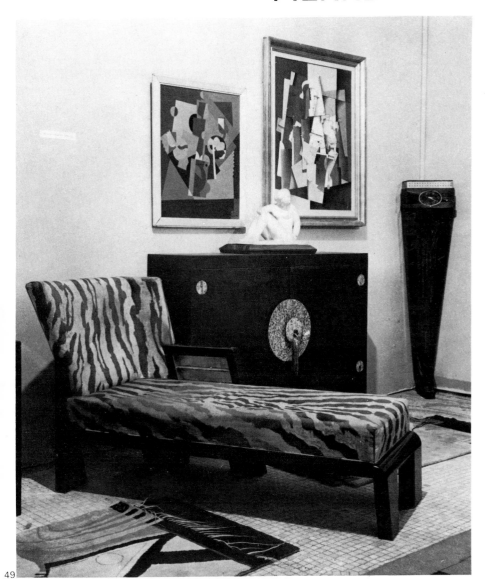

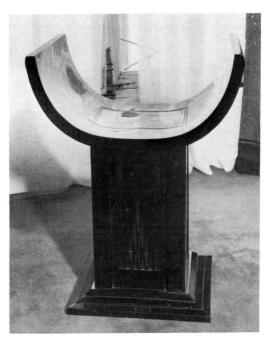

150

149 PIERRE LEGRAIN Room setting from Jacques Doucet's Studio with stained oak clock, black lacquered beech chaise-longue with mother-of-pearl inlays and cabinet covered in green morocco leather by Paul-Louis Mergier. (Musée des Arts Décoratifs, Paris)

150 PIERRE LEGRAIN A curule stool from Jacques Doucet's Studio, veneered in ebony with geometric mother-of-pearl inlay, c.1922-1923. (Private Collection, Paris)

151 PIERRE LEGRAIN A pair of stools and table in silvered and lacquered wood with metal handles from the veranda of Mme Tachard's house at Celle-Saint-Cloud, furnished and landscaped entirely by Legrain, c.1922-1925. (Private Collection, Paris)

49

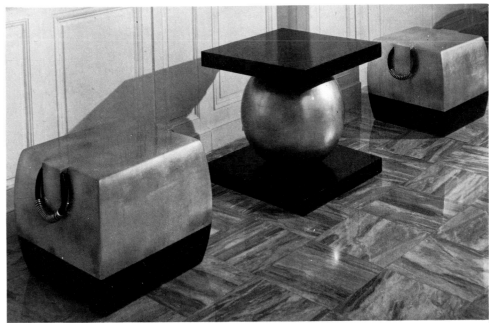

151

EILEEN GRAY

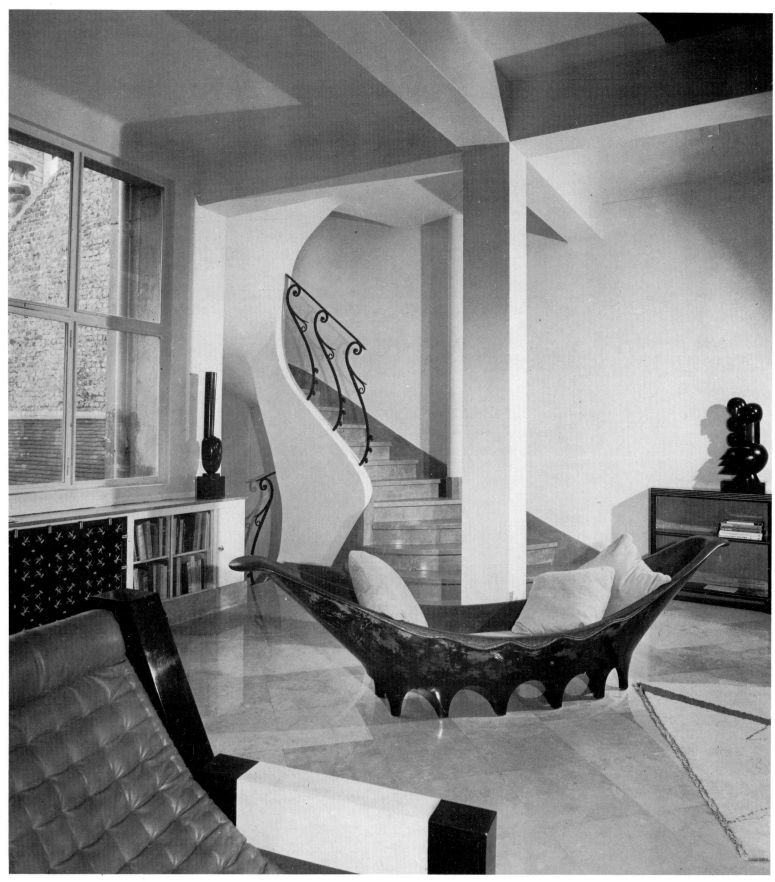

152 EILEEN GRAY Canoe-shaped couch in black and gold lacquer resting on arched legs, designed for Mme Mathieu Lévy, c.1920-1922. (Private Collection, Paris)

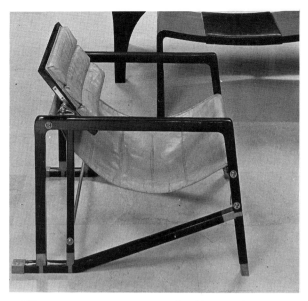

153 EILEEN GRAY Armchair with adjustable seat and armrests.

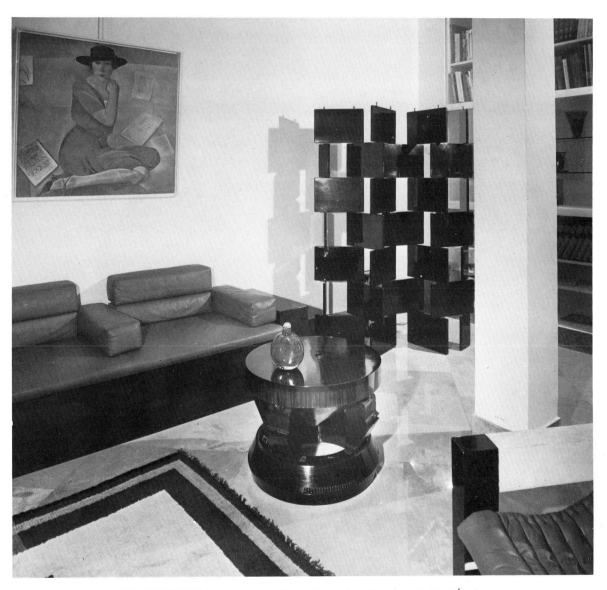

154 EILEEN GRAY Lacquer screen with movable panels made for Mme Mathieu Lévy. The table in the foreground is of solid ebony with Brazilian rosewood veneer, designed by Pierre Legrain for Jacques Doucet, c.1925-1928. (Private Collection, Paris)

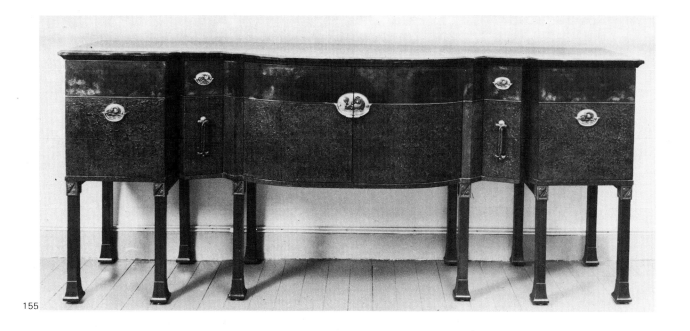

155

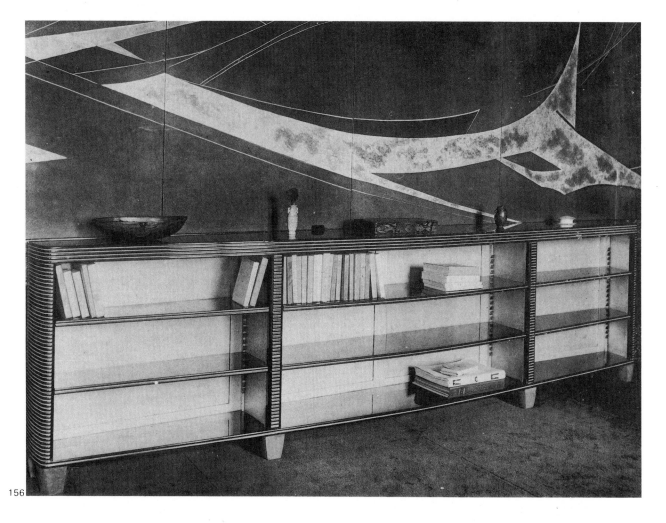

156

155 EILEEN GRAY Lacquer chest with twelve legs and bronze handles and motifs. The central panel with double doors is flanked by protruding sections, c.1920. (Collection Yves Saint-Laurent)

156 EILEEN GRAY Lacquer and silver bookcase.

157-158 MARCEL COARD Cubist bedroom furniture in macassar ebony veneer with ivory and lapis lazuli inlay within a bronze framework, c.1926-1927. (Private Collection, Paris)

159 MARCEL COARD Armchair from Jacques Doucet's Studio, in oak veneer and red lacquer, upholstered in horsehair with diamond-shaped design. The Brazilian rosewood veneer cupboard with gilt interior was made for Doucet in collaboration with the sculptor, Josef Csaky, c.1925-1928. (Musée des Arts Décoratifs, Paris)

MARCEL COARD

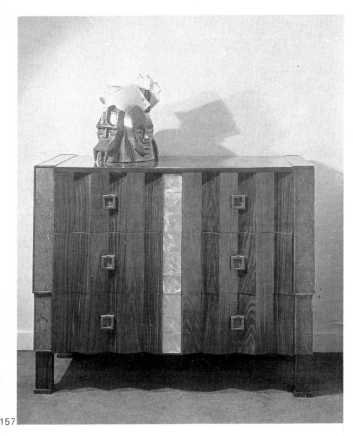

157

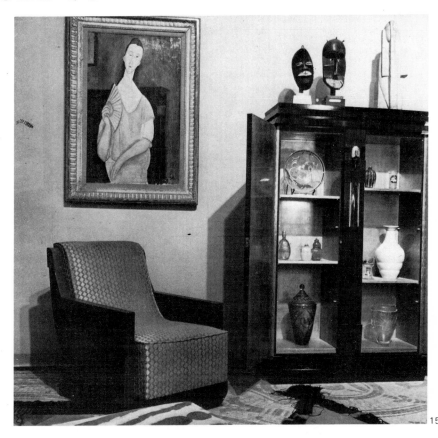

159

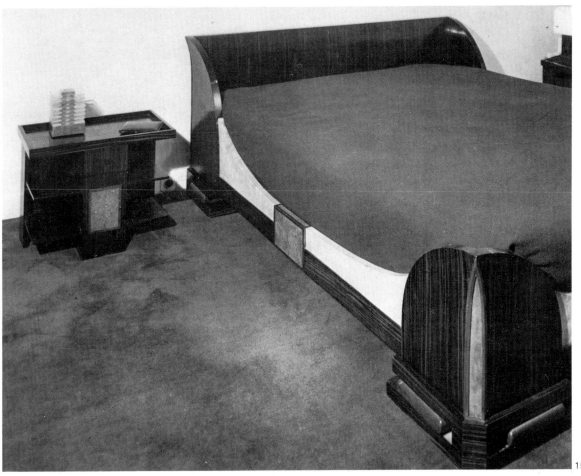

158

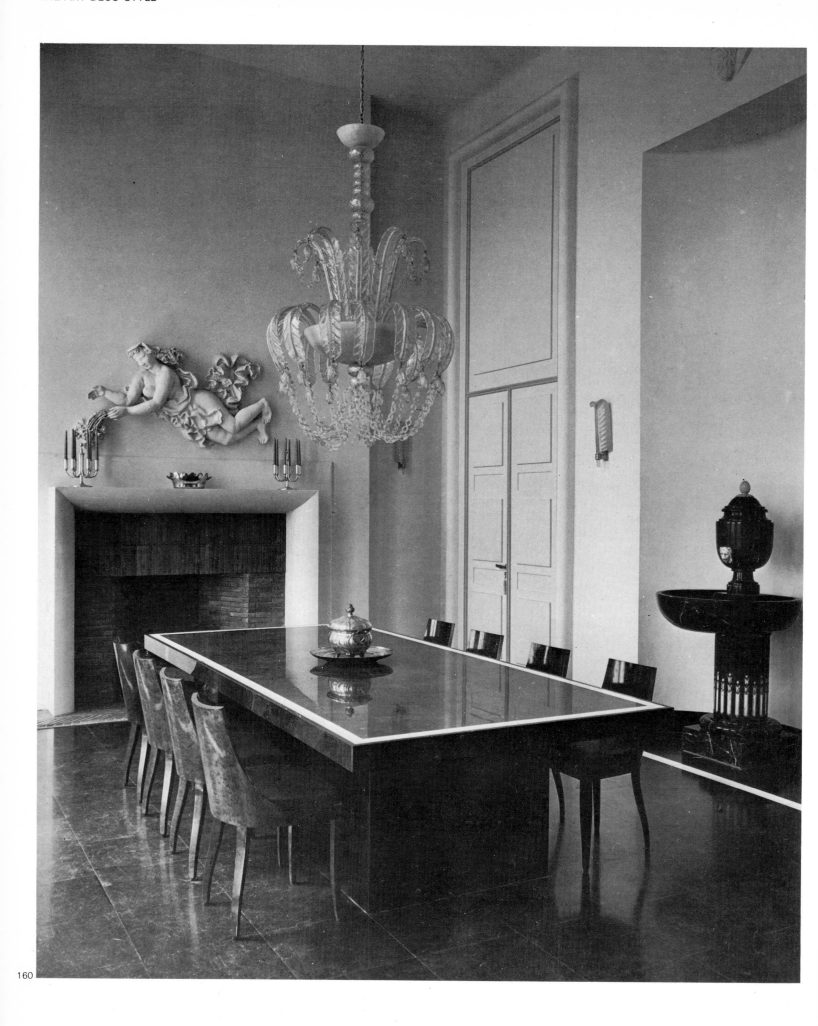

160

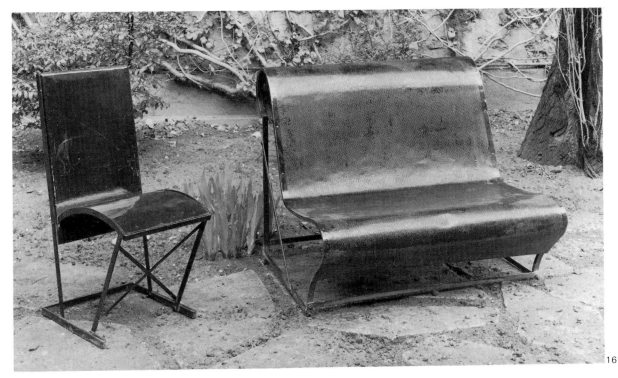

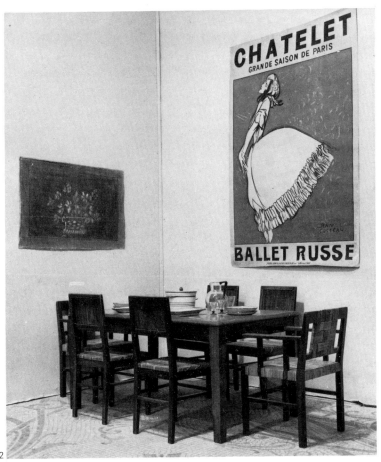

160 MARCEL COARD Dining-room in Dinard for the architect, Michel Roux-Spitz.

161 MARCEL COARD Garden seats in plated steel, perforated metal and black lacquer, c.1927-1930. (Collection Dr and Mme Vellay, Paris)

162 FRANCIS JOURDAIN Dining-room suite in solid wood and cane. (Private Collection, Paris)

163 MARCEL COARD Brazilian rosewood veneered wardrobe with tall, carved figure gilded and painted blue by the sculptor Csaky, made for Jacques Doucet between 1925 and 1928. (Musée des Arts Décoratifs, Paris)

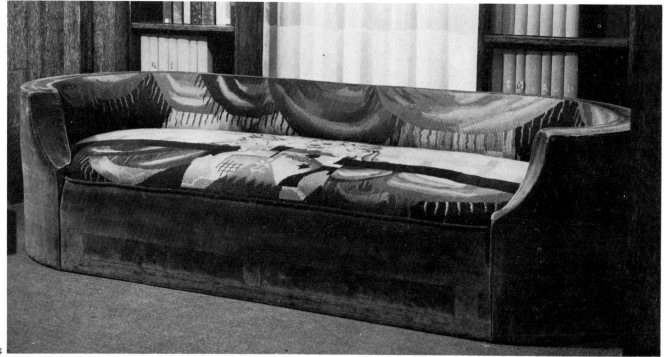

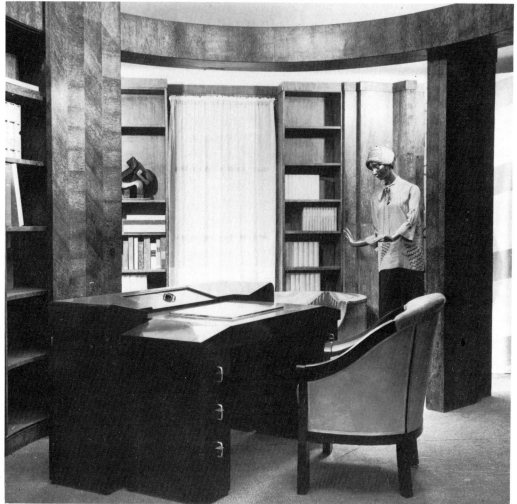

164 PIERRE CHAREAU Sofa from the Maison de Verre, rue Saint-Guillaume, upholstered with a Jean Lurçat tapestry. (Collection Dr and Mme Vellay, Paris)

165 PIERRE CHAREAU Palmwood bookcase designed for the study of the Ambassade Française at the 1925 Exhibition. The desk is of mahogany and oak veneered in Brazilian rosewood and the armchair is of lacquered and varnished beech. (Musée des Arts Décoratifs, Paris)

166 JEAN-CHARLES MOREUX Low table with shagreen top and crystal feet, c.1926. (Collection Maonoukian, Paris)

JEAN DUNAND

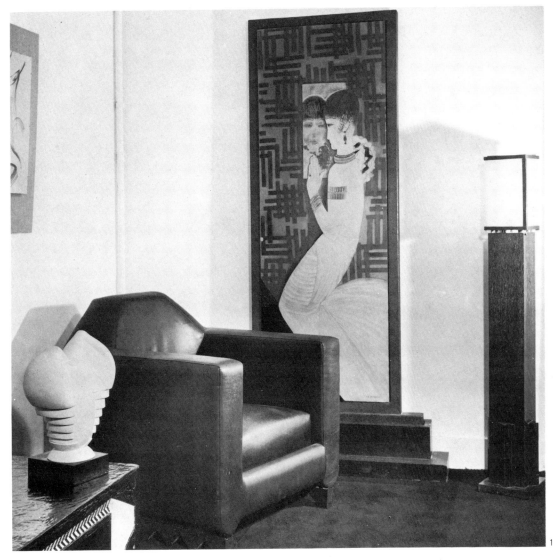

167

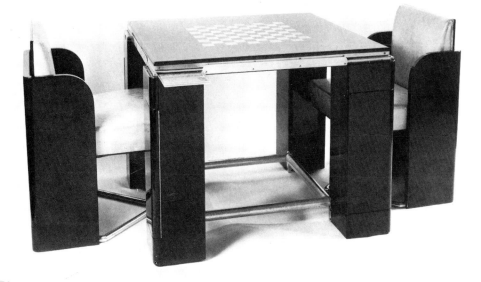

68 169

167 JEAN DUNAND Swing mirror decorated by a figure possibly attributed to Foujita on a black and gold lacquer base. The lamp and leather chair are by Pierre Legrain. (Private Collection, Paris)

168-169 JEAN DUNAND Card table made for Madeleine Vionnet, c.1925, in black lacquer with eggshell chequers.

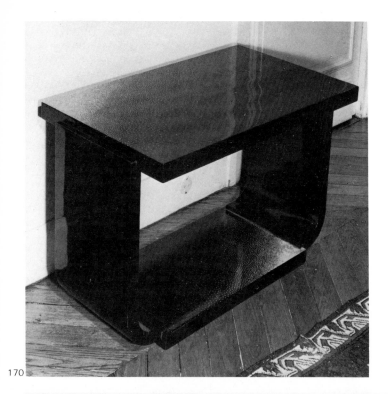

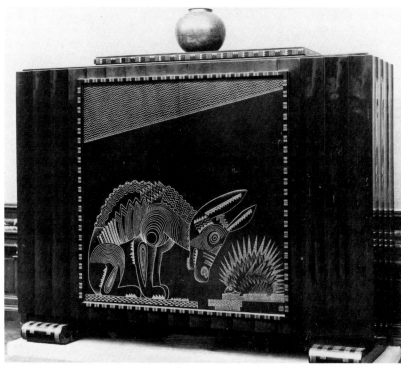

170

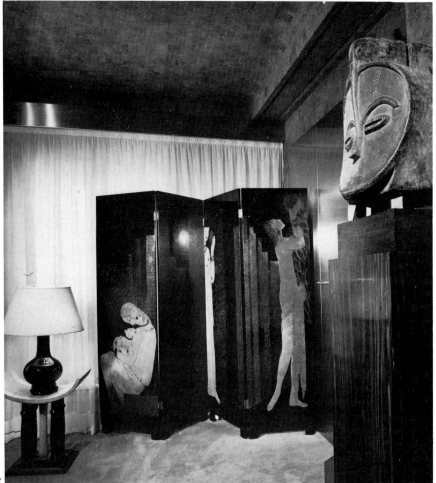

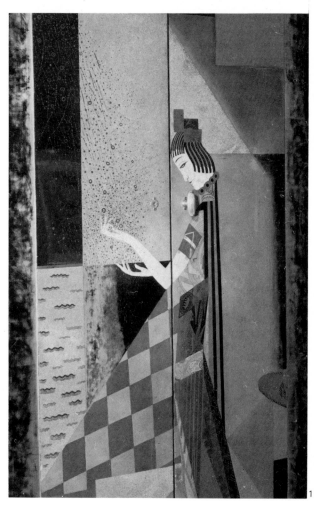

172

170 JEAN DUNAND Black lacquer and eggshell table with curved sides attached to the base. (Private Collection)

171 JEAN DUNAND Black lacquered cabinet designed by Ruhlmann and exhibited in the Grand Salon of the Pavillon du Collectionneur. It was lacquered by Jean Dunand after a pictorial design by Jean Lambert-Rucki. (Collection Félix Marcilhac, Paris)

172 JEAN DUNAND Screen 'à figures . The seat by Legrain is of shagreen and lacquer and was originally from Jacques Doucet's collection as was the Gabonese mask in the foreground. (Private Collection)

173 JEAN DUNAND Two swing doors decorated with a figure in the style of many of François-Louis Schmied's illustrations. (Collection Manoukian, Paris)

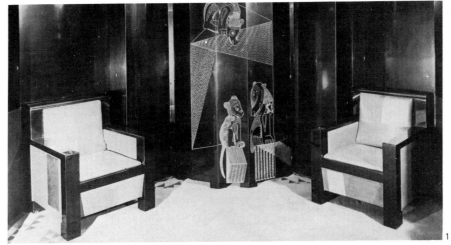

174

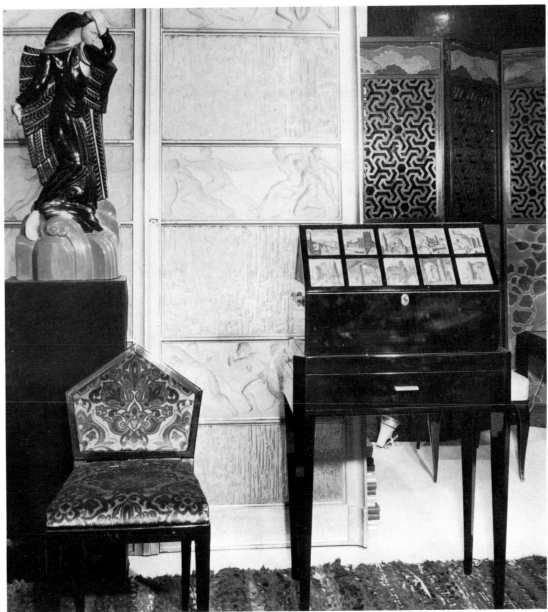

175

174 JEAN DUNAND Smoking room of the Ambassade Française designed by the Société des Artistes Décorateurs for the 1925 Exhibition. The lacquer ceiling is covered in silver leaf and the woodwork is highly polished and lacquered in black. Framing a cabinet with engraved silver designs in the style of Jean Lambert-Rucki are two cubic armchairs in black and grey lacquer with silver-plated sides.

175 JEAN DUNAND Bureau and chair in black lacquered wood, c.1925. The Lalique glass doors are from Jacques Doucet's Studio. (Collection Félix Marcilhac, Paris)

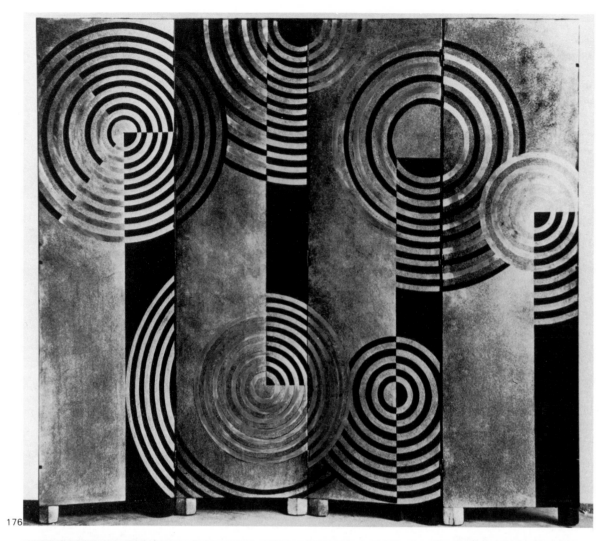

176

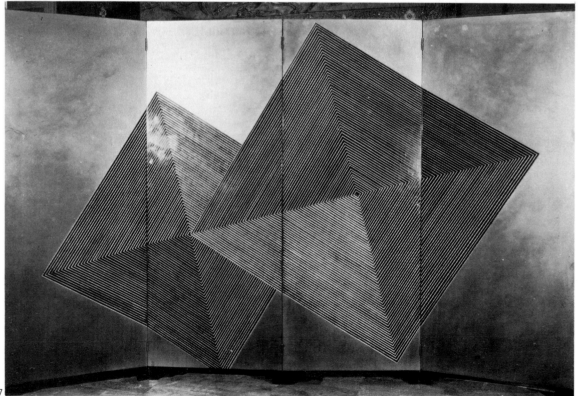

177

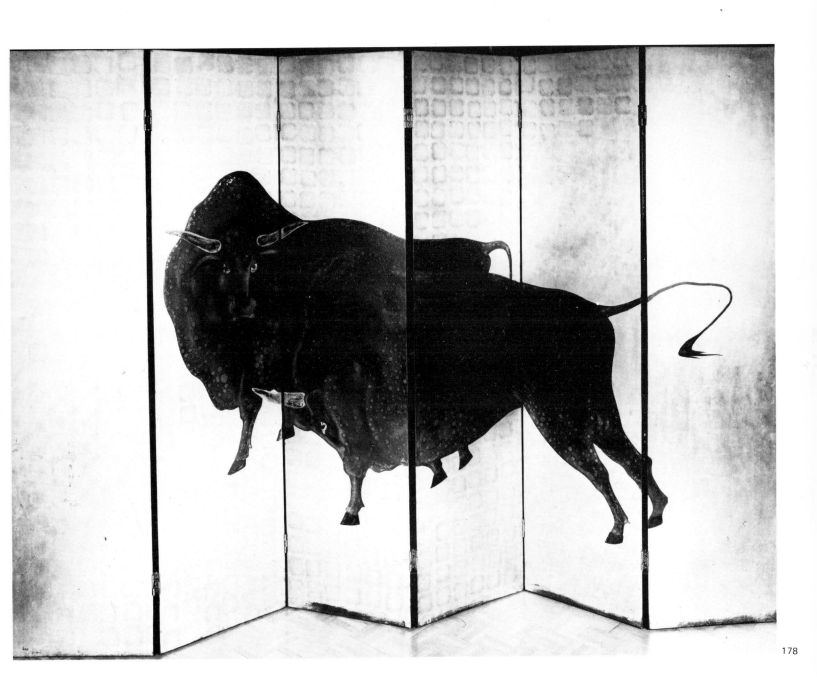

178

176 JEAN DUNAND 'Rayonniste' style screen with four leaves in silver lacquer on a black background, c.1928-1930.

177 JEAN DUNAND Four-leaved screen in silver lacquer carved with overlapping squares and exhibited at the Salon des Artistes Décorateurs in 1927.

178 JEAN DUNAND *Les Taureaux,* a polychrome lacquer screen, c.1920-1930. (Collection Alain Lesieutre, Paris)

ROBERT MALLET-STEVENS

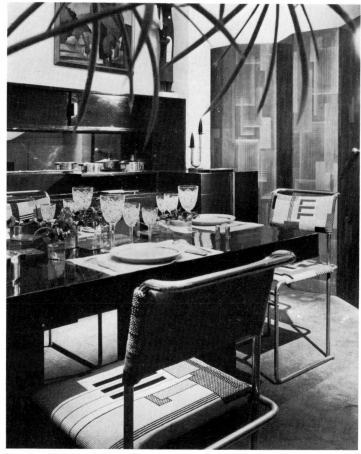

179 ROBERT MALLET-STEVENS Lounge in his house with tubular steel furniture and yellow upholstery.

180 ROBERT MALLET-STEVENS Dining room in the same house with tubular steel seats upholstered in a Hélène Henry fabric, table and sideboard in dark wood and carved lacquer screen in the background by Dunand.

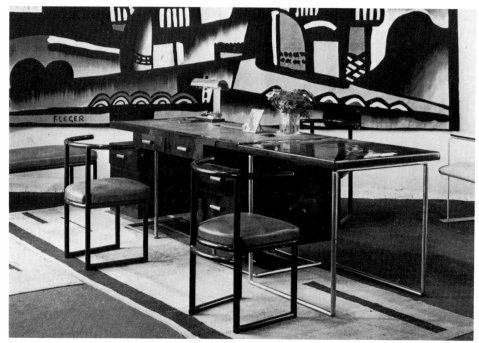

181 ROBERT MALLET-STEVENS Desk and chairs in brown tubular steel and rugs designed by Mallet-Stevens and Jean Burkhalter exhibited at Les Années 25 Exhibition at the Musée des Arts Décoratifs, Paris in 1966. (Musée des Arts Décoratifs, Paris) The design for the wall-hanging was taken from the model of the stage curtain for the ballet, *La Creation du Monde*, by Fernand Léger, 1924. (Musée Fernand Léger)

LE CORBUSIER

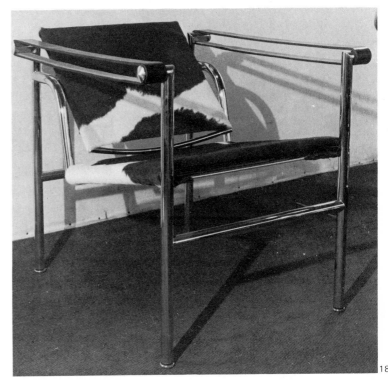

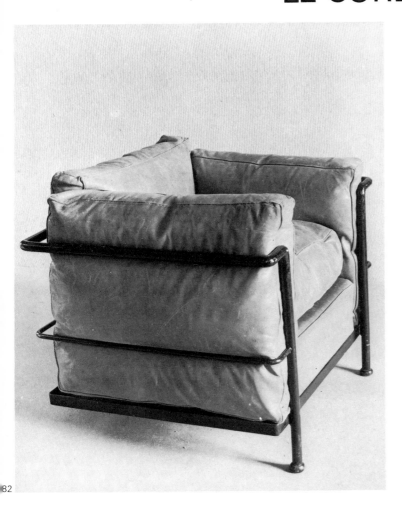

183

182 LE CORBUSIER, PIERRE JEANNERET and CHARLOTTE PERRIAND 'Fauteuil grand confort' of nickel-plated steel tubing with leather upholstery. First manufactured by Thonet in 1929 and from 1965 on by Cassina. (Collection Charlotte Perriand)

183 LE CORBUSIER, PIERRE JEANNERET and CHARLOTTE PERRIAND Chair with reclining back in chrome tubular steel upholstered in pony skin with black leather. Designed in 1928 it has been manufactured since 1965 by Cassina. (Musée des Arts Décoratifs, Paris)

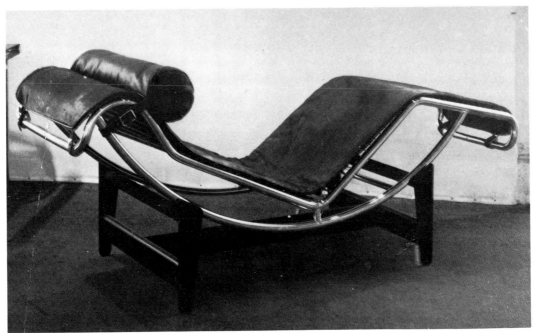

184 LE CORBUSIER, PIERRE JEANNERET and CHARLOTTE PERRIAND Chaise-longue in chrome tubular steel, manufactured by Thonet in 1928 and later by Cassina in 1966. (Musée des Arts Décoratifs, Paris)

COMPARATIVE SURVEY

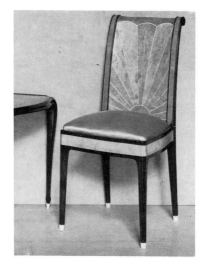

Clément Rousseau, p. 59

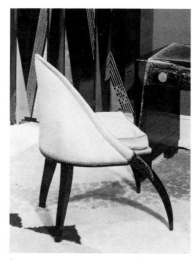

Emile-Jacques Ruhlmann, p. 58

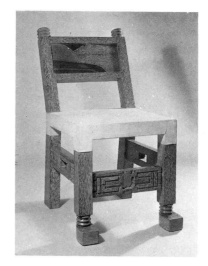

Pierre Legrain

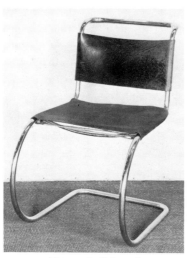

Mies van der Rohe, p. 9

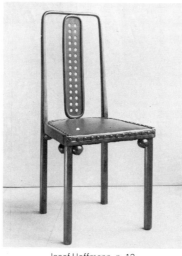

Josef Hoffmann, p. 13

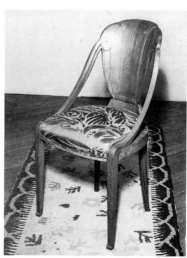

Süe et Mare, p. 45

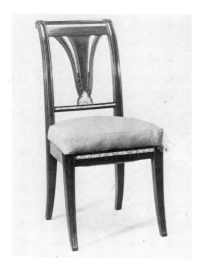

Clément Mère, p. 42

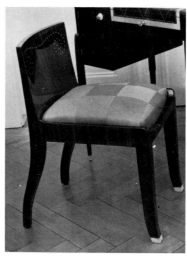

Emile-Jacques Ruhlmann, p. 46

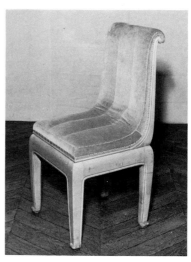

Atelier Martine, p. 59

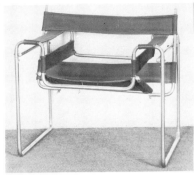

Marcel Breuer, p. 12

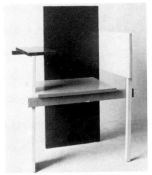

Gerrit Rietveld, p. 9

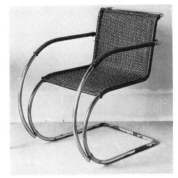

Mies van der Rohe, p. 9

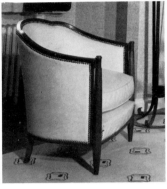

Dominique, p. 39

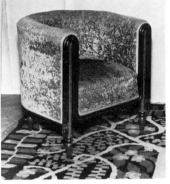

Atelier Martine, p. 59

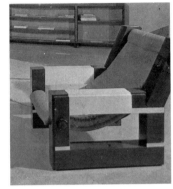

Pierre Legrain, p. 70

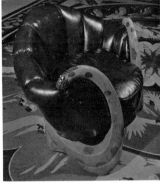

Eileen Gray, p. 69

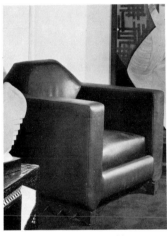

Pierre Legrain, p. 83

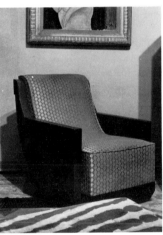

Marcel Coard, p. 79

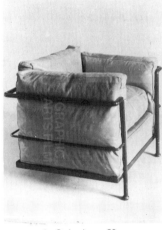

Le Corbusier, p. 89

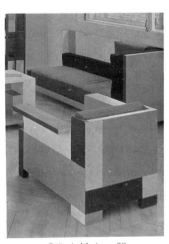

Félix de Marle, p. 68

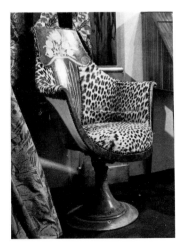

Paul Iribe, p. 30

Süe et Mare, p. 45

André Groult, p. 35

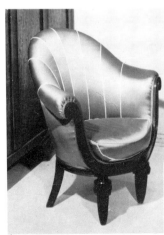

Maurice Dufrêne, p. 38

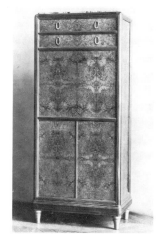

Léon Jallot, p. 29

Emile-Jacques Ruhlmann, p. 55

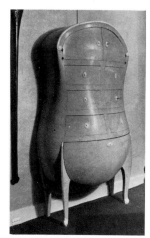

André Groult, p. 34

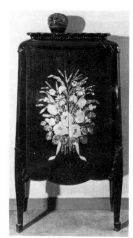

Süe et Mare, p. 44

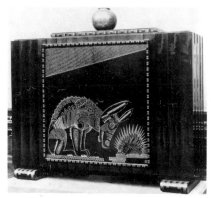

Jean Dunand, p. 84

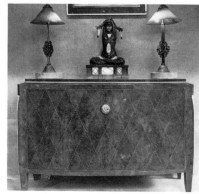

Emile-Jacques Ruhlmann, p. 57

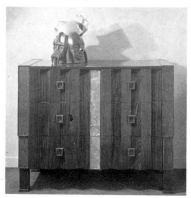

Marcel Coard, p. 79

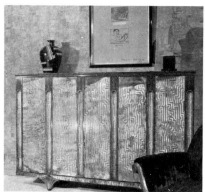

Eugène Printz, p. 66

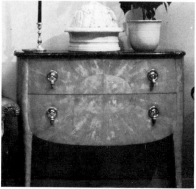

André Groult

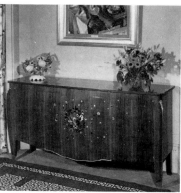

Jules Leleu, p. 40

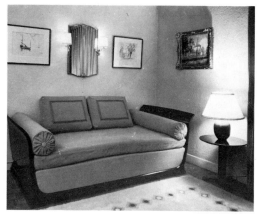

Jules Leleu, p. 41

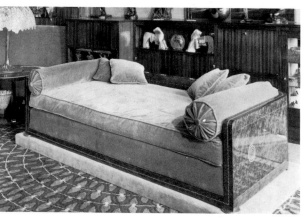

Emile-Jacques Ruhlmann, p. 48

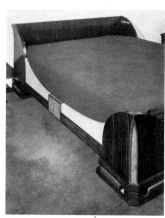

Marcel Coard, p. 79

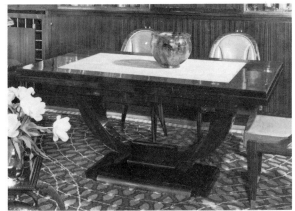

Emile-Jacques Ruhlmann, p. 52

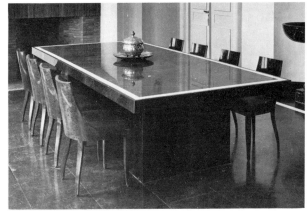

Marcel Coard, p. 80

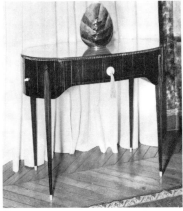

Emile-Jacques Ruhlmann, p. 49

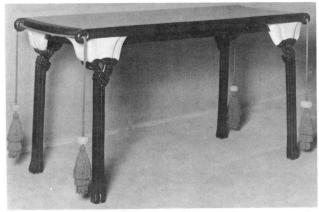

Eileen Gray, p. 69

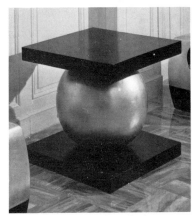

Pierre Legrain, p. 75

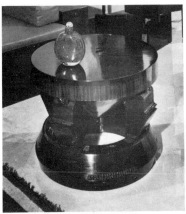

Pierre Legrain, p. 76

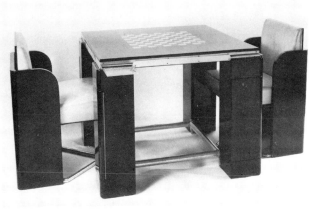

Jean Dunand, p. 83

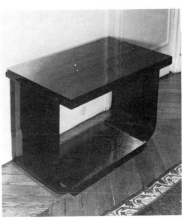

Jean Dunand, p. 84

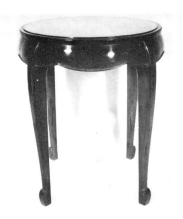

Süe et Mare, p. 44

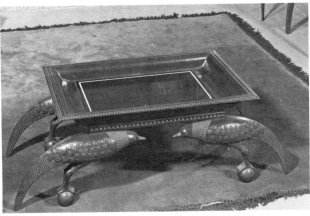

Armand-Albert Rateau, p. 36

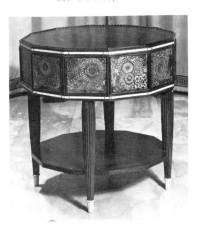

Maurice Dufrêne, p. 38

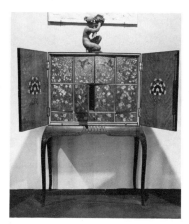

Pierre Lahalle, p. 33

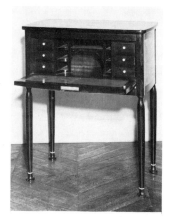

André Groult

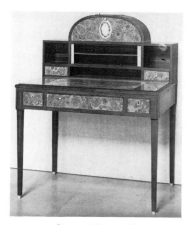

Clément Mère, p. 42

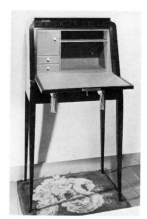

Emile-Jacques Ruhlmann, p. 46

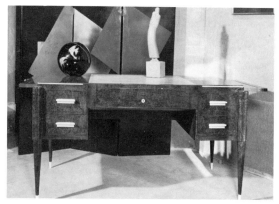

Emile-Jacques Ruhlmann, p. 50

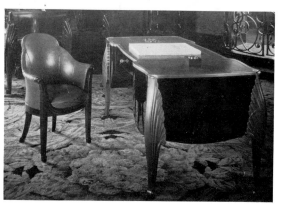

Süe et Mare, p. 43

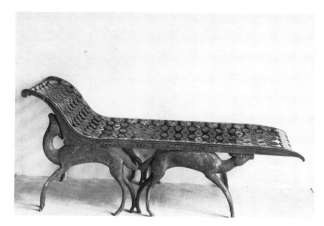

Armand-Albert Rateau, p. 38

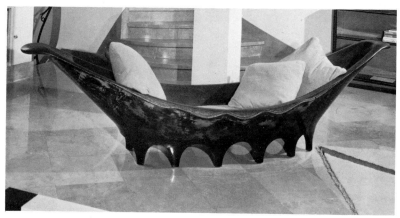

Eileen Gray, p. 76

FLOOR AND WALL DECORATION

CARPETS

Carpeting in the West has often come up against an incorrect conception of its use and hence of the way to treat it. Around 1900, certain artists, such as Georges de Feure and Edward Colonna attempted to separate it from the La Savonnerie tradition which set out more to produce a painting in wool than a floor-covering.

The following generation also became interested in the problem. The decorators who were interested in the whole ensemble regarded carpets as an essential part of the decor and made designs for them themselves. With Maurice Dufrêne, Paul Follot, Süe et Mare, Nathan, Coudyser, Groult and Ruhlmann, Art Deco knotted carpets were covered in flowers following a thoroughly French tradition. In an analogous style, Edouard Bénédictus (1878-1930) worked on knotted carpets and Jacquart wall-to-wall carpeting at the same time. The floral patterns of the students at the Martine workshop contributed a new look before 1914 with a renewal of the range of colours at the service of free and youthful inventiveness.

A series of exhibitions of Moroccan art in 1917, 1919 and 1923, revealed Berber carpets in deep wool and their designs in red and black. They inspired a current whose finest exponents were Stephany and above all Bruno da Silva Bruhns. This influence fell in easily with that of Cubism or even of Negro art in the beautiful carpets designed by Jean Burkhalter and Robert Mallet-Stevens and those that Jacques Doucet commissioned from designs by the sculptor Gustave Miklos for the Neuilly Studio.

Manufacturers in turn gave new life to their production of carpets by turning to contemporary artists for their designs, though always to the most classical of them. La Savonnerie commissioned designs from Gaudissart and Bonfils as did the Beauvais workshop from Bénédictus.

From 1910 onwards, a number of manufacturers including Cornille, Tassinari and Chatel and Bianchini-Férier began to produce silks designed by contemporary painters and decorators, instead of limiting themselves to perpetual copies of antique cloths. The Ballets Russes and the Werkbund were not unconnected with this decision. Styles based on Russian and Oriental folklore were successfully interpreted and adapted to the French temperament by Paul Iribe whose influence can clearly be seen in albums of models published in 1913 and 1914.

FURNISHING FABRICS

The modern style defined itself with difficulty. Its beginnings were hybrid, with Coudyser, Follot and his colleagues of the Pomone workshop, Dufrêne and Bénédictus who combined themes drawn both from Art Nouveau and from Cubism. Their originality was more in the treatment than in the theme itself — flowers and fruit were preferred, interpreted in a rustic style by André Mare and on a grand scale by Etienne Kohlmann. Two figures stand out from the period leading immediately up to the war: Paul Poiret, the leading spirit of the Martine workshop and Francis Jourdain. But it is to Raoul Dufy (1877-1953) that we are indebted for the best Art Deco cloths such as the beautiful lampas produced by Bianchini-Férier, *Longchamps, Paris* (1923) and *la Jungle*, in which the painter managed to bend his craft and his genius to the service of a genre which makes imperious demands on those who venture into it, not least of which is the need for recurrent motifs.

The cloths produced by Hélène Henry (1891-1958) represent an altogether different tendency. After her arrival in Paris in 1918, she established a workshop for craft weaving in which she herself produced silk and rayon cloths, whose essentially geometric and linear decoration and colours based on white, yellow, brown and grey, did not conceal the cloth's texture. Hélène Henry worked with Francis Jourdain, Mallet-Stevens and Chareau and was, with them, one of the founder members of the U.A.M.

The printing of cloth led to the rediscovery of wood-cutting and printing. Jaulmes, Boigegrain and Victor Menu founded the Société des Toiles de Rambouillet before 1910, which they supplied with floral compositions in which the rose reigned supreme. André Groult produced work based on his own designs as well as on those of Iribe and Drésa. They were principally concerned with colour, as was the case with the Martine workshop and Francis Jourdain whose designs were stencilled onto the cloth. The most beautiful printed cloths such as *La Moisson, La Pêche, Danse* and *Tennis* — detailed compositions based entirely on the use of lines — were due once more to Raoul Dufy's brush. They were produced by Bianchini-Férier under the name of Toiles de Tournon in black and white, red and white or yellow and white. Designs by Mare, Ruhlmann, Martin and Marty were likewise printed on silk and cambric.

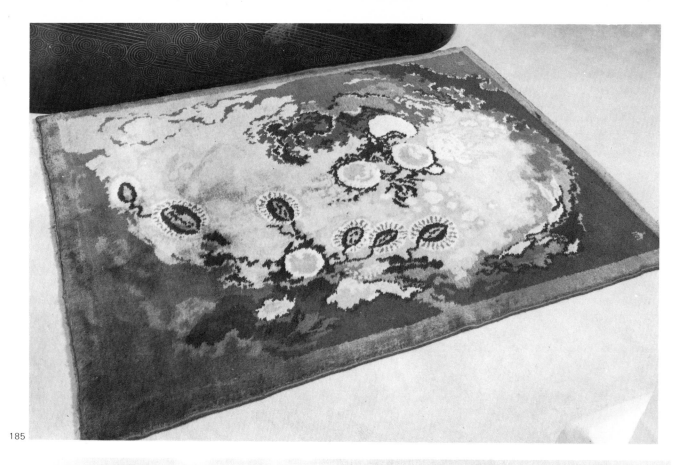

185

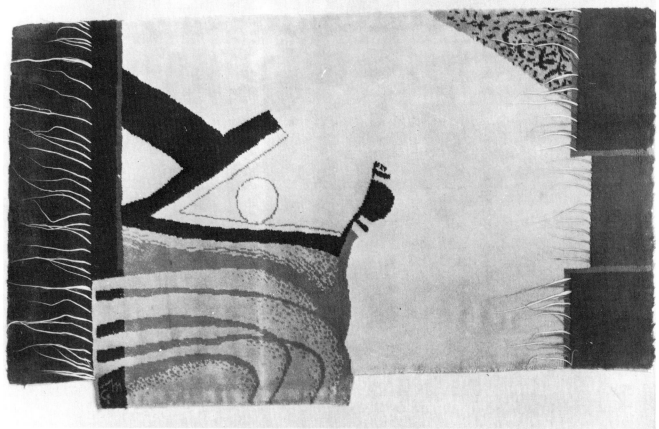

186

185 Art Deco style knotted rug with polychrome flower design, c.1925. (Galerie du Luxembourg, Paris)

186 GUSTAVE MIKLOS Knotted rug designed for Doucet's Studio, c.1925-1928. The linear design is on a white background with dark and light brown borders and fringing at both ends. (Musée des Arts Décoratifs, Paris)

187-189 BRUNO DA SILVA BRUHNS Knotted rugs with geometric designs influenced by Berber work, c.1925-1930.

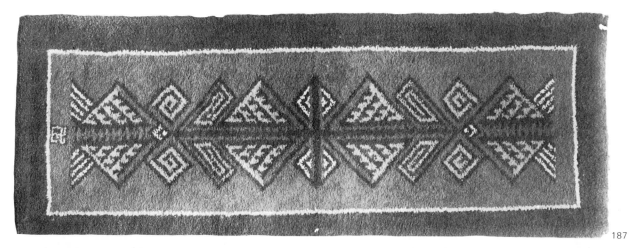

187

188

189

190

191

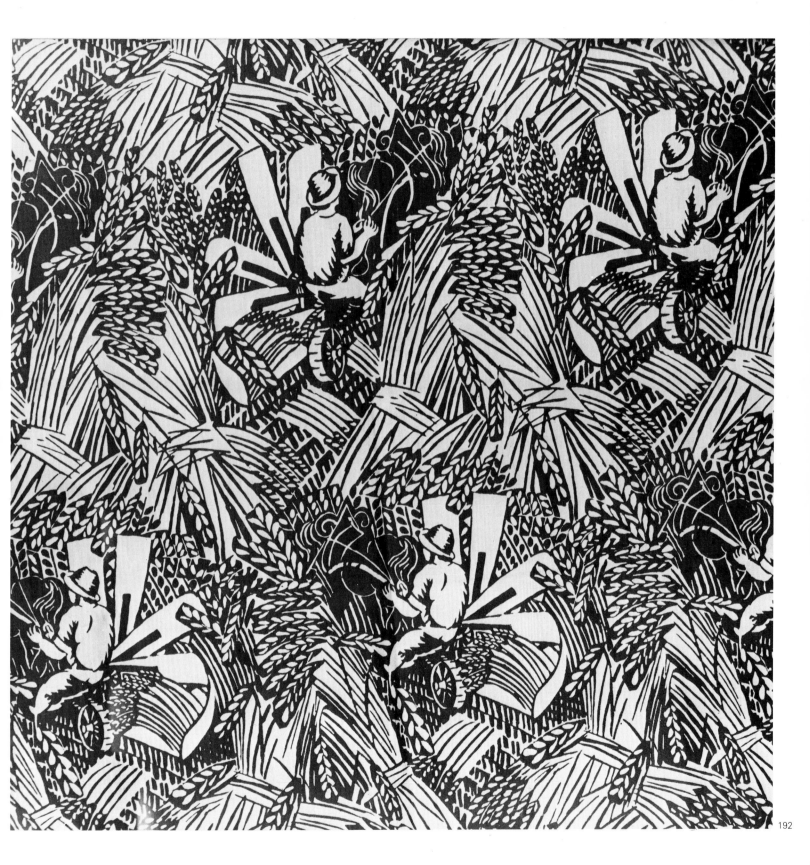

192

190 BRUNO DA SILVA BRUHNS Knotted rug with triangular design within a wide frame, c.1925-1930.

191 BRUNO DA SILVA BRUHNS Knotted rug with central triangular design and alternating greek border and undulating line, c.1925-1930.

192 RAOUL DUFY Tournon cloth, *La Moisson*, printed in navy blue on a white background and manufactured by Bianchini-Férier, 1920. (Musée des Arts Décoratifs, Paris)

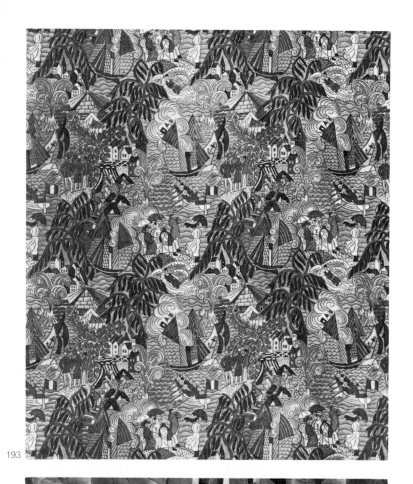

193 *Les Régates*, a printed shantung.

194 Paris, a brocade manufactured by Bianchini-Férier, 1923.

195 *Flamme moderne*, figured satin.

196 *Tapis fleuri*, figured satin.

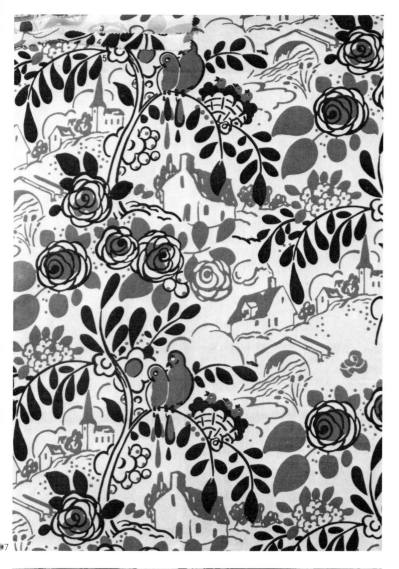

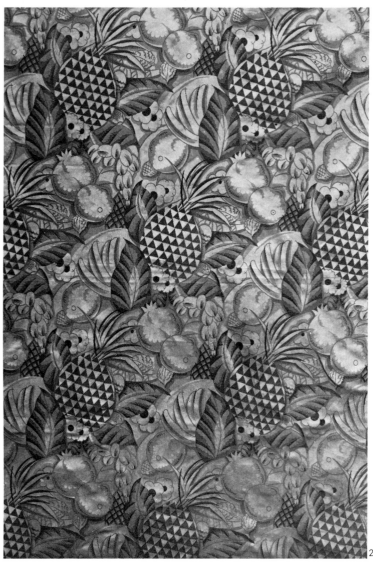

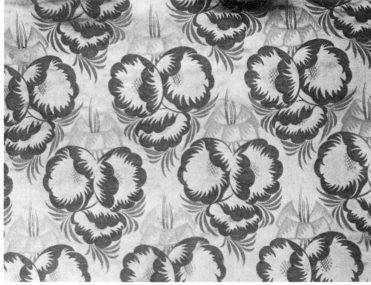

197 *Paysage*, printed cotton in yellow-orange and navy blue. (Collection Tassinari and Chatel)

198 ROBERT BONFILS *Les Anémones*, figured satin.

199 Grey and red damask. (Collection Tassinari and Chatel)

200 CHARLES MARTIN *Les Ananas*, figured satin.

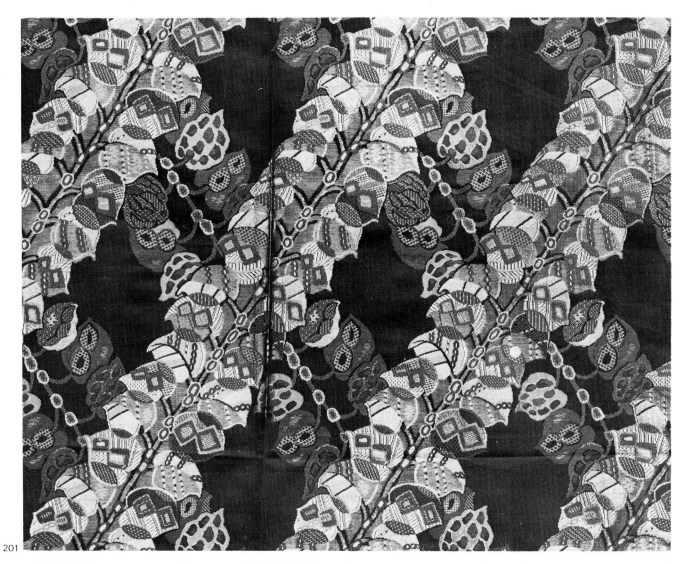

201

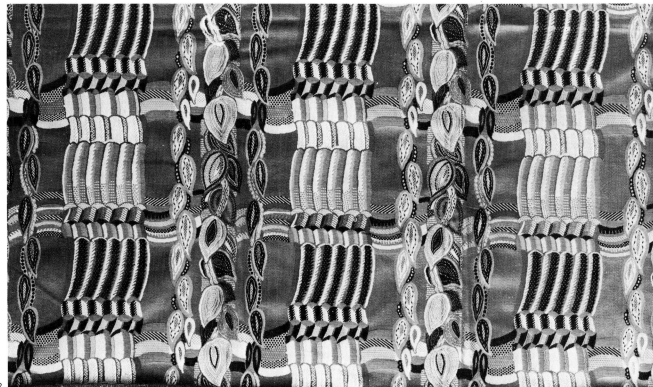

202

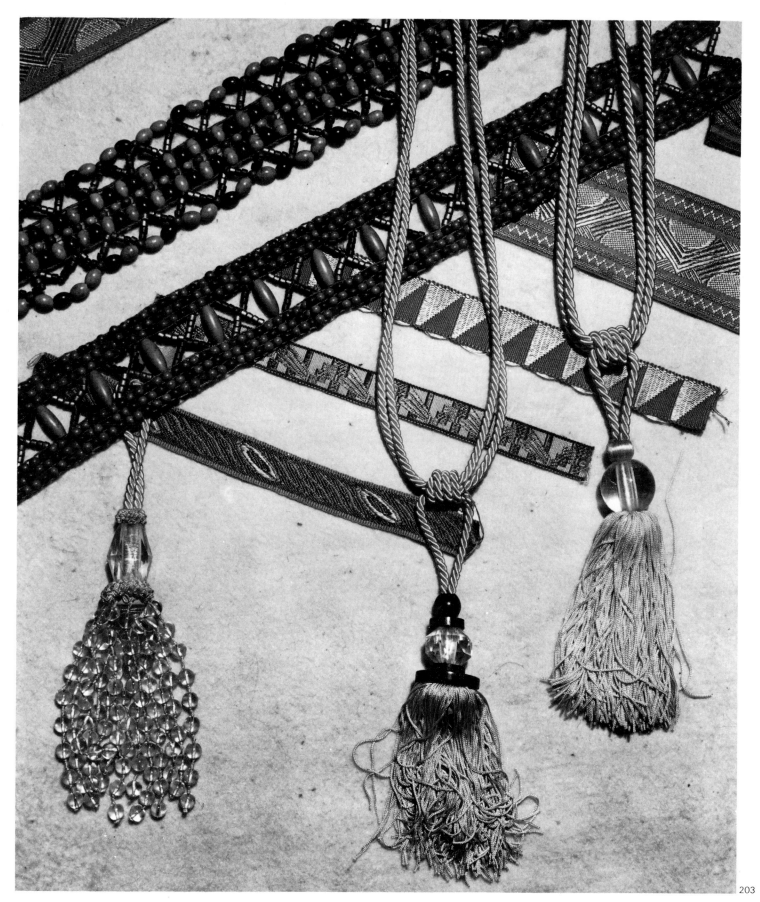

201 EDOUARD BENEDICTUS *Croisillon*, a brocade manufactured by Brunet, Meunié et Cie, 1925.

202 *Les Fruits d'or*, a brocade manufactured by Brunet, Maunié et Cie, 1925. (Musée des Arts Décoratifs, Paris)

203 Art Deco Trimmings showing an increasing use of satin covered materials, stained woods, glass, bakelite and nickel-plated metal pearls. (Collection La Passementerie nouvelle)

204

20

204-205 Silk and rayon tassels with bakelite and glass.

206 Art Deco trimmings with gathered flounces. (Collection la Passementerie nouvelle)

206

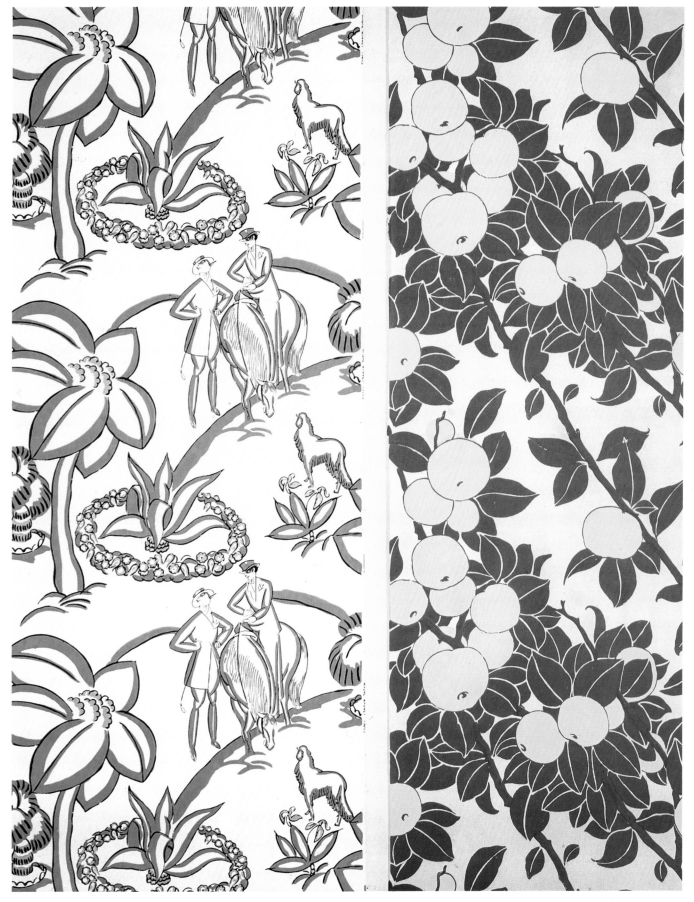

207-208 ANDRE GROULT Two wallpapers designed between 1912 and 1920 and printed
by stencil; *Amazone*, a print produced in 1967 by the Maison Hans and *Les Oranges*, also
produced by Hans in 1967. (Musée des Arts Décoratifs, Paris)

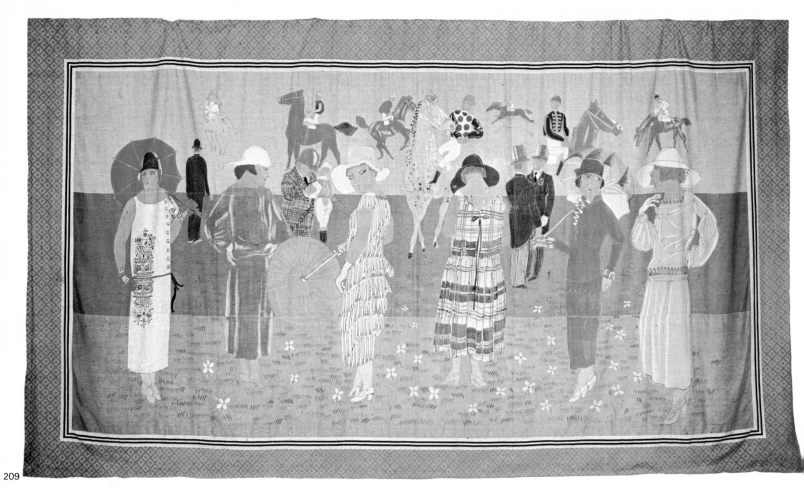

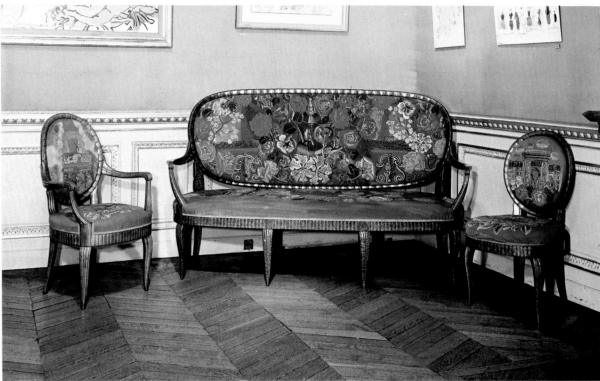

209 RAOUL DUFY Wall-hanging entitled *Les Mannequins de Poiret aux courses* designed for the barge *Orgues*, created by Paul Poiret for the 1925 Exhibition. (Private Collection)

210 RAOUL DUFY Tapestry upholstery made in the Beauvais workshop entitled *Vues de Paris* for the sofa and chairs by André Groult. (Mobilier National, Paris)

211 *(above)* RENE BUTHAUD Glazed stoneware vase, 1925; *(below left to right)* EMILE DECOEUR Turned and glazed stoneware bottle, c.1925; EMILE LENOBLE Turned stoneware vase on which the design is overlaid with slip, c.1925 and tobacco pot in turned stoneware overlaid with slip and made for Félix Boutreux. The Brazilian rosewood and ivory lid is by Ruhlmann, c.1926-1927. (Musée des Arts Décoratifs, Paris)

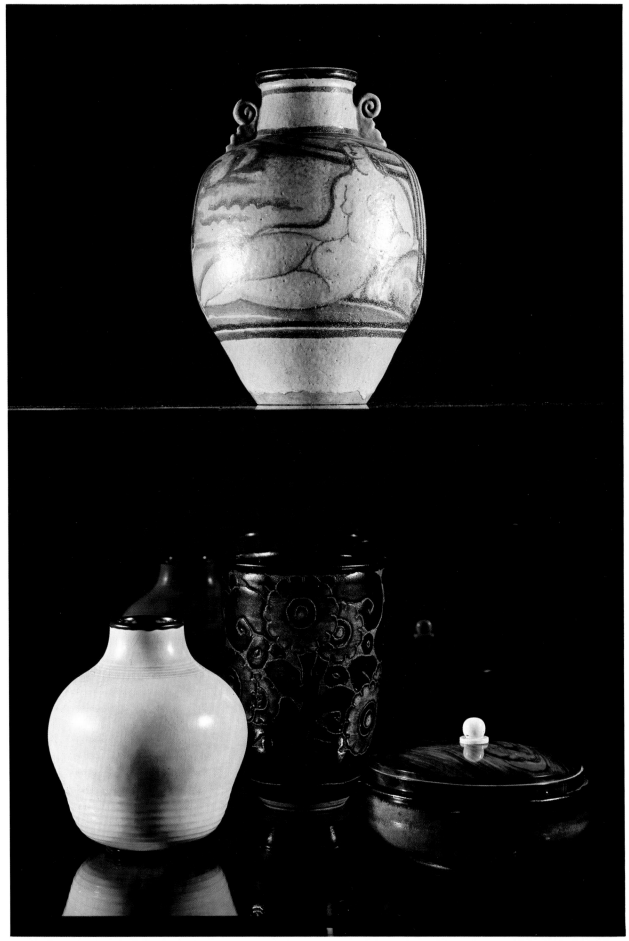

211

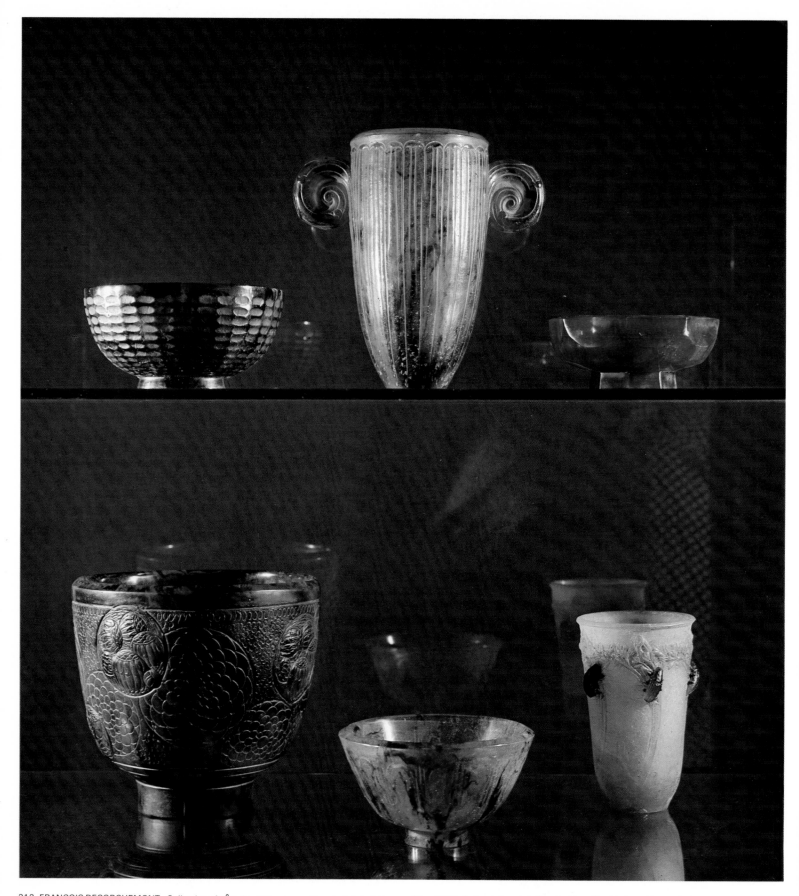

212 FRANCOIS DECORCHEMONT Collection of pâte-de-verre vases and bowls. *(above left to right)* Olive bowl in nickel, green, pink and cauldron brown, 1928; large vase with leaf-shaped handles in green and white with streaks of brown, 1925 and faceted bowl in cobalt blue, 1925. *(below left to right)* Bowl with stylised fruit and flower design in violet and brown, 1922; bowl 'frise ondulée' in uranium and brown glass, 1926-1927 and vase with five emerald insects in relief on a yellow ground, 1912. (Musée des Arts Décoratifs, Paris)

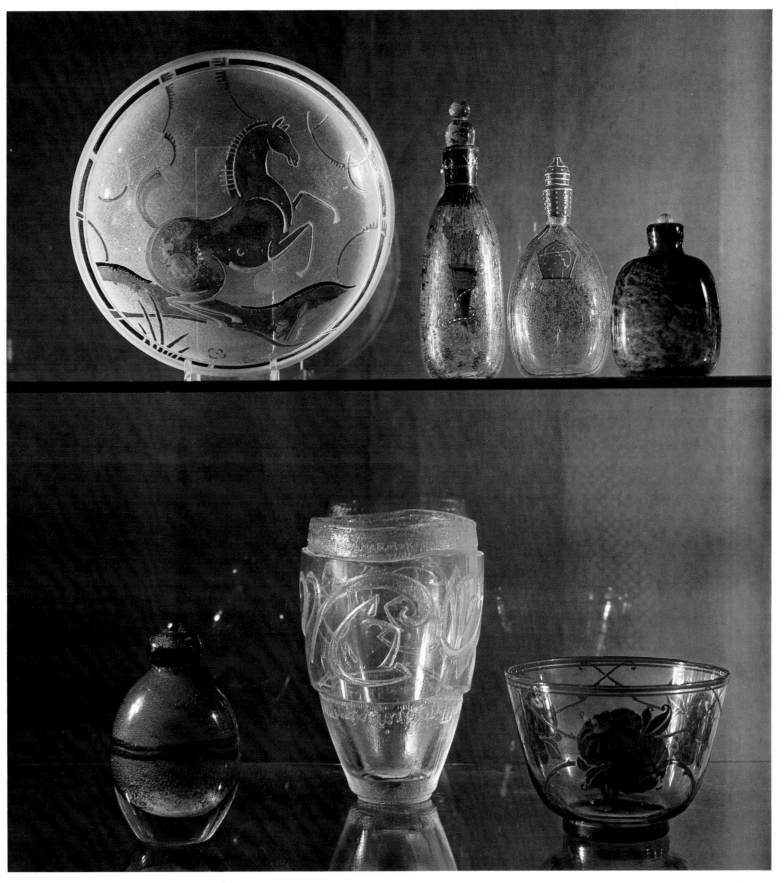

213 MAURICE MARINOT *(above left to right)* Bowl in pink glass with highly polished metallic surface, 1922; two flacons with enamelled designs in clear glass with layers of trapped bubbles, c.1922 and flacon with layers of crackled glass, c.1927-1930. *(below left to right)* Furnace flacon 'modelé à chaud' with layers of trapped crackles and bubbles and bands of blue enamel, c.1928-1930; colourless vase with etched designs, 1920. *(far right)* MARCEL GOUPY Enamelled glass bowl, 1920. (Musée des Arts Décoratifs, Paris)

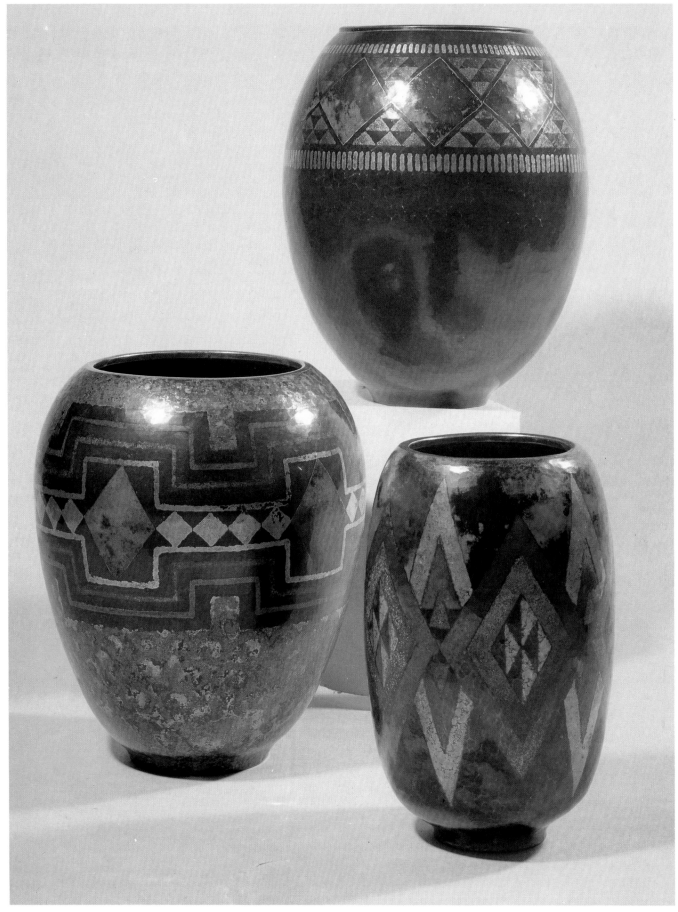

214 CLAUDIUS LINOSSIER Three vases in nickel silver and silver dated 1926, 1927 and 1928. (Musée des Arts Décoratifs, Paris)

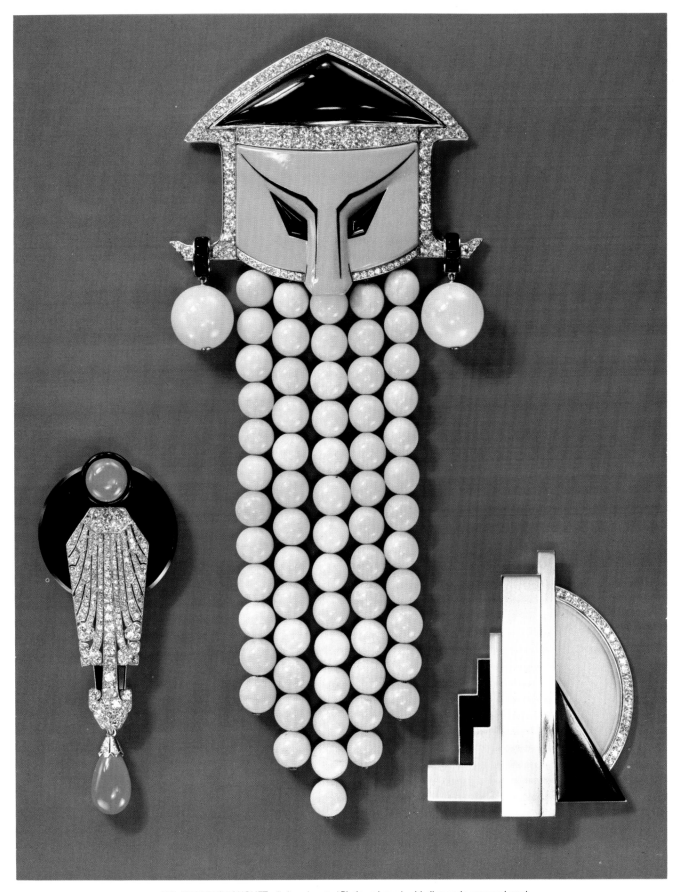

215 GEORGES FOUQUET *(left and centre)* Platinum brooch with diamonds, onyx and coral
and dress brooch of white gold with diamonds, jade, onyx and enamel. *(right)* JEAN FOUQUET
Yellow and white gold brooch with rock crystal, onyx and lacquer. (Private Collection)

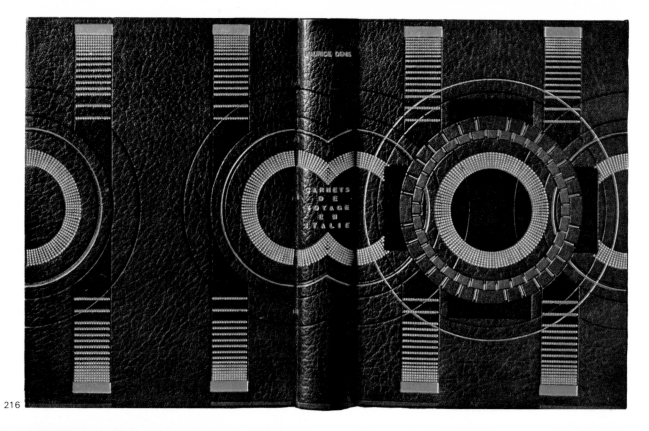

216

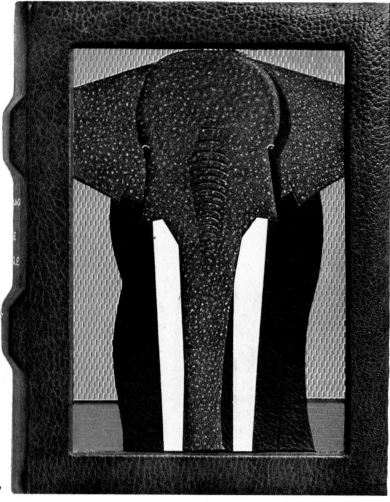

217

218

216 PIERRE LEGRAIN Binding for *Carnets de voyages en Italie* by Maurice Denis.

217 LOUIS CREUZEVAULT Binding for *Le Livre de la jungle* by Rudyard Kipling.

218 FRANCOIS-LOUIS SCHMIED Morocco binding with polychrome leather inlays and gold and silver appliqué designs for *Le Paradis Musulman* by Dr. Mardrus, 1930. (Collection Félix Marcilhac, Paris)

WALLPAPER

The evolution of wallpaper is linked with that of printed cloths for the techniques and artists involved are practically the same and identical or mixed designs are printed on both cloth and paper.

Without abandoning industrial production, whose leading exponent was Isidore Leroy, printed paper became primarily the concern of screen printers. Under the hand of Paul Dumas, some remarkable flower and plant designs were produced by the Martine workshop such as *Eucalyptus, Roses Roses* and *Orties* in black, white and silver, with extraordinary delicacy. André Groult printed on paper the same designs that he was producing on cloth which made it possible to co-ordinate furniture, cloth and wallpaper. The decorator, René Gabriel, printed and sold his designs himself in his workshop, Au Sansonnet and later supplied Papiers peints de France with small scale geometrical, floral and anecdotic motifs. The best architects and decorators of the 20s were attracted by this difficult art which requires a precise distribution of tones and a thoroughly ordered composition.

Wallpaper was attacked by Le Corbusier who, in 1925, published a declaration of faith that struck a damaging blow to its future. 'If some Solon imposed the following two laws: Enamel Paint and Whitewash, we would make a declaration of moral principle to "love purity" and "be discriminating!" Such a declaration would lead to pleasure and the pursuit of perfection. Consider the effects of the Enamel Paint Law. Every citizen would be required to replace his stencils, wallhangings, wallpapers and damasks with a layer of pure white enamel paint. Within the house all would be clean; there would be no dirty or dark corners and everything would appear as it was. Then our inner selves would also be cleaned up, for we would be moving in the direction of refusing all that was not legitimate, authorised, willed, desired or planned . . . We would, after the enamel painting of our walls, be our own master. And we would want to be precise, to think clearly.' The moralist triumphed over decorated wallpaper and from the 30s, and for a long time afterwards, a layer of whitewash replaced coloured hangings.

219

220

219-220 *Choses de la mode*, two wallpapers based on designs by students at the atelier Martine, 1912.

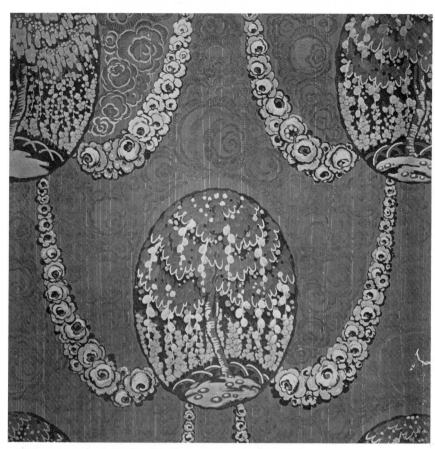

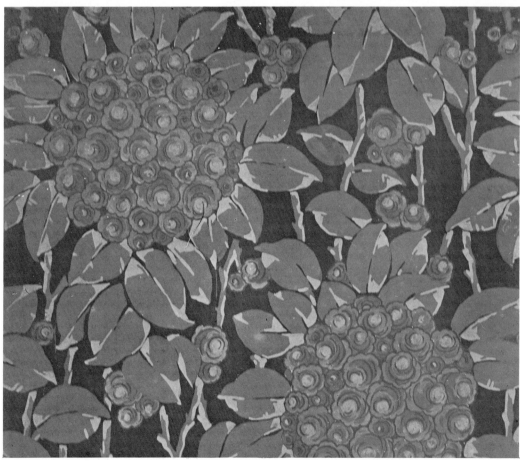

221-223 PAUL FOLLOT Three wallpapers designed for the 1925 Exhibition.

TAPESTRY

A desire for newness animated the directors of tapestry manufacturers. Gobelins wove from designs by Bonfils, Jaulmes, Piot and Roussel whose subjects were drawn from contemporary life. Seat and screen panel tapestries which emerged from the Beauvais workshops from 1914 onwards were signed by Charles Dufresne, Gustave Jaulmes, Paul Vera and Raoul Dufy. The two manufacturers began to collaborate with each other and from this time on contributed to common projects. It is however significant that few of the painters who really marked the period, with the exception of Raoul Dufy, were spotted by established organisations. Tapestries from designs by Leger or Picasso were woven due to private initiative.

The origins of the renewal of tapestry work are in fact to be found in independent workshops such as Gustave Jaulmes' in Neuilly, which was directed by his wife. At Aubusson,

Georges Manzana-Pissarro (1871-1961), the son of the painter, set up a workshop with his wife before 1914 in which his own works were woven. Gold, silver and silk were mixed with wool in compositions peopled with animals, birds and exotic women. After the war, the director of the Ecole d'Art Décoratif at Aubusson commissioned designs from artists of, regrettably, secondary interest, such as Paul Véra. 'It is to be feared,' wrote the historian, Luc Benoist in 1926, 'that the apparent rebirth of weaving these days is nothing more than an artifical survival.' In the 30s Marie Cuttoli was able to give the lie to this prediction, by having the work of several painters such as Picasso, Dufy, Braque, Matisse, Mirò, Derain and Lurçat woven at Aubusson. But the results were merely 'paintings in wool'; only Lurcat was sufficiently interested in the problem to produce genuine tapestry designs.

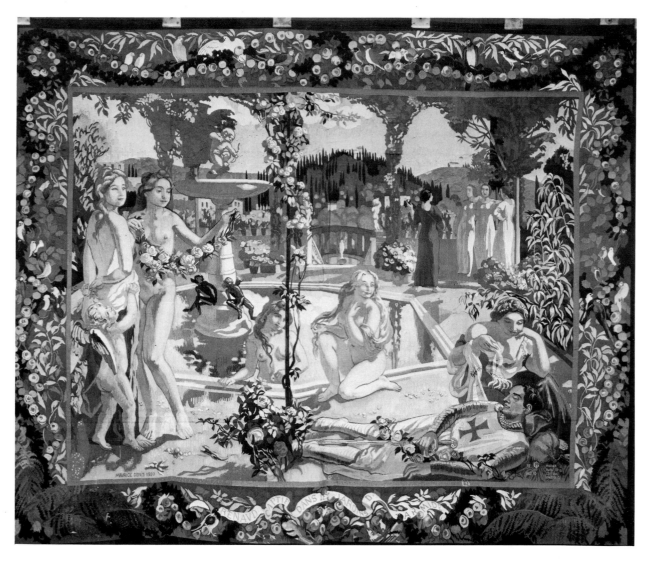

224 MAURICE DENIS *Renaud dans les jardins d'Armide.* (Mobilier National, Paris)

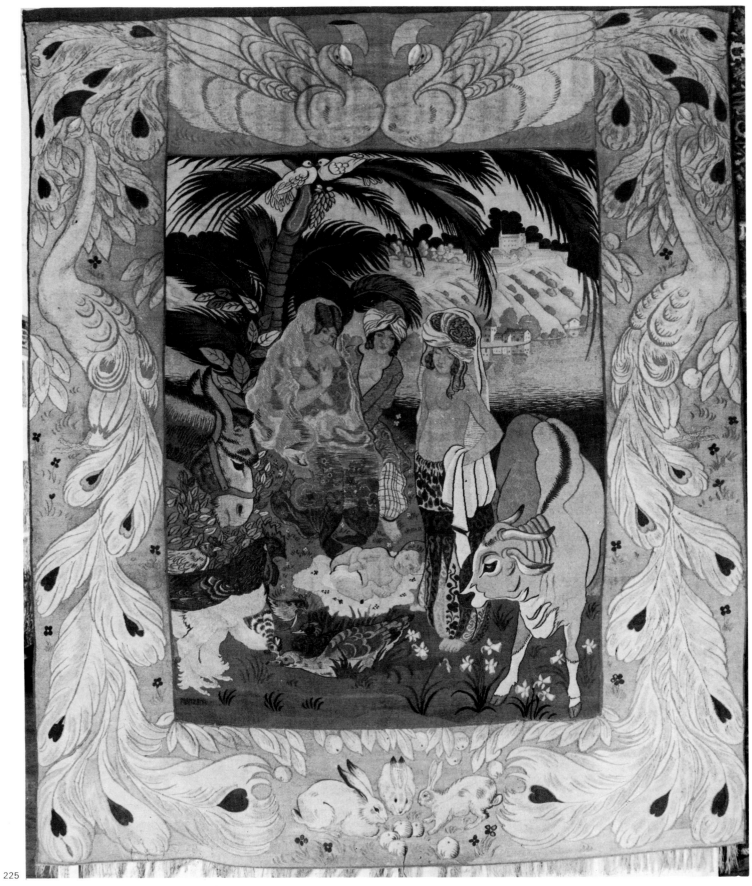

225

225 GEORGES MANZANA PISSARRO *La Nativité*, a wool and silk tapestry made between 1910 and 1912. (Musée des Arts Décoratifs, Paris)

226 GUNTA STOLZL A tapestry by Stölzl who taught at the Bauhaus, 1927-1928. (Bauhaus-Archiv, Berlin)

227 Pastoral scene based on a sketch by Jean Dunand, woven in 1932.

228 PAUL FOLLOT Chair upholstered with a tapestry after Weber, 1920.

229 Wooden chair upholstered by Roustan, 1932-1934. (Mobilier National, Paris)

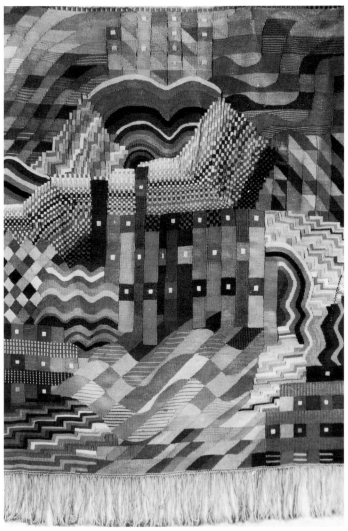

226

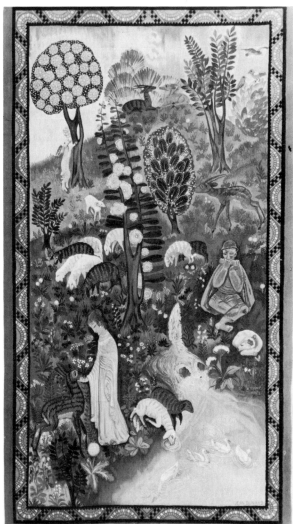

227

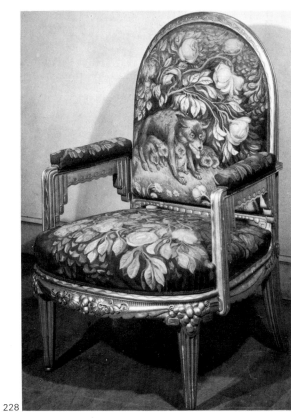

228

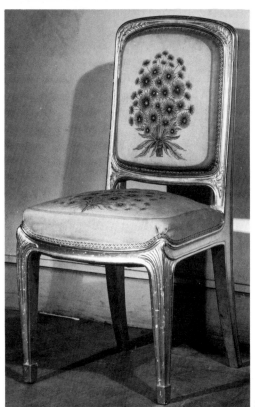

229

APPLIED ARTS

METALWORK, DINANDERIE AND ENAMEL

Metal played a privileged role in the decorative art of the 20s. It was used, as we have seen, at the level of furniture of all sorts but above all for tables, consoles, screens and mirror frames. With the 'reactionary' architects and Le Corbusier, tubular steel began to replace wood in the construction of chairs. Whether it was a question of iron, copper, tin, bronze or precious metals, the work was essentially that of the craftsman.

Rehabilitated by Armand Rateau, who used it for all purposes, bronze was principally the preserve of locksmiths. These were represented in France by the Maison Fontaine who from thoroughly praiseworthy motives employed contemporary decorators such as Süe et Mare, Montagnac, Prou and occasionally certain sculptors. Two door-knockers in the 1925 Exhibition were by Antoine Bourdelle and Aristide Maillol.

In 1905, a young Swiss sculptor, John Dunand, stood out at the Salon organised by the Société Nationale des Beaux-Arts, for his showcase of vases and metal objects 'hand-forged from single pieces of metal'. The man who was to be the finest exponent of Art Deco dinanderie, under the name of Jean Dunand, was at that time influenced by the repertoire of Art Nouveau in its decline, and hence his vases conjure up fruit and vegetables with full blown shapes related to the stoneware of Dalpayrat, Carriès and Bigot. But his taste inclined him more towards simple, plain forms. Dunand created his repertoire from traditional models — long or short necked bottles, round and octagonal plates, flower-pot holders, vases with wide bodies and narrow necks, broad shouldered vases ending in openings without lips and that extremely elegant type of vase whose thin stemmed profile narrows slightly over two-thirds of its curve, to bloom out at the top in flattened lips. Dunand formed his shapes by the use of 'rétreinte', that is to say by using the hammer to reduce the spread of the metal — whether steel, copper, pewter or silver. It is the longest and hardest of techniques, but one that also allows the artist to invent the shape he desires in the very process of forming it. Whatever style or technique Dunand used, the decoration of his vases always had that special quality of adhering firmly to the rest of the piece. To the reliefs associated with naturalistic work, he soon added patinas or overlays in more delicate metals such as gold, silver or nickel. At the same time as he discovered the temptations of colour, Dunand passed from naturalism to abstraction and geometry. In 1913, Dunand's art had already reached a peak of excellence, both aesthetically and technically. At that point he enriched his range of work by partially covering his vases and objects with lacquer in the Japanese style.

Dunand's discovery of the craft of lacquer work, at which he was to become as expert as he was at repoussé work, transformed his activities by multiplying them. While working on his panels and screens, Dunand remained a metalworker. He purified the shapes of his vases which became less organic and more the perfect sphere on which colour could be imposed. He acquired a greater freedom in this field and hence the motifs of the 20s which were on a small scale and laid out in vertical or oblique parallel strips, gave way to the chaotic interlaced and colliding lines of his 30s vases. Dunand did not altogether abandon overlaying, but concentrated his attention on lacquer decoration, covering the whole object with it and then adding a contrasting design in black, red or gold, or an overlay in delicate eggshell. Dunand found his style and produced entirely original work through such disparate influences as French Art Nouveau, Negro art and finally Russian Constructivist painting. The importance of his contribution is obvious as soon as one compares one of Dunand's vases with one of Maurice Daurat's pewter pots or even with a vase by Claudius Linossier (1893-1953). Linossier who after a short time in Dunand's workshop went to live permanently in Lyon, his native town, produced works of quality which are nonetheless minor, perpetually repeating the same techniques and the same decorations.

Jean Goulden (1878-1947) learned champlevé enamelling techniques from Dunand. First in Paris, then in Rheims where he lived from 1928 onwards, he produced marvellous work in silver, polished or gilded copper or bronze with champlevé enamel highlights on boxes, caskets of every size and shape, flower stands and candlesticks. His shapes are geometrical and his decoration composed as for painting. Certain objects are exceptional, for instance, his caskets made of overlapping and uneven blocks and his astonishing cubist pendulum clock which revitalised this kind of object while avoiding both the anecdotic forms of Chiparus and functionalist dryness. Goulden's precise and restrained art is diametrically opposed to those enamelled vases from Limoges or Christofle which are enjoying such success nowadays. All they have to offer is a fashionable form of art, whose momentary appeal depends on their somewhat simplistic and vulgar play of colours and on the combination in a single object of the whole, if stereotyped, range of Art Deco themes.

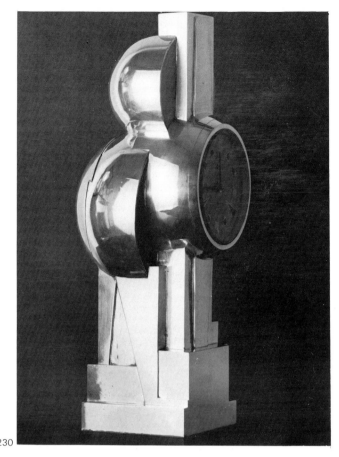

230

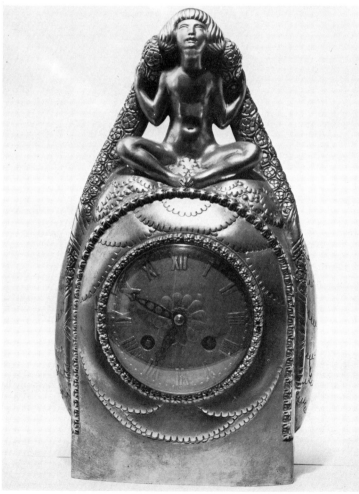

31

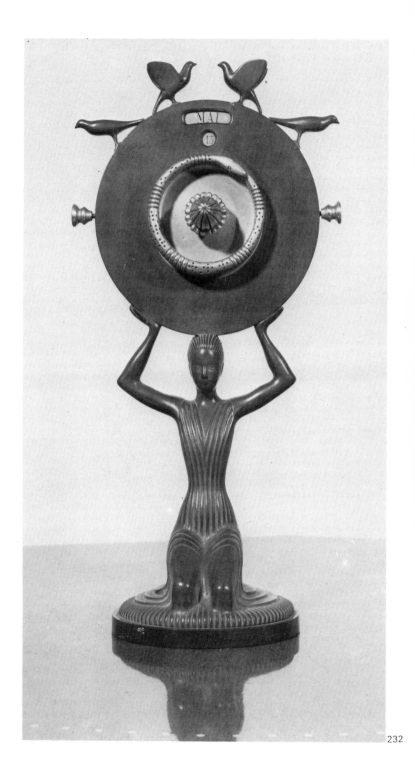

232

230 JEAN GOULDEN Cubist clock in bronze and enamel raised on a base of black marble, dated 1929 and numbered XLVII. (Private Collection, Richmond)

231 GILLOT Patinated bronze clock, c.1925. (Collection Alain Lesieutre, Paris)

232 ARMAND-ALBERT RATEAU Perpetual calendar in green patinated and gilt-bronze, c.1922-1925. (Collection Jean-Pierre Badet)

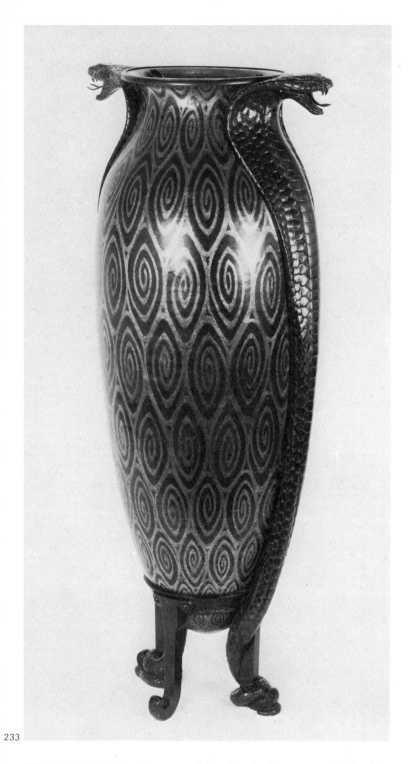

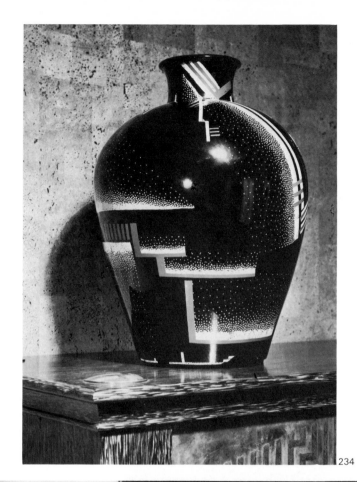

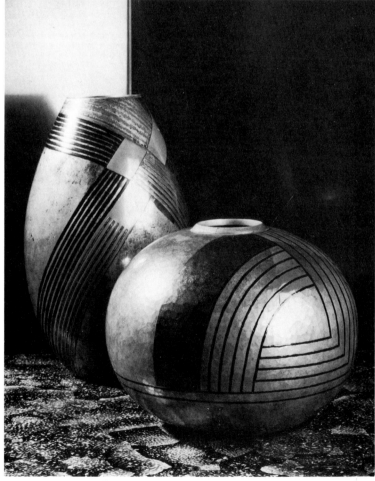

233

234

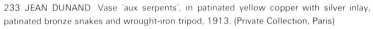

233 JEAN DUNAND Vase 'aux serpents', in patinated yellow copper with silver inlay, patinated bronze snakes and wrought-iron tripod, 1913. (Private Collection, Paris)

234 JEAN DUNAND Black lacquer vase with geometric designs and eggshell inlay, c.1925. (Private Collection)

235 JEAN DUNAND Two nickel-silver vases with red and black lacquer designs and silver inlay, c.1928-1930. (Private Collection)

236 LOUIS SUE Oxydised metal box made for the 1925 Exhibition. (Collection Christofle)

237 LUC LANEL Vase with geometric motifs obtained by oxydising the metal which in this case is brass on copper. (Collection Christofle)

238 CHRISTOFLE Rectangular box in oxydised metal made for the 1925 Exhibition.

36

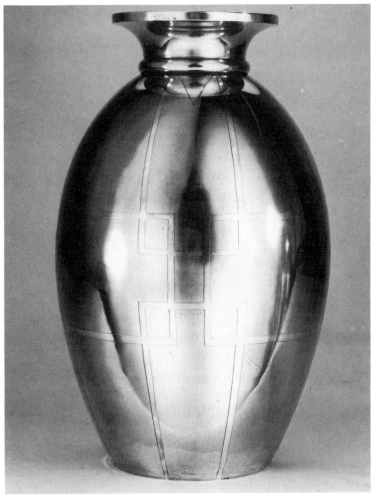

237

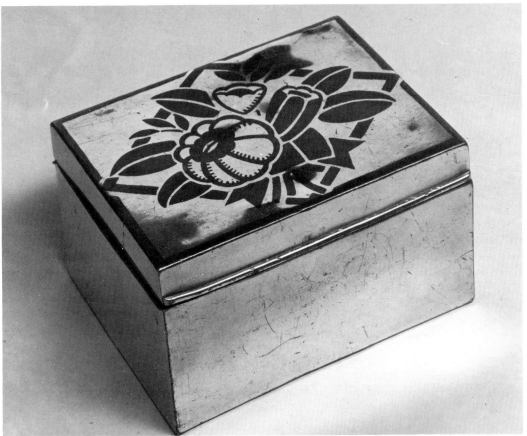

238

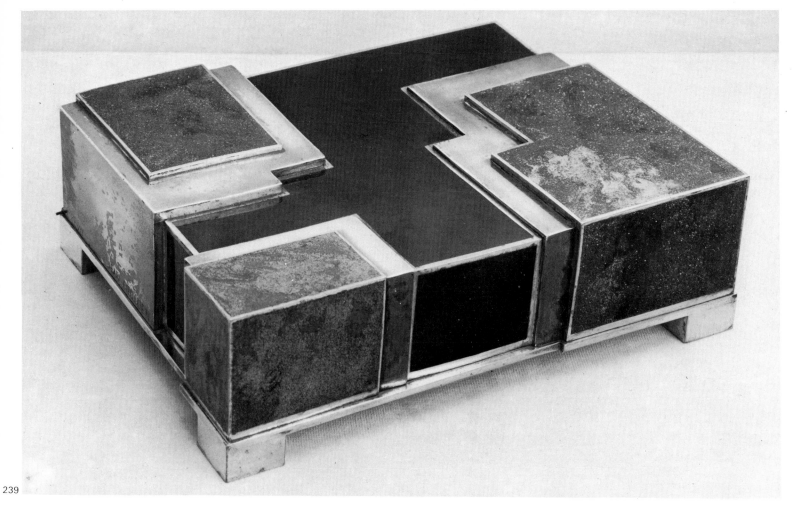

239

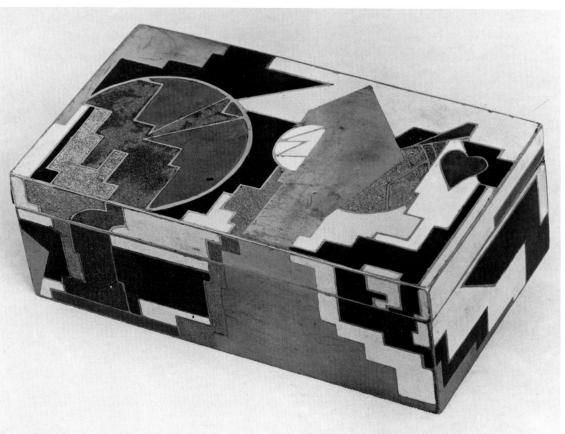

240

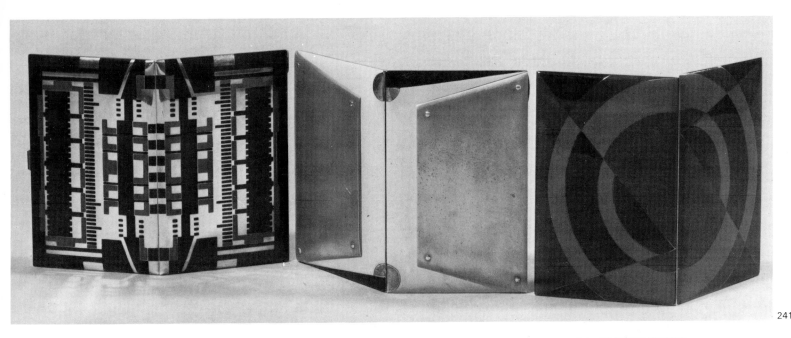

241

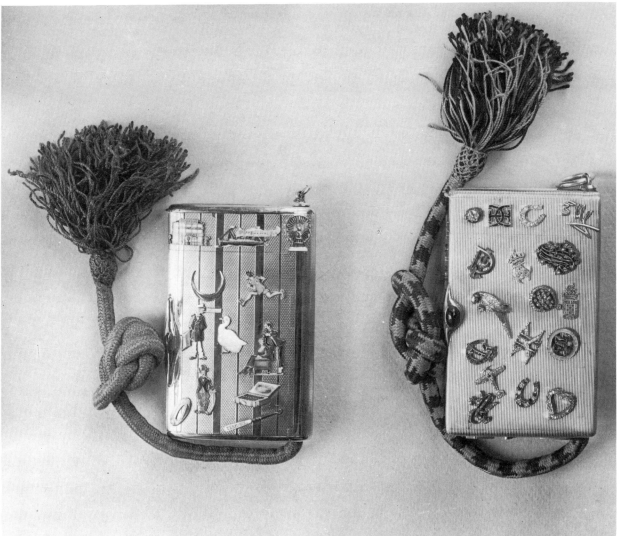

242

239 JEAN GOULDEN Silvered copper and enamel box on four legs, c.1930. (Private Collection)

240 JEAN GOULDEN Copper and enamel casket 'au coeur', 1925. (Private Collection)

241 RAYMOND TEMPLIER Cigarette cases in silver and blue, red and black lacquer, c.1930. (Musée des Arts Décoratifs, Paris)

242 CARTIER Cigarette cases: (left) yellow gold guilloché and enamel, made in Paris between 1921 and 1922; (right) gold, enamel with diamonds and precious stones, c.1918. (Musée des Arts Décoratifs, Paris)

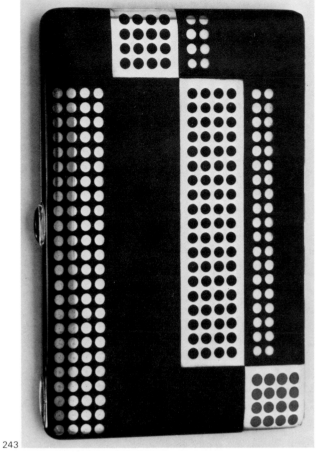

243

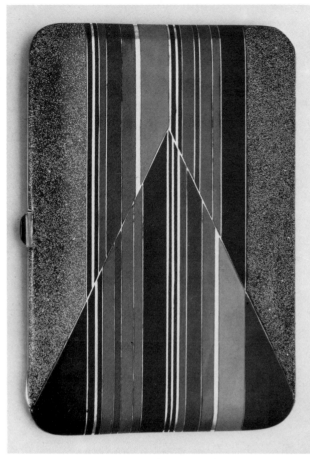

244

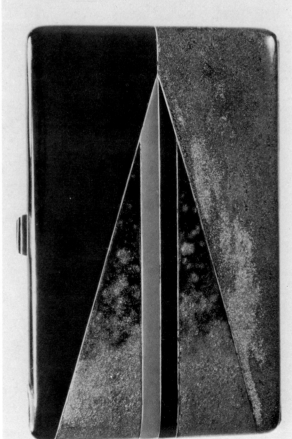

245

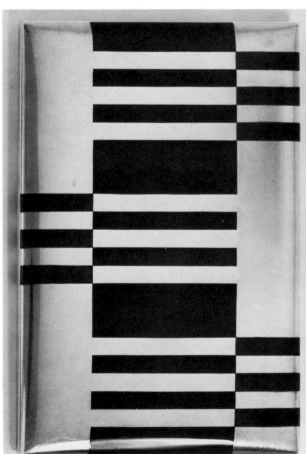

246

243-246 GERARD SANDOZ Cigarette cases. (Private Collection)

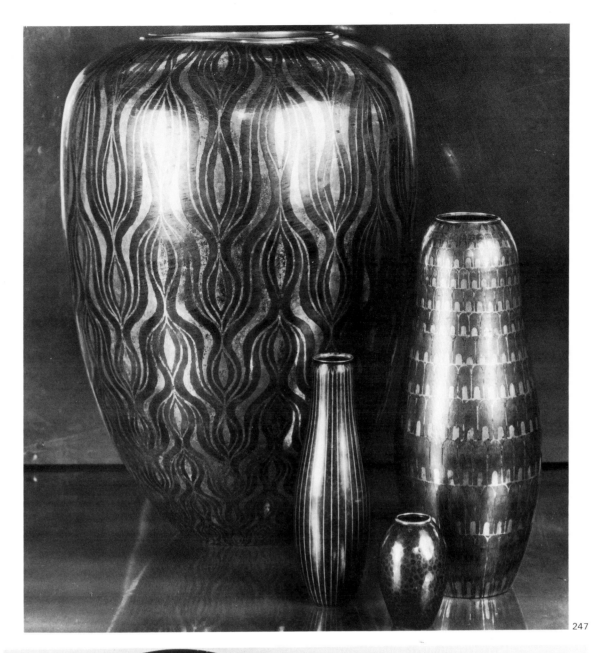

247

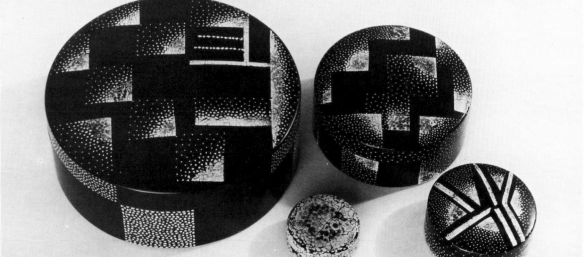

248

247 JEAN DUNAND Nickel silver vases inlaid with silver, 1924. (Galerie du Luxembourg, Paris)

248 JEAN DUNAND Three sweetmeat boxes in black lacquered copper with square motifs highlighted in eggshell, c.1925. Small brass and eggshell box, c.1925. (Private Collection)

SILVERWORK

This was mainly concerned with tableware. Certain artists dissociated themselves from types of work which, through an extreme search for simplicity, tended towards barrenness. These were Gérard Sandoz, Jean Serrière and above all, Jean Puiforcat (1897-1945). From a family firm of goldsmiths, founded by his father, Puiforcat was also a sculptor and therefore able to contribute new forms to silver tableware. He loved strict shapes, smooth surfaces and would add precious materials to the silver, such as ivory, wood, lapis-lazuli, jade or crystal. A founder member of the U.A.M. in 1930, he now appears as the father of modern gold and silver work. The firm of Christofle played an interesting role in its choice of craftsmen and produced work by Süe, Groult, Cazès, Lanel, but also by foreign goldsmiths, architects and decorators such as the Italian, Gio Ponti and the Dane Christian Fjerdingstad.

249 GEORG JENSEN Fruit bowl in hammer-wrought and chased silver, 1914. (Musée des Arts Décoratifs, Paris)

250-251 GIO PONTI Two candlesticks, *Dauphin* and *Flèche* in Christofle metal, c.1927. (Collection Orfèvrerie Christofle)

252 JEAN PUIFORCAT Samovar, 1925.

253 JEAN PUIFORCAT Box. (Private Collection)

254 JEAN PUIFORCAT Vegetable dish, 1925. (Collection Orfèvrerie Puiforcat)

255 JEAN PUIFORCAT Silver soup tureen with jade ring, 1925. (Musée des Arts Décoratifs, Paris)

256 JEAN PUIFORCAT Cutlery, 1925. (Collection Orfèvrerie Puiforcat)

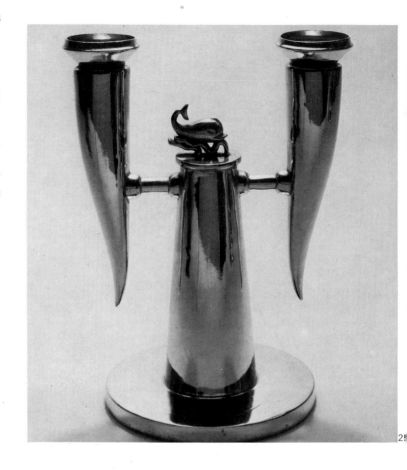

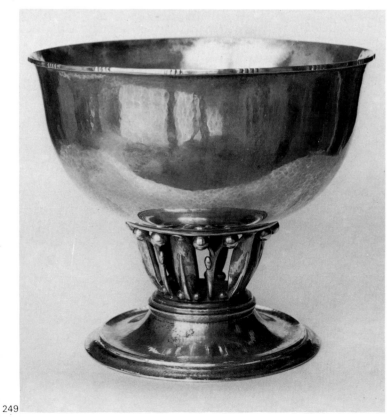

249

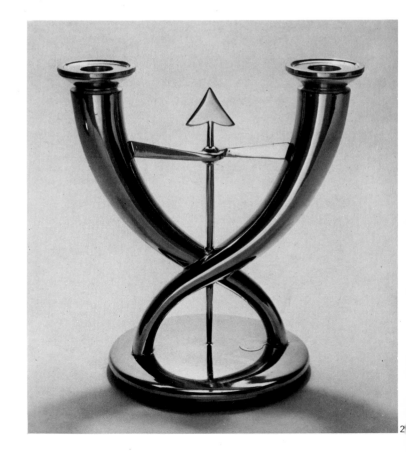

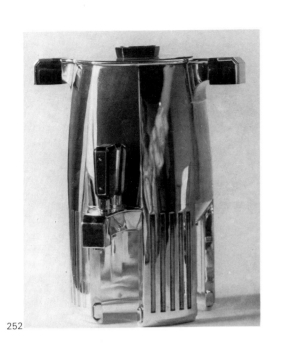

252

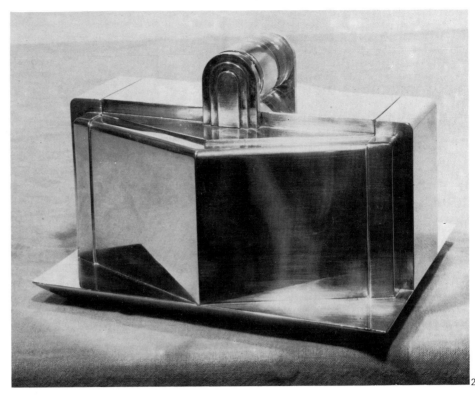

253

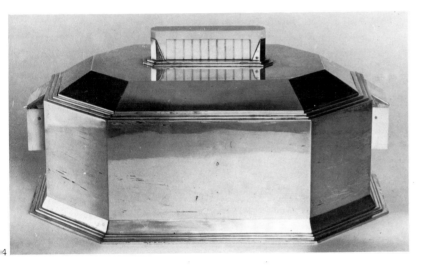

4

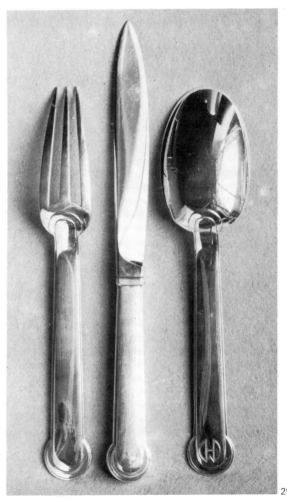

256

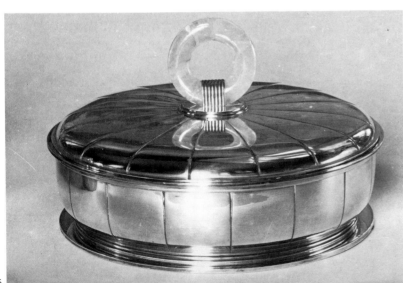

5

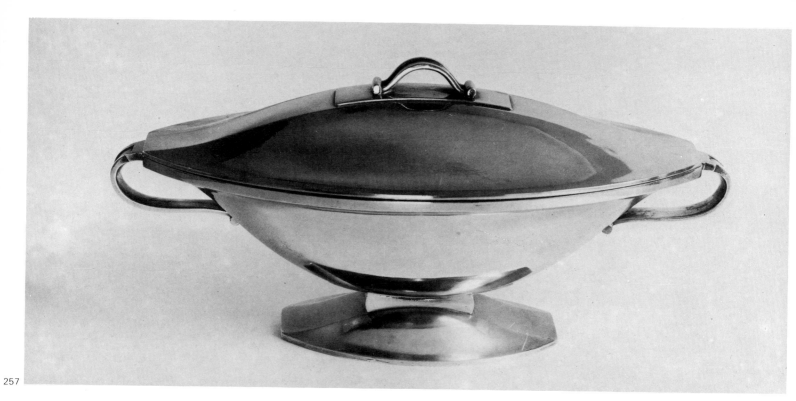

257

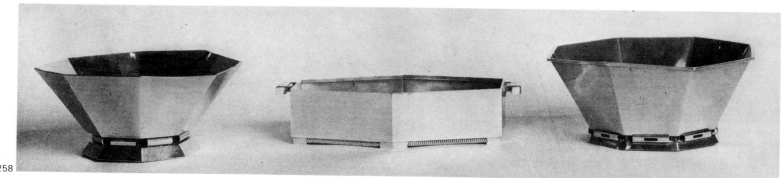

258

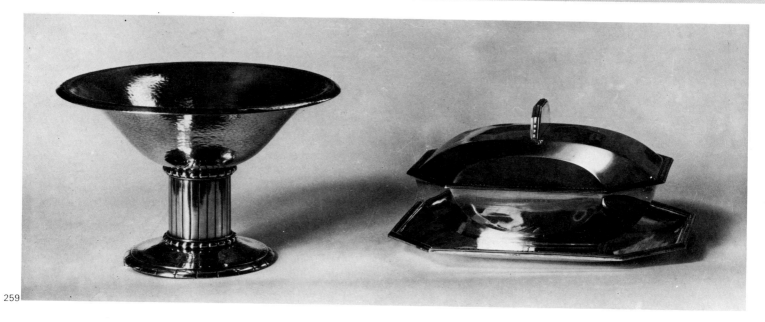

259

257 GEORG JENSEN Solid silver vegetable dish.

258 CHRISTIAN FJERDINGSTAD Dishes in silvered metal. (Collection Christofle)

259 GERARD SANDOZ and LOUIS AUCOC Bowl and vegetable dish. (Musée des Arts Décoratifs, Paris)

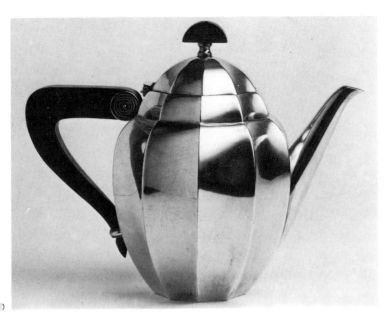

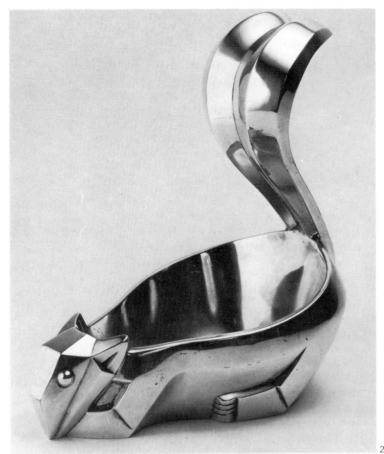

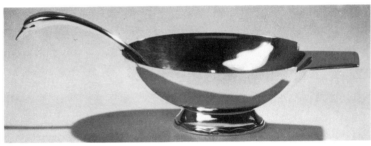

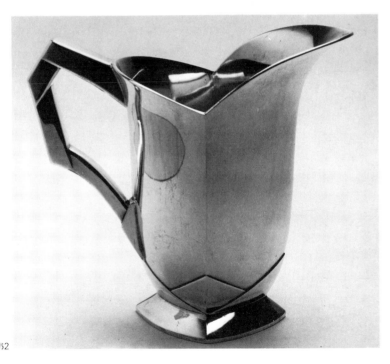

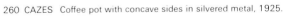

260 CAZES Coffee pot with concave sides in silvered metal, 1925.

261 CHRISTIAN FJERDINGSTAD *Cygne* sauce boat in silvered metal, the spoon of which forms the bird's head and waves are engraved on the base, 1920-1925.

262 LOUIS SUE Water jug in silvered metal, 1910-1920.

263 LOUIS SUE Sweet dish in the shape of a squirrel, entirely worked by hand, 1910-1920.

264 ANDRE GROULT Silver coffee pot, 1920-1930. (Collection Christofle)

DOOR FURNITURE

265

266

267

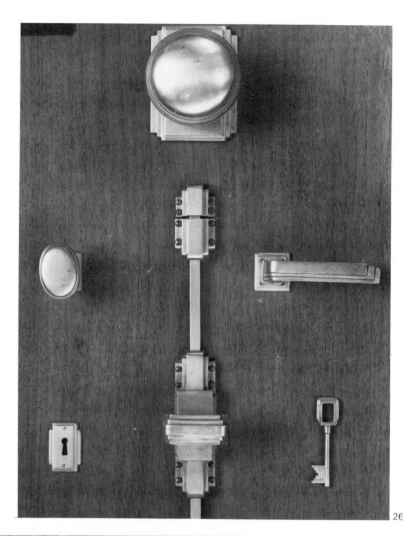

268

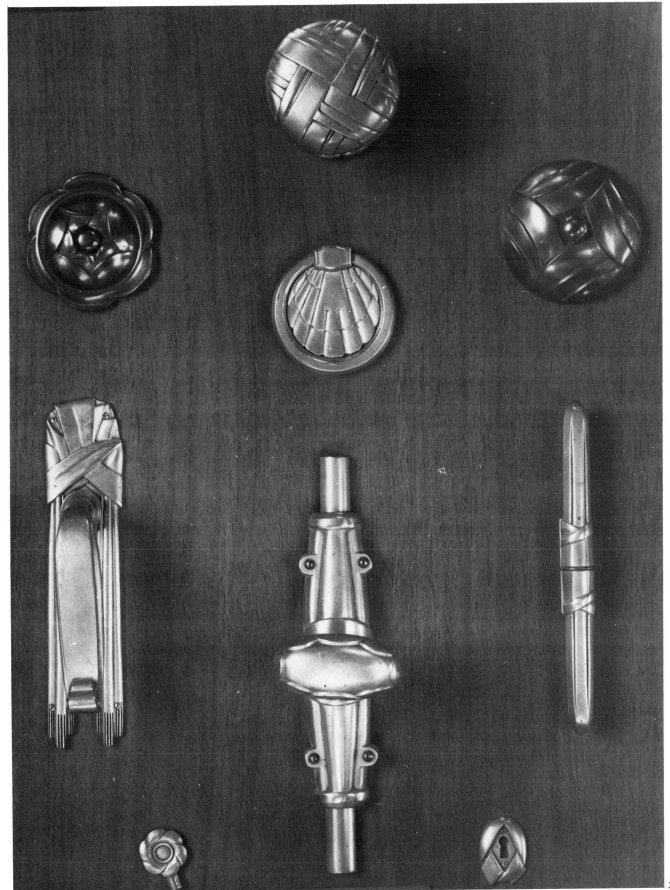

265-268 LE BOURGEOIS Nickel-plated metal locks and handles manufactured by Fontaine, c.1925.

269 MAURICE DUFRENE Nickel-plated metal pieces manufactured by Fontaine, c.1925.

270 SUE ET MARE Locks and handles manufactured by Fontaine in gilt-bronze with grey-blue patina, c.1925. (Musée des Arts Décoratifs, Paris)

CLOCKS

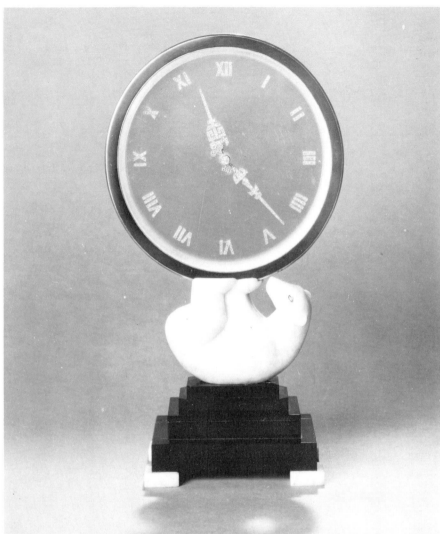

271

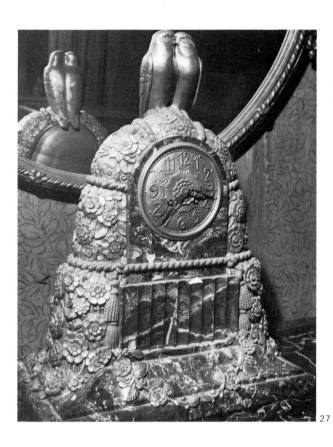

27

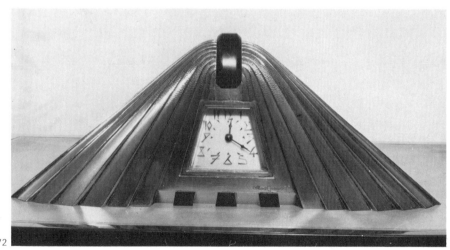

272

27

271 VAN CLEEF Unusual clock with jade bear resting on an onyx base, rock crystal face and diamond incrusted hands and numbers. (Private Collection)

272 ALBERT CHEURET Metal clock. (Private Collection)

273 PAUL FOLLOT Marble and gilt-bronze clock with two parakeets.

274 RENE LALIQUE Clock. (Private Collection)

CERAMICS

The ceramics of the 20s followed on from that golden age of the last years of the nineteenth century. Never had so many craftsmen and artists, painters and sculptors concerned themselves with this art, attempting to pick up again a tradition of craftsmanship which had been lost for several centuries. Up to halfway through the nineteenth century ceramic work was carried out in workshops and factories, where the work was broken down into isolated fragments. Thus the artist would decorate a shape that had been modelled or turned in a nearby workshop. Despite some undeniable successes, this method led eventually to the kind of disastrous production which we know so well today. The raw material, clay, practically no longer existed; it was merely an arbitrary medium, veiled by a coating which in turn formed the background for the painted decoration. The rebirth of ceramic work took the form of a return to the sources of the craft, to a knowledge of the different clays, pottery, earthenware, stoneware, porcelain and glazes and to the furnace that binds them together. The potters of the first years of the century discovered, through the Japanese stoneware on show at international exhibitions, that original beauty was to be found in objects modelled free hand or on the potter's wheel whose shape was highlighted by glazes which stressed rather than masked its simplified lines. Once the situation had been clarified, the industry could begin to concern itself with ceramics based on new ideas. Chaplet, Delaherche, Carriès, Bigot and Dalpayrat rediscovered a tradition of stoneware and porcelain based on the Japanese example, on national sources and on Art Nouveau themes.

Auguste Delaherche (1857-1940) continued his work throughout and beyond the war and was able in 1925, to contribute a vast store of experiences as a craftsman in stoneware and porcelain. From 1904 onwards, he became more interested in shapes and the quality of glazes than in their brilliance and his work developed in the direction of increasingly formal simplicity, in tune with the atmosphere of the times. Delaherche introduced ceramic work into architecture by modelling panels and borders, as well as fireplaces that were complete sculptures.

Two men dominated the 1910-1930 period, Decoeur and Lenoble. A decorator and earthenware craftsman, Emile Decoeur (1876-1953) was drawn to stoneware whose possibilities he studied in depth. He carried out as many experiments as possible — initially with flambé porcelain. His development with both materials went hand-in-hand, as Decoeur applied to his generally heavy porcelain, the same decorations and enamel work he was using for stoneware. For him decoration had no inherent value. It existed only as a function of the shape he turned; spherical vases with short necks, bowl vases, dishes or plates. In 1925, Decoeur began to produce his purest masterpieces — vases, dishes and bowls enveloped with magnificent heavy pale glazes in yellows, blues, greens, whites and pinks which made all decoration redundant.

Decorative work reasserted itself with Emile Lenoble (1876-1940). It was geometric or floral, perfectly adapted to the shape and incorporated with the material, engraved in the clay or in the slip, moulded in light relief, or painted under or over the glaze. After a seven year apprenticeship in industry where he learned to work in earthenware, Lenoble turned to stoneware and high temperature firing in 1904. From the beginning, he was clearly distinguished in his fields of study from his master, Henry Rivière, who as a connoisseur of Middle Eastern and Oriental art, had helped him to find his way by revealing Korean pottery and Sung ceramics to him. His pots, cylindrical vases, bottles and bowls were hand-turned and made of a mixture of kaolin and stoneware to give exceptional delicacy and lightness. The artists who, with differing degrees of success, followed the trail blazed by the pioneers of Art Nouveau were numerous. Some stand out from the crowd: Henri Simmen, who would cover pieces made on the turn-table with natural or monochrome glazes including the splendid 'sang-de-boeuf' thereby imitating the Japanese range; Paul Jeanneney, one of Carriès' students, profoundly marked by Far Eastern techniques and shapes; Raoul Lachenal who learned the craft from his father and who launched himself simultaneously into the field of earthenware decorated with geometrical motifs, sometimes cloisonné with acid, and of porcelain work; and finally Séraphin Soudbinine, Rodin's favourite student, who discovered Chinese and Japanese ceramics. He attempted to imitate their perfection in turned or moulded stoneware or porcelain, which he would highlight with brilliant varnishes or thick white and crackled glazes. Special mention must be made of Georges Serré (1889-1956), a less well-known artist in ceramics, whose work is nonetheless profoundly representative of the period. Encouraged by Lenoble and Decoeur, he began to turn heavy stoneware and 'chamotté' clay in 1922, which he would then engrave with geometrical motifs and simple designs sometimes highlighted with oxides or glazes.

Decorated ceramics, hence, received a shot in the arm and earthenware too, neglected in favour of stoneware and porcelain, regained its rightful place for the smooth unbroken glazed surface it gave was an ideal medium for decoration when painted with metallic oxides. When André Methey (1871-1921) abandoned stoneware around 1906, he opened an earthenware workshop and called on the decorative talents of the painters to whom he had been introduced by Ambroise Vollard: Redon, Rouault, Matisse, Bonnard, Vuillard, Friesz, Derain and Vlaminck. Etienne Avenard's work remained, in contrast, more popular and personal. Around 1913, using clay from his garden and commercial oxides and glazes, he turned and pressed all sorts of shapes, but chiefly bowls, which he would then paint with yellow, green, blue and red motifs. Three artists specialised in decorations drawn from life: Mayodon, Buthaud and Besnard. Jean Mayodon hand moulded or brush painted his decorations

— animals or people — on earthenware pastes hardened by traces of baked and powdered potter's clay. René Buthaud's figures were in general traced, in vivid glazes on solid or thick-set shapes, with an antique nobility. Jean Besnard, Albert Besnard's son, preferred light colours and gold or silver highlights.

The use of ceramics in industry drew on the research work and productions of independent artists. It was generally concerned with tableware; shapes evolved only slowly, often merely replacing curves by angles. Théodore Haviland at Limoges, worked with Suzanne Lalique, the glassmaker's daughter, and with Jean Dufy, Raoul's brother. The businessman, Géo Rouard, produced earthenware and porcelain dinner services decorated with flowers, butterflies or animals by Marcel Goupy among others. From 1911 onwards, Jean Luce concerned himself with the double problem of shape and decoration; painted by hand, or from stencils. His motifs were linear and naturalistic, stylised in the Art Deco fashion and highlighted with gold for luxury services. The decoration workshops in the big department stores, particularly Primavéra and Süe et Mare's Compagnie des Arts Français, in turn came to terms with the problems of mass-production, in order to offer their customers table-services or objects to match their decor or furniture. In his rue de Sèze shop in Paris, the decorator Francis Jourdain sold earthenware and varnished clay services, some of whose models he had designed as early as 1912-1914.

The Sèvres factory finally decided to play its role, under the direction of Lechevallier-Chevignard. He set up an earthenware workshop directed by Avenard, then by Gensoli, and prepared for the 1925 Exhibition by calling on various artists of varying interest. A casual glance reveals such names as Rapin, Ruhlmann, Lalique, Dufy, Jaulmes and the Martel brothers. He arranged exchanges with the Danish firm Bing and Gröndahl, opening the Sèvres workshops to Danish artists, including Jean Gauguin.

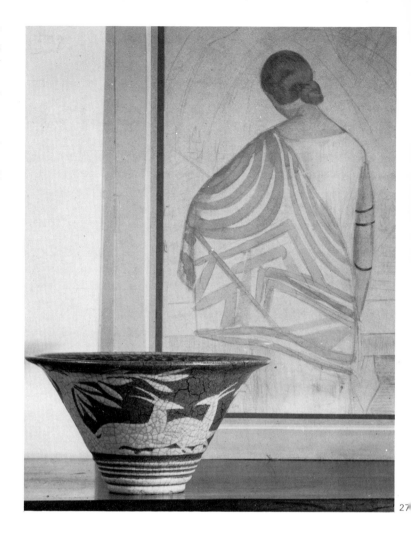

275 JEAN MAYODON Ceramic bowl in front of a drawing by Marianne Clouzot.

276 JEAN BESNARD Three ceramic pieces. (Collection Stéphane Deschamps)

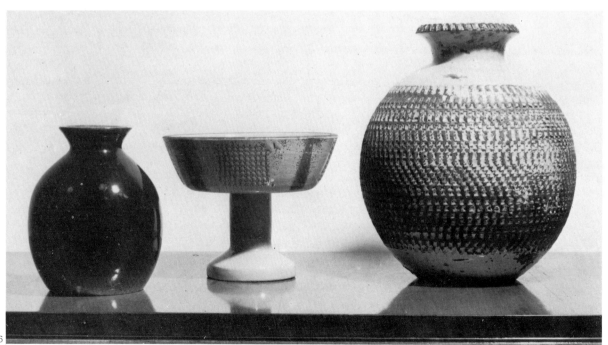

276

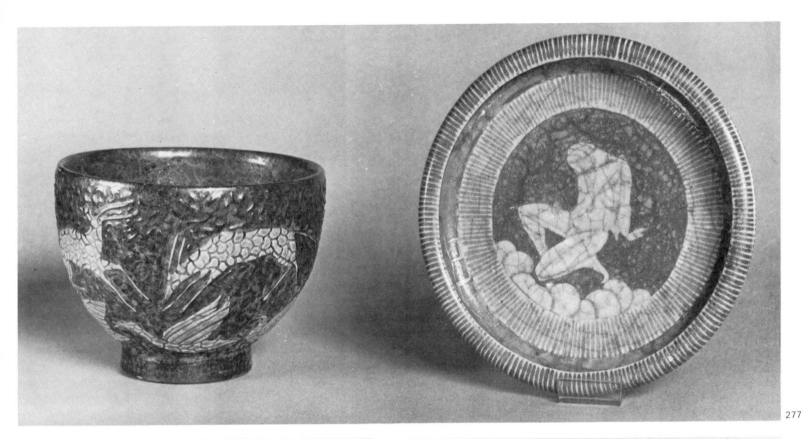

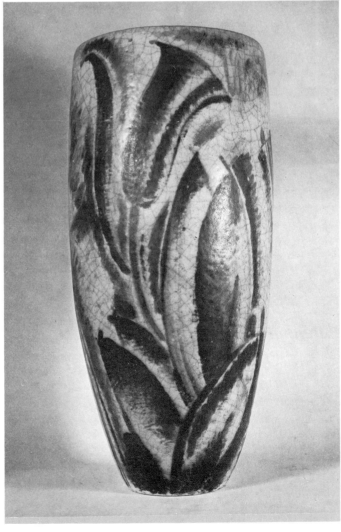

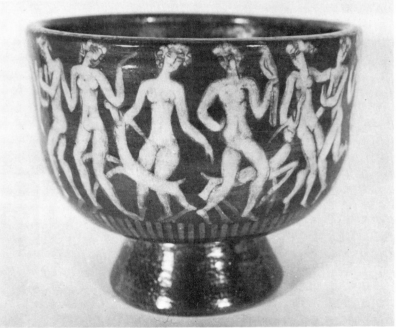

277 JEAN MAYODON Bowl and platter in glazed polychrome stoneware with gold strands, c.1925. (Musée des Arts Décoratifs, Paris)

278 RENE BUTHAUD Faience vase with floral decoration painted onto the crackled glaze, c.1925. (Collection Félix Marcilhac, Paris)

279 EDOUARD CAZAUX Painted ceramic bowl, c.1925. (Collection Félix Marcilhac, Paris)

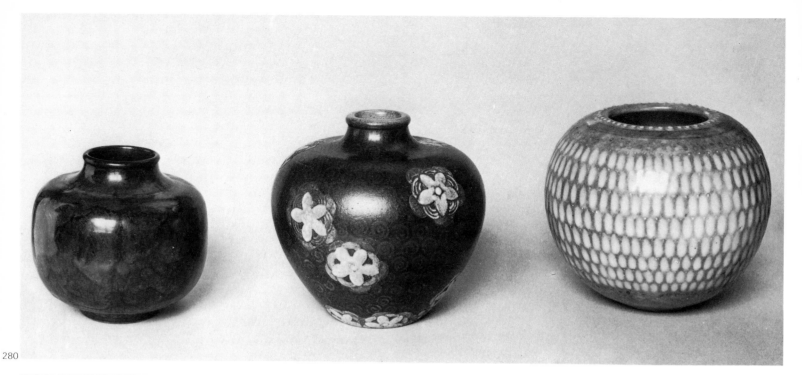

280

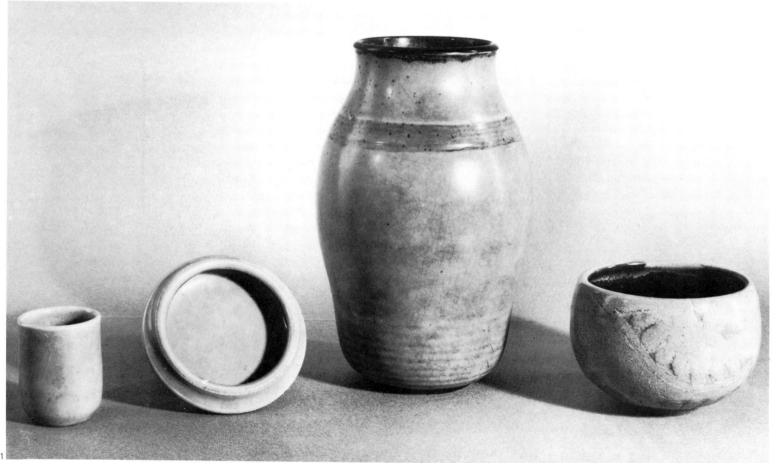

281

280 EMILE DECOEUR *(left to right)* Stoneware vase, turned, glazed and enamelled in brown, c.1930, turned and glazed stoneware vase with grey flowers on a brown ground, 1910 and turned stoneware bowl with design modelled in slip under a whitish glaze, 1920. (Musée des Arts Décoratifs, Paris)

281 EMILE DECOEUR Large vase, bowl and cup in turned stoneware with thick glaze, c.1925-1930. (Private Collection)

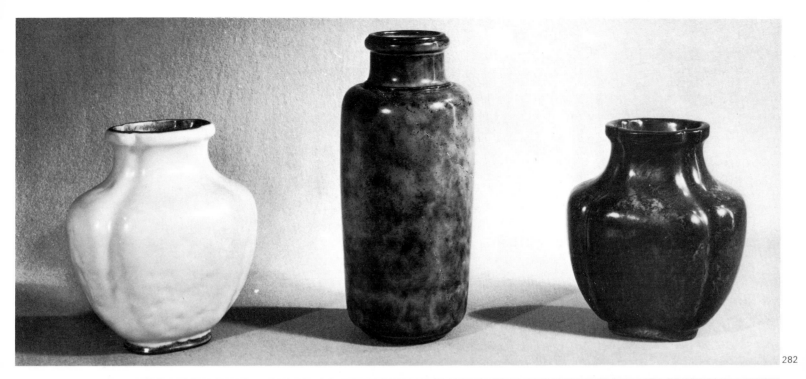

282

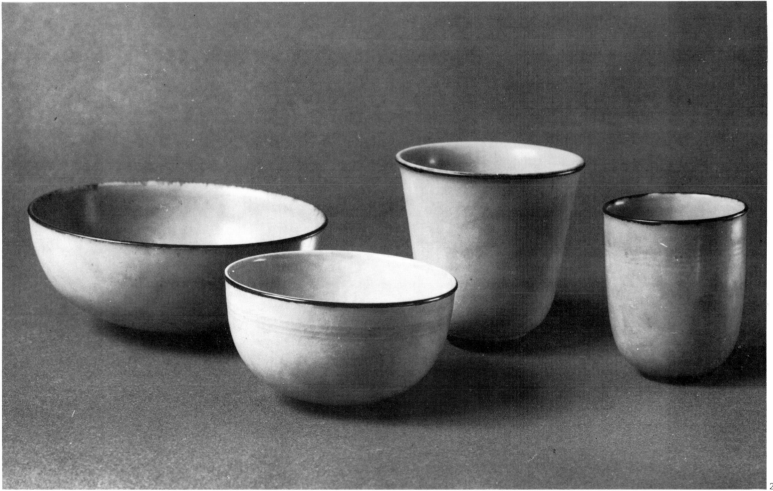

283

282 EMILE DECOEUR Vases in turned stoneware with a milky glaze giving the appearance of marble, c.1930. (Private Collection)

283 EMILE DECOEUR Fine, turned stoneware cups and bowls with a yellow-green milky glaze encircled at the rim in purple-brown, c.1925-1930. (Musée des Arts Décoratifs, Paris)

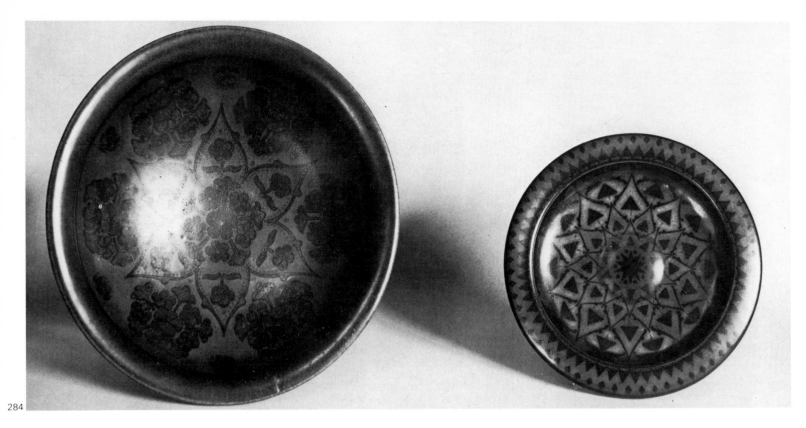

284

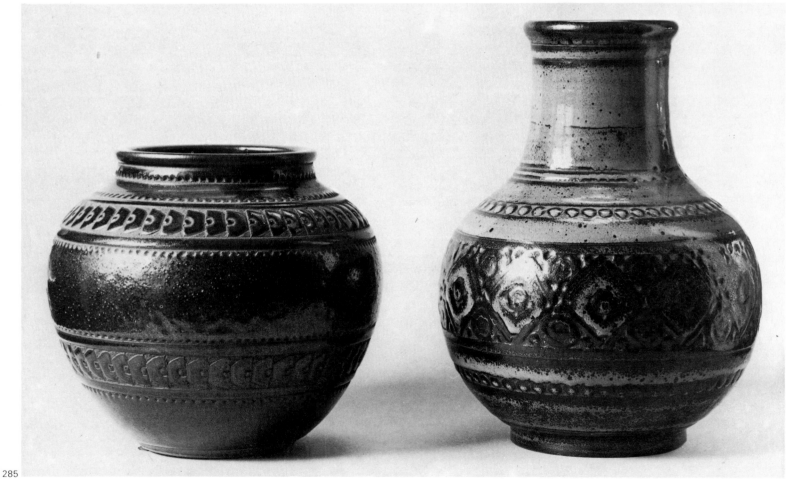

285

284 EMILE LENOBLE Thick porcelain platter with painted designs in black beneath a green glaze and porcelain plate with black designs beneath a yellow-brown glaze, 1910. (Musée des Arts Décoratifs, Paris)

285 EMILE LENOBLE Two beautiful turned stoneware vases with designs scraped through the slip, c.1926-1927. (Musée des Arts Décoratifs, Paris)

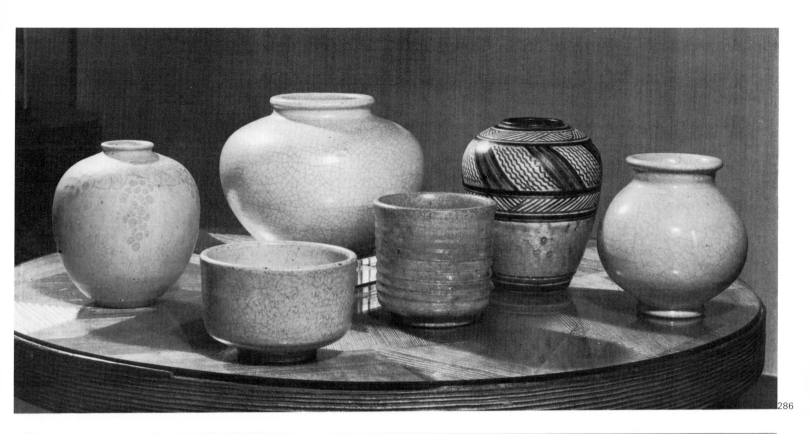

286

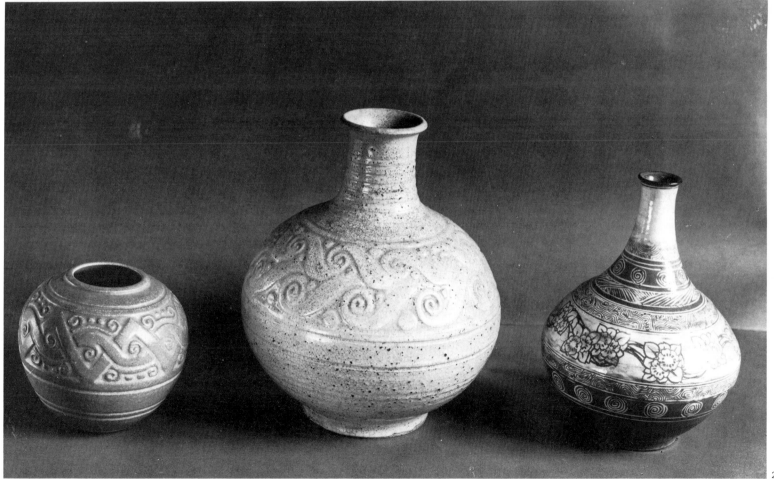

287

286 EMILE LENOBLE Group of white vases. (Private Collection)

287 EMILE LENOBLE *(left to right)* Turned stoneware vase, the design engraved in the slip, c.1912, large turned stoneware vase engraved and glazed in white, c.1912 and stoneware bottle ornamented in slip, c.1907. (Musée des Arts Décoratifs, Paris)

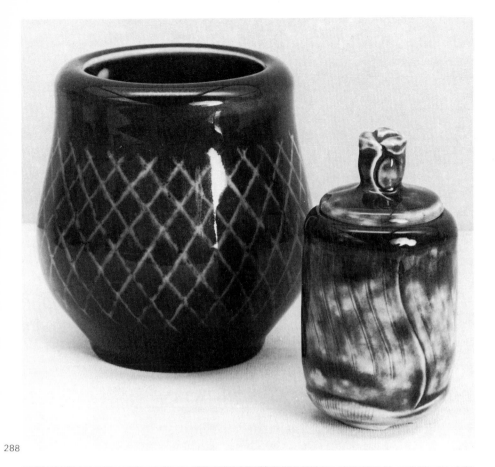

288

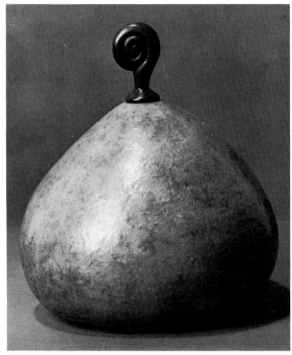

28

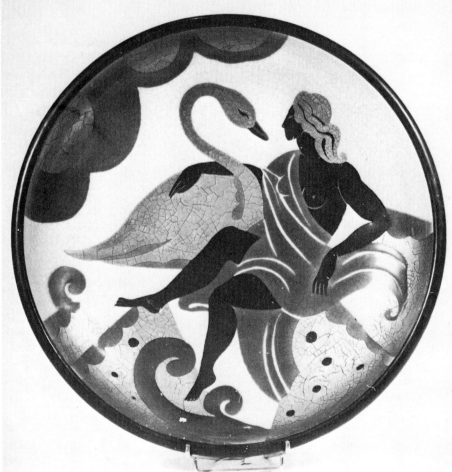

290

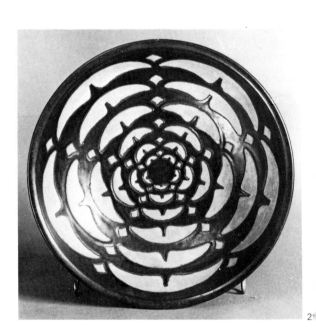

2

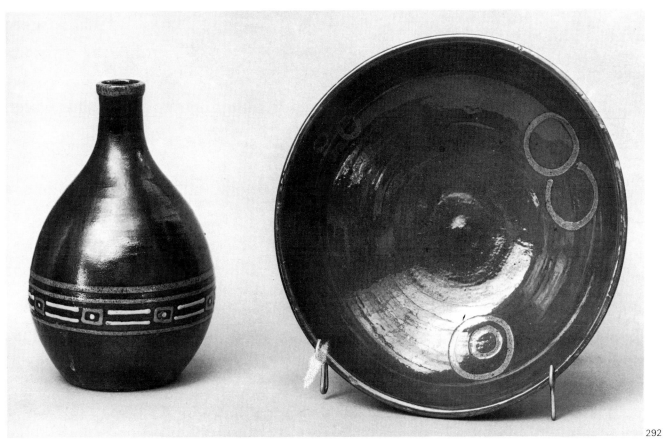

292

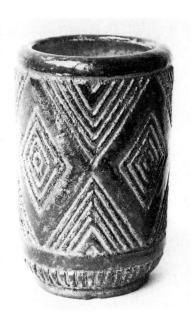

93

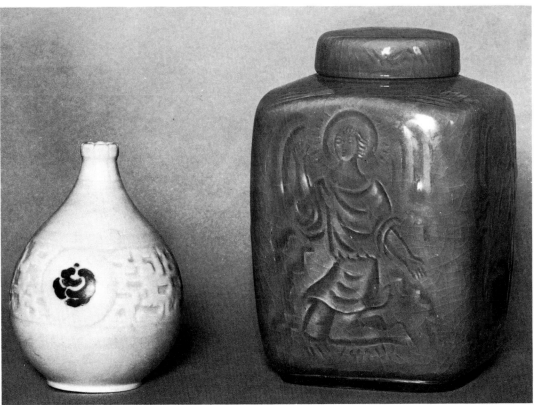

294

288 MAURICE GENSOLI Two vases. (Galerie du Luxembourg, Paris)

289 HENRI SIMMEN Glazed stoneware pear, the stem of which is carved in oak by Mme O. Kin Simmen. (Collection Félix Marcilhac, Paris)

290 CLAUDE LEVY Platter. (Collection Félix Marcilhac, Paris)

291 RAOUL LACHENAL Turned stoneware platter with cloisonné enamel in concentric layers of blue-black and orange-green, 1914. (Musée des Arts Décoratifs, Paris)

292 FRANCIS JOURDAIN Bottle and platter in turned and glazed earthenware, c.1919-1925.

293 GEORGES SERRE Stoneware vase with brown glaze, c.1917-1929.

294 (left) BING and GRONDAHL White porcelain vase with matt finish, c.1925. (Royal Copenhagen Factory); (right) JAIS NIELSEN Celadon china with engraved designs, 1923. (Musée des Arts Décoratifs, Paris)

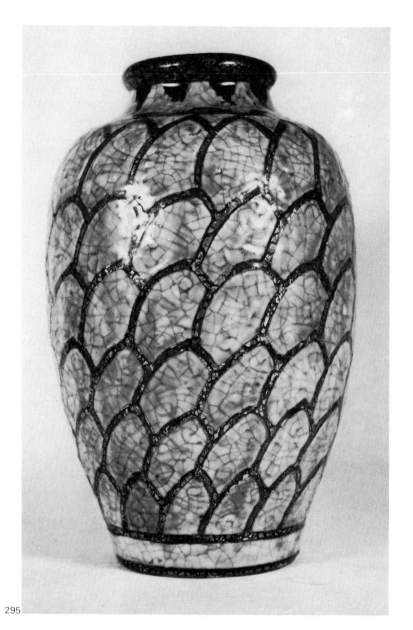

295

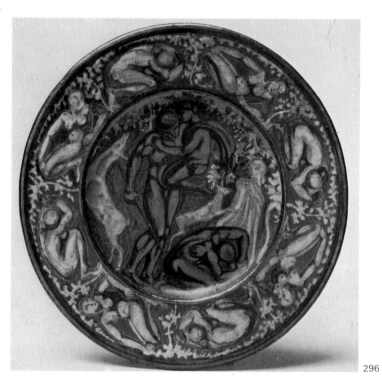

296

295 ANDRÉ METHEY Stoneware vase with crackled glaze, c.1910-1911 (Collection Félix Marcilhac, Paris)

296 ANDRÉ METHEY Ceramic platter. (Collection Maria de Beyrie)

297 Three faience plates, two painted by Vlaminck and the third on the right by André Derain, 1908. (Musée des Arts Décoratifs, Paris)

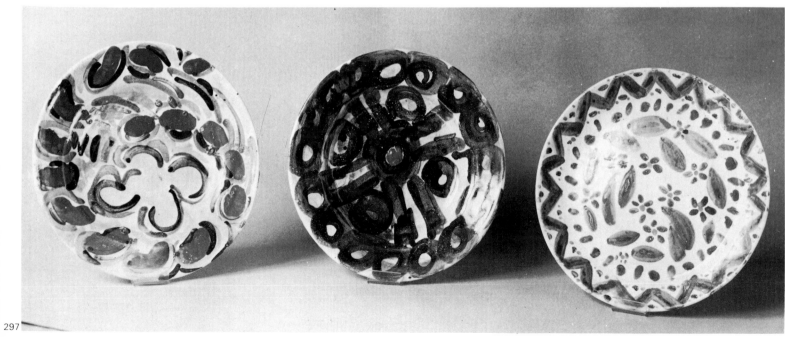

297

298 JEAN SERRIERE Bowl.

299 Vase by Félix Massoul and bas-relief by André Methey in front of the painting by Marianne Clouzot depicting the typical woman of the 20s.

300 Profile of the bowl by Serrière and vases by Grange and Laurent Laurencon. (Collection Stéphane Deschamps)

299

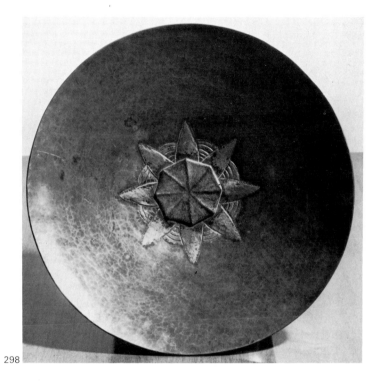

298

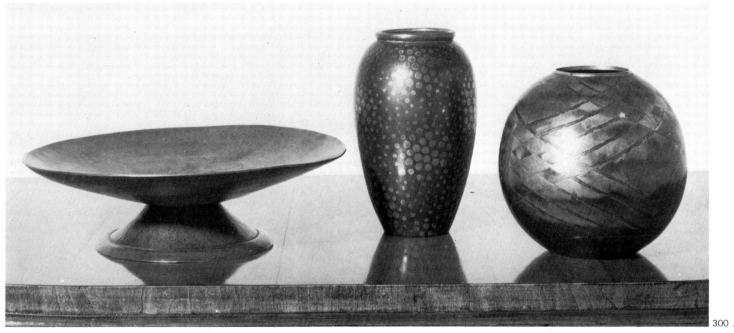

300

143

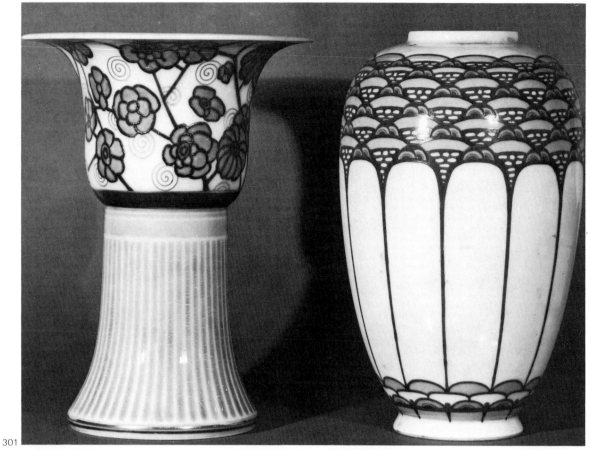

301 SEVRES Porcelain vases, 1924-1925. (Collection Mobilier National)

302 HENRI RAPIN Faience vegetable dish with pattern in relief beneath the glaze, 1925. (Musée des Arts Décoratifs, Paris)

303 THEODORE HAVILAND Limoges porcelain plates ornamented by Marcel Goupy and manufactured by Rouard in Paris

304 THEODORE HAVILAND Limoges porcelain service with designs by Jean Dufy, exhibited at the 1925 Exhibition. (Musée des Arts Décoratifs, Paris)

305 JEAN LUCE White porcelain plates painted *(left)* in silver and gold and *(right)* in gold, blue and green exhibited at the 1925 Exhibition. (Musée des Arts Décoratifs, Paris)

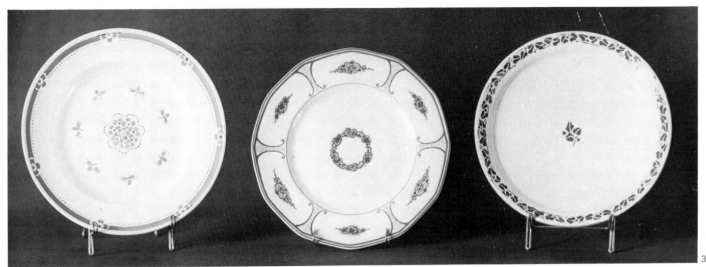

303

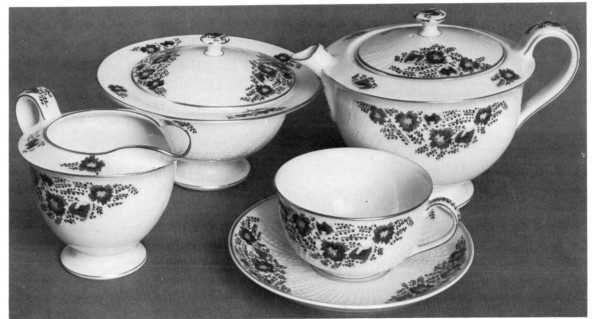

304

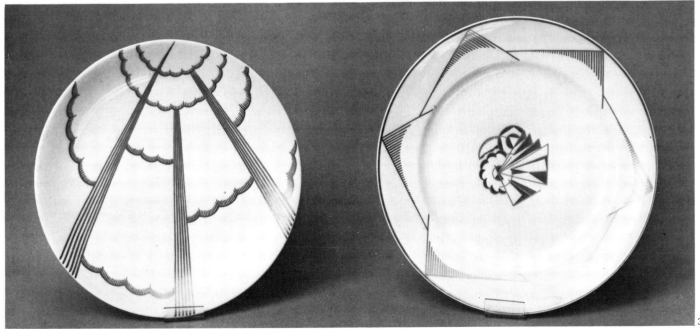

305

GLASS

The glassmaker's art in the 20s owed a great debt to that generation of glassworkers who, from 1870 onwards, working outside industry and leaving to it that technical perfection which had succeeded in eliminating the living nature of the material, made every effort to 'think glass'. In order to attain their goal, these painters, sculptors and decorators had transformed themselves into workers in the material with which they intended to express themselves. Forty years later, the successors of Brocard, Rousseau, Gallé, Dammouse and Cros adopted the same approach when the question was posed of rethinking glasswork in terms of their period.

This was the case of the painter Maurice Marinot (1882-1960), who discovered glasswork in 1911, on a visit to the Viard factory at Bar-sur-Seine. If his first works were painted over with gold or enamel which hid the material, he very soon set himself the task of becoming an expert in the craft. At the Bar glassworks, he had his own bench, his pipe, his instruments and the glassblowers initiated him in the secrets of their trade. Marinot perfected a technique for applying enamel in successive layers, modulating their thickness to integrate them with the medium. He obtained some brilliant successes at the cost of considerable difficulty and danger because they required consecutive firings. Not only was the enamelling strictly co-ordinated with the medium, but so also was the lively, geometrical decoration and the shape, whether gourd, goblet, vase or dish. 'Painting and glasswork,' wrote Marinot in 1914, 'have their source in the joyful desire to create, through shape and colour, works whose birth is in feeling and whose completion is in reasoned order.' In 1914, Marinot's enamels were white or poppy red, while the glass was thick, sometimes opalescent. His translucent enamel work dates from 1919 and opaque enamels later on. The enamel period covered nearly 10 years, from 1913 to 1922 but it became gradually less numerically important as his other techniques developed. The earliest of these was acid engraving. This consisted of light, superficial traces or deep etching obtained by repeated dipping in hydroflouric acid. The general mass of the heavy glass he used would be clear or coloured, while its decoration was necessarily restrained by the nature of the technique itself. Marinot also cut glass with a wheel-cutter on large surfaces or with a flint knife. 1927 saw the beginning of a period which was for him his 'most exciting': heat-moulding — 'the end point of (his) long association with glass. There is for each piece a struggle between one's breath acting on the inside, and the pressures, the inducements of the tools applied to the outside, with these two forces acting alternately . . . The material is fleshy, muscled, and the different layers of glass slide and struggle in it as in the geological epochs.' The bottles, mortars and pestles, dishes, flacons made of this 'fleshy' matter are tessellated with clear or golden bubbles caught between the layers of glass, with acid-induced frosting, with crackling and with streaks of red, green or blue-black oxide.

The material's transparency was the guiding principle of the Daum workshops in 1925. From the time of its re-opening in 1918, the Nancy factory made use of the techniques per-

306 GRANGE Glass vase. (Collection Stéphane Deschamps)

fected around 1900, but in a wholly different spirit, in the 'geometrical' taste of the day: powder insertions, overlays, gold leaf which in the course of moulding the piece would break up into a multiplicity of specks. Louis Majorelle's blown glass in wrought-iron frames drew fairly generally on these methods. The time-honoured technique of layered glass made it possible to produce contrasting decorations, clear tracing on a dark background or vice versa, associated with streaks of gold speckling and animal and floral themes all treated in the Art Deco style. Maurice Marinot's respect for the material, shown in all his experiments from his earliest acid-etching work, marked a turning point in Daum's production in 1925. Clear glass, or glass tinted throughout in ice blue, sea green, emerald, straw yellow, amber, or smoke grey, would be etched with acid and the essentially geometrical design, like the shape itself, stood out in counter relief or was traced on a frosted background. Around 1930, there began to appear a form of work in heavy glass deeply hollowed merely as a function of shape.

The man who before 1900 had created the most extraordinary jewellery, full of sensual and symbolic beauty, became in the 20s a glassblower entirely converted to modern methods. René Lalique (1860-1945) had used glass moulding well before 1914 for his jewellery; the transparent quality of which has linked it with the translucent enamels of Art Nouveau jewellery.

Lalique's first important work was the door of his Cours-la-Reine mansion in 1902. A commission for the label on a François Coty scent bottle in 1908 stimulated his interest in

the bottle itself and was the first step in a form of work which was to earn him a world-wide reputation. In his workshops at Combs-la-Ville and then at Wingen-sur-Moder in Alsace, he perfected mechanised methods which allowed him to mass-produce glass and therefore cut his prices. His clear or opaque glass was sometimes tinted blue, brown, green or black. From 1913, onwards, the Art Nouveau influenced shapes of his early glass work began to give way to geometrical lines, regular curves and right angles. The moulded decoration in relief or counter-relief might also at times be etched with acid. Around 1925, Lalique produced some exceptional pieces, using cire-perdue engraving through wax, such as his vase 'aux enfants' in the Musée des Arts Décoratifs in Paris, as well as fountains or parts for lamps.

Pâte-de-verre, obtained not from the actual constituents of the material but from powdered glass or crystal refired in a mould had tempted many artists at the turn of the century such as Cros, Dammouse, Despret and Walter. The painter, François Décorchemont (1880-1971) made his first experiments in the genre in 1903, creating small pieces in very fine, barely translucent paste which were closely allied to the work of Dammouse. In 1910, he began to use a heavier, altogether translucent paste but his shapes and decorations were still heavily influenced by Art Nouveau. Décorchemont's contribution to Art Deco began after the war when his shapes became larger and shot through with veins of colour to resemble marble or hard stone. They were produced by using successive layers of crystal granules placed in the mould and which mixed on melting during firing. Their decoration, in the form of flowers, animals or fruit, was geometric and their handles sometimes stood out heavily in the form of snakes, fish, caryatids or were often simply voluted. In the very varied range of colours used by Décorchemont at this time there were a particularly attractive

dark brown tinted with manganese and a tortoiseshell yellow. In 1928, Décorchemont began to abandon the anecdotal in favour of purified forms, smooth faces barely animated by the occasional geometrical design. This was the great period of glass production, which preceded the beginning of his more monumental, stained glass work in 1933. The pâte-de-verre used — it was in fact crystal — was more translucent than ever, the colours were sumptuous, less mixed than in earlier periods and underlined the structural sobriety of each piece — or each 'pot' as Décorchemont used to call them.

Alongside these outstanding figures in the world of glass artwork in the 20s, numerous other artists made contributions to the period: Manzana-Pissarro, who highlighted thin glass dishes with translucent enamel or gold; Jean Luce, Marcel Goupy and Auguste Heiligenstein, specialists in table and toiletry glassware decorated with enamel, Georges Dumoulin who followed in the steps of Marinot and Joachim and Jean Sala, two Catalans living in Paris who produced coarse and opaque glass tinted with intense blue or yellow. The most original was undeniably Henri Navarre (1885-1971), an engraver, sculptor and later, glassworker. He used modern methods of glass pressing and produced beautiful vases in crystal streaked with bubbles, powdered oxides and broad dark veining.

The Baccarat crystal works, founded in 1764, distinguished itself from other industrial glass producers by making a genuine contribution to the history of Art Deco through its scent bottles with unusual and figurative shapes and pieces for dinner services. The best of these were designed by Georges Chevalier, such as the *Yacht* service on square bases, produced in 1924. At the 1925 Exhibition its contribution stood out for its thorough-going modernism, compared with Orrefors' engraved glass and with the Italian or Czech creations.

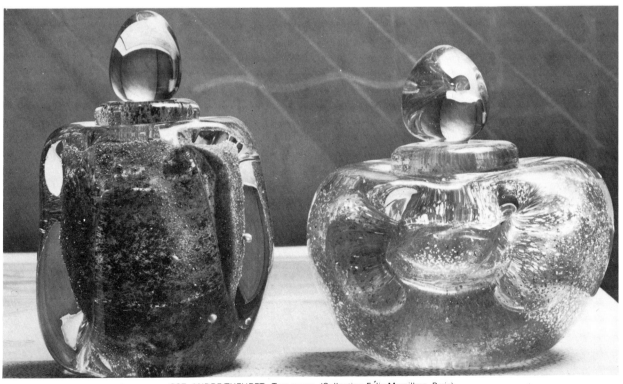

307 ANDRE THEURET Two vases. (Collection Félix Marcilhac, Paris)

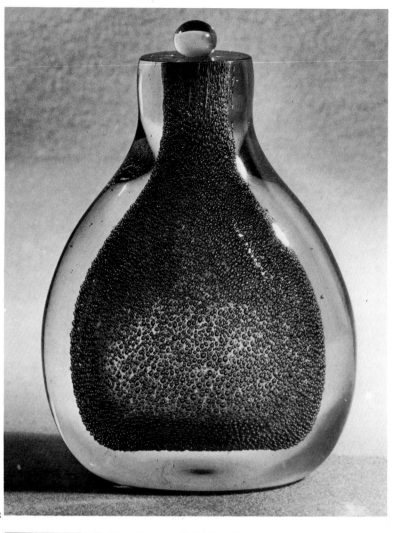

308

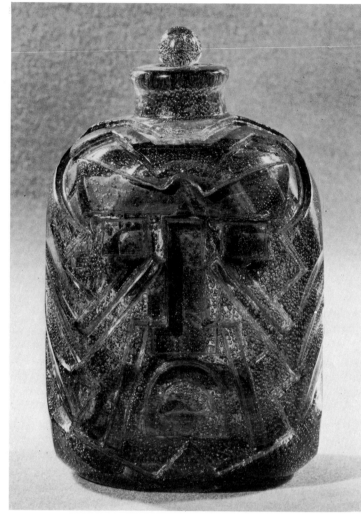

309

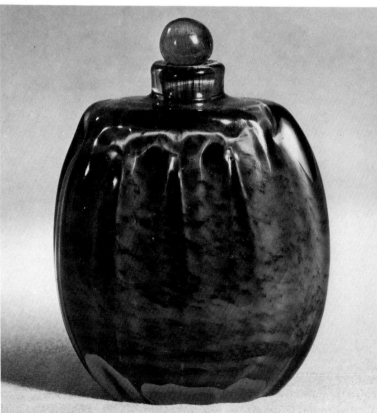

310

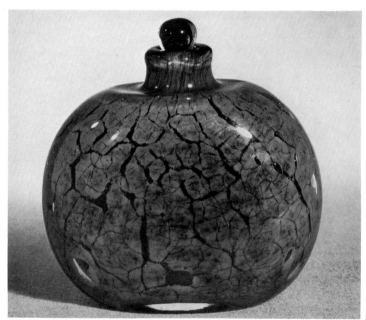

311

308 MAURICE MARINOT Furnace flacon with air bubbles trapped within the layers of glass, c.1927-1930.

309 MAURICE MARINOT Thick glass flacon with trapped air bubbles, c.1927-1930.

310-311 MAURICE MARINOT Furnace flacons with layers of crackled glass, c.1928-1930. (Private Collection)

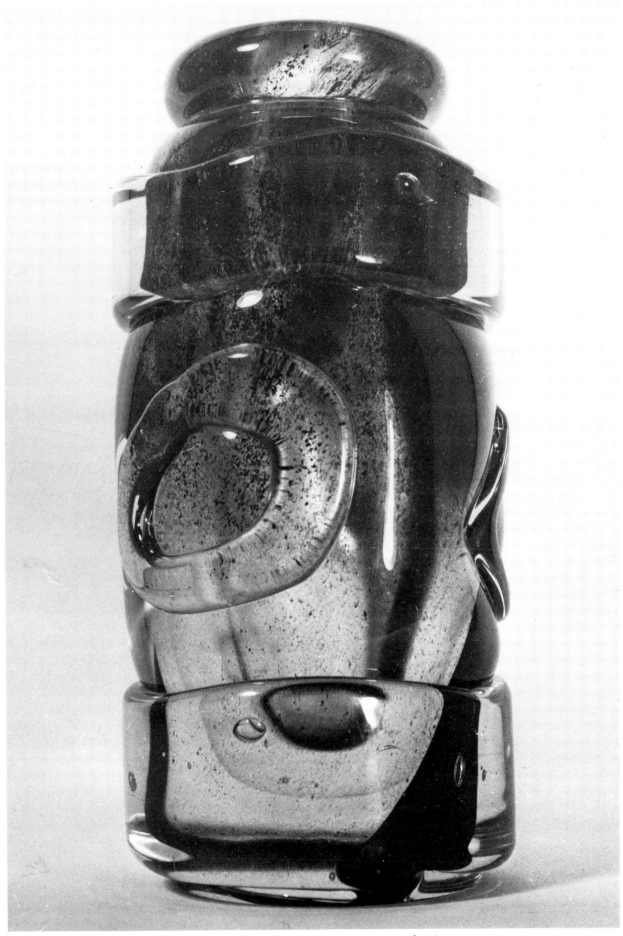

312 HENRI NAVARRE Furnace-wrought vase, c.1935. (Collection Félix Marcilhac, Paris)

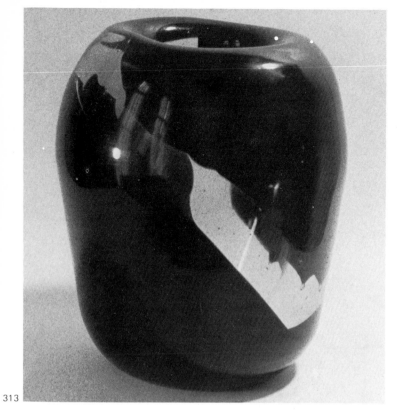

313

31

314

313 HENRI NAVARRE Opaque glass vase.

314 HENRI NAVARRE Transparent crystal vase, the sulphide spangled with white forming an arabesque. (Collection Félix Marcilhac, Paris)

315 HENRI NAVARRE Blown crystal vase with sulphide designs, the transparent marbled glass contrasting with the dark brown opaque area. (Collection Félix Marcilhac, Paris)

317

316

318

316 FRANCOIS DECORCHEMONT Pâte-de-verre vase with three grotesque masks, 1912-1913. (Collection Félix Marcilhac, Paris)

317 LEGRAS et CIE Glass and crystal bowl made at Saint-Denis.

318 JEAN LUCE Clear vase with engraved geometric design, c.1925-1930. (Collection Knut Günther)

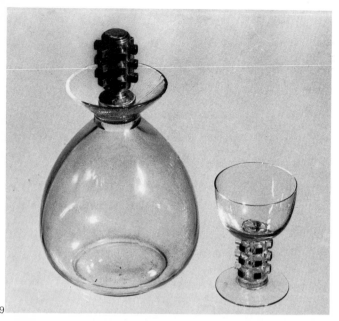

319 RENE LALIQUE Decanter and liqueur glass. The stopper and stem of the glass are made of six vertical rows of black enamelled 'teeth'. (Collection Knut Günther)

320 RENE LALIQUE Illuminated fish on a table by Eileen Gray. (Collection Maria de Beyrie)

321 RENE LALIQUE Glass bottle moulded in relief with sirens and sea-monsters and exhibited at the Salon in 1911. (Collection Félix Marcilhac, Paris)

322 RENE LALIQUE Glass box moulded in relief with garlands of roses, c.1925.

323 RENE LALIQUE (left to right) Flacon moulded with masks of Bacchus; early blown glass vase with designs etched in acid and with the wheel and flacon with stopper moulded as a kneeling nude.

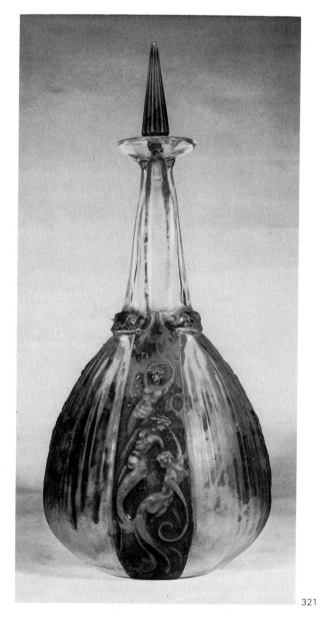

322

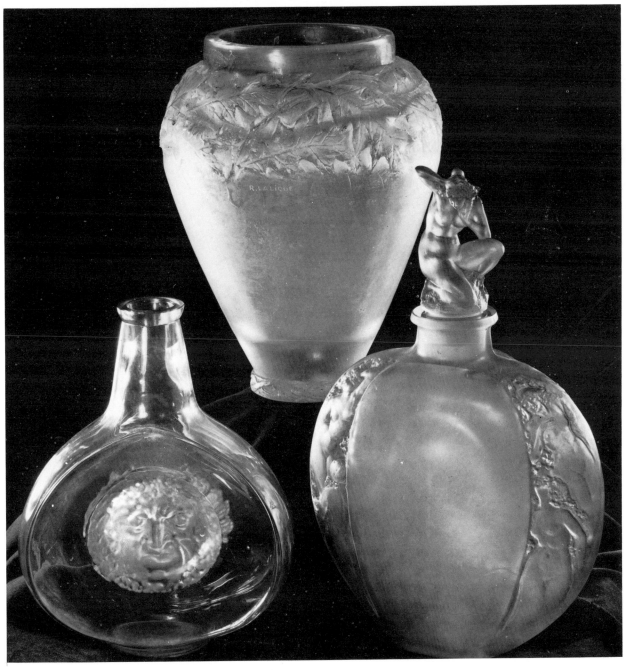

323

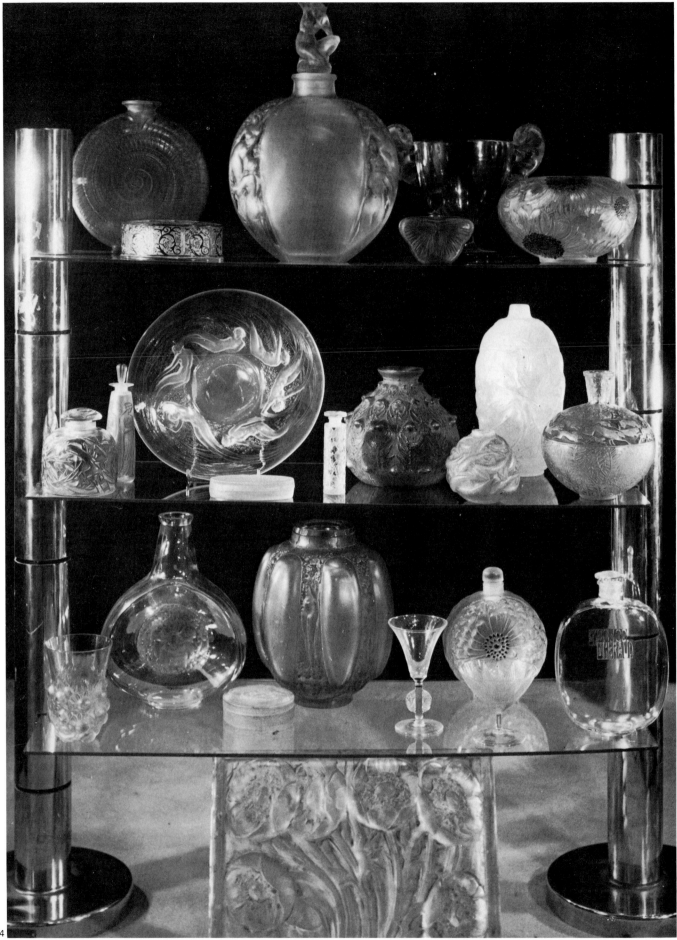

324

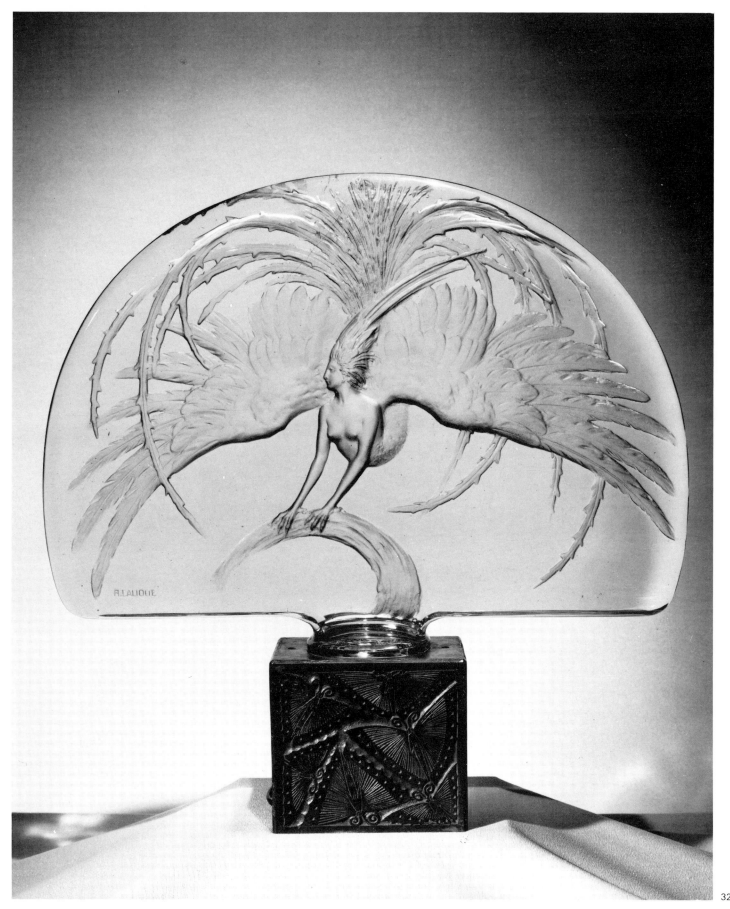

324 RENE LALIQUE Collection of glass showing a variety of techniques, shapes and designs. (Collection Maria de Beyrie)

325 RENE LALIQUE *Oiseau de feu*, a fan-shaped glass plaque set into a bronze base chased with stylised butterflies. The firebird is intaglio-moulded and the details finished on the wheel. (Editions Graphiques Gallery, London)

SCULPTURE

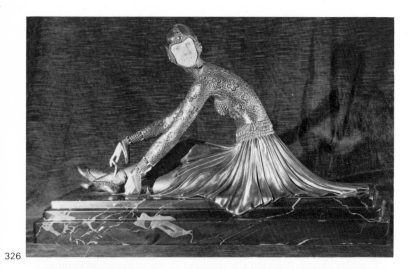

326

3

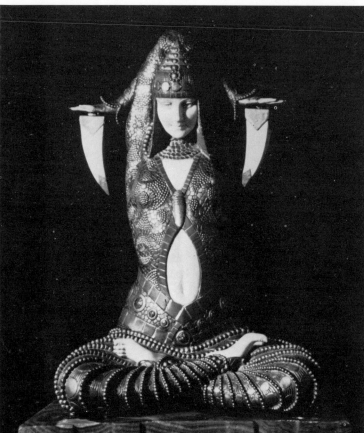

329

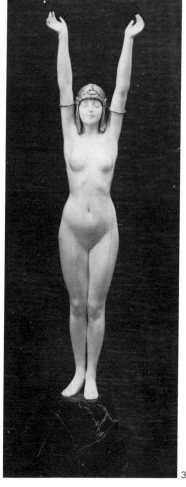

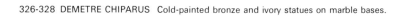

326-328 DEMETRE CHIPARUS Cold-painted bronze and ivory statues on marble bases.

329 DEMETRE CHIPARUS *Femme Bouddha,* a bronze lampstand. (Collection Maria de Beyrie)

330 DEMETRE CHIPARUS *The Flared Skirt.* (Editions Graphiques Gallery, London)

328

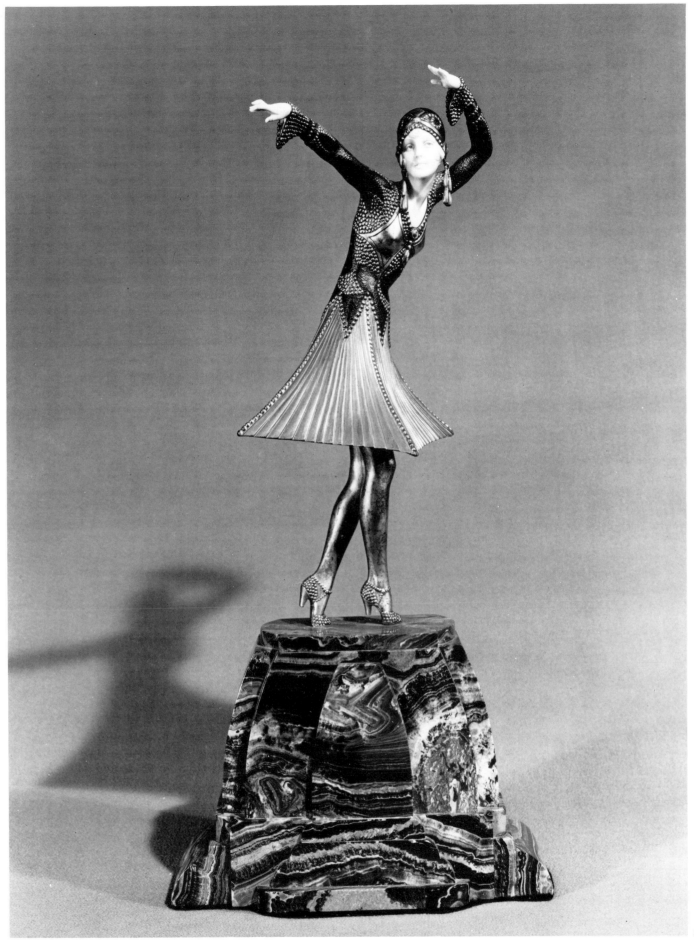

330

JEWELLERY

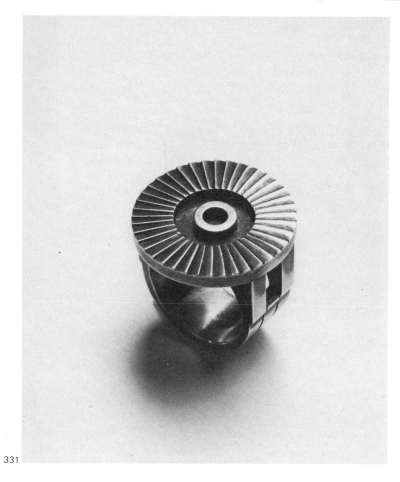

331

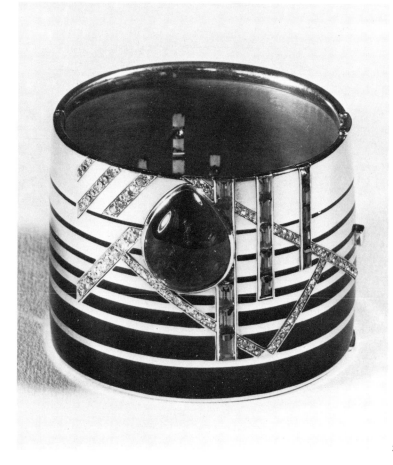

3.

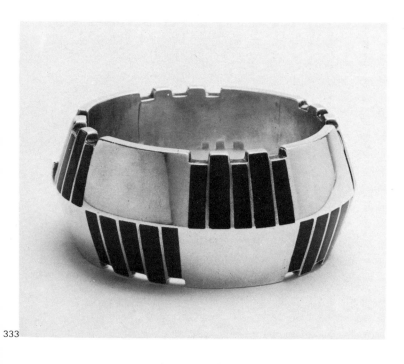

333

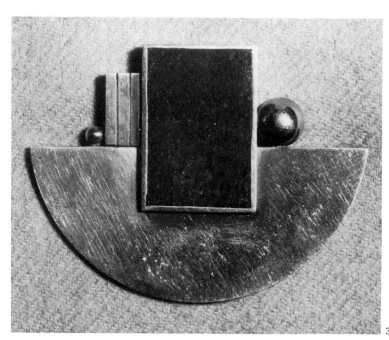

33

331 JEAN DESPRES Ring. (Musée des Arts Décoratifs, Paris)

332 GEORGES FOUQUET Enamelled gold bracelet ornamented with an emerald and thin straps of topaz and based on a design by Ernest Léveillé, 1925. (Private Collection)

333 Silver and black lacquer bracelet. (Private Collection)

334 JEAN DESPRES Brooch. (Collection Stéphane Deschamps)

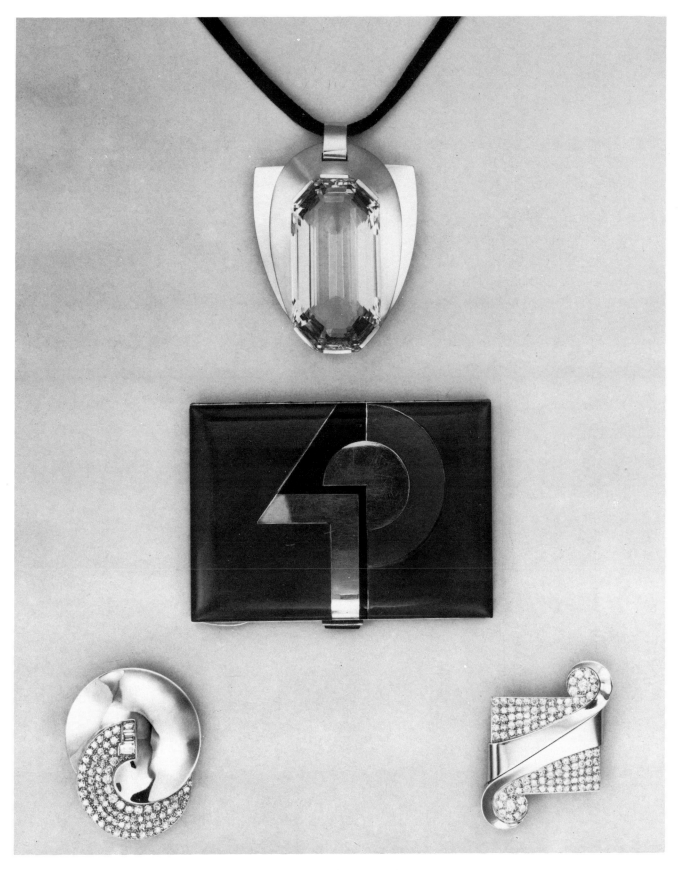

335 RAYMOND TEMPLIER Platinum pendant with aquamarine, c.1925; silver cigarette
case with green, red and black lacquer and two platinum and diamond brooches, c.1935.
(Private Collection)

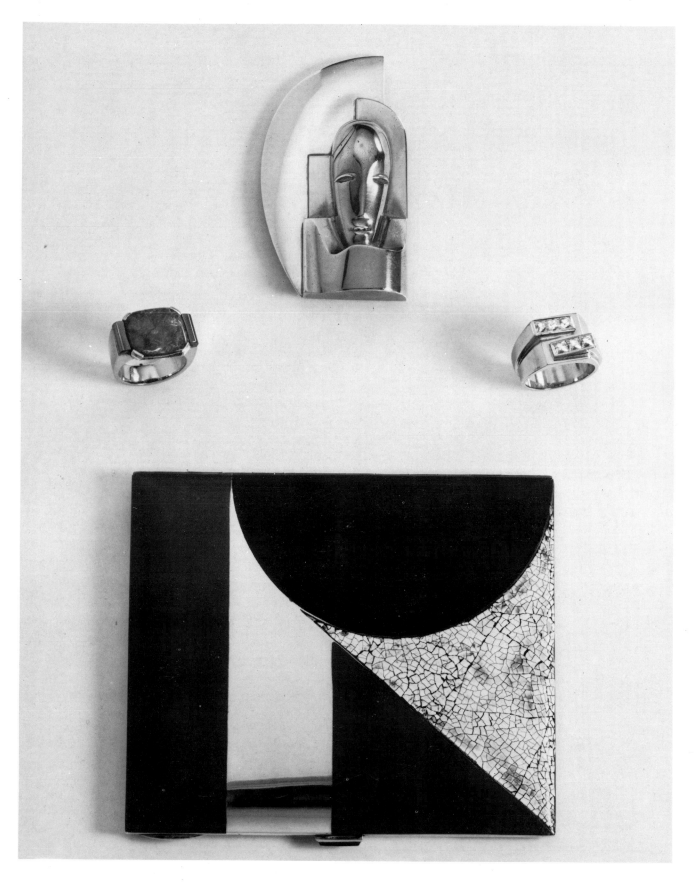

336 RAYMOND TEMPLIER Yellow and white gold brooch based on a design by Gustave Miklos; platinum ring with black opal and onyx; platinum and diamond ring and silver cigarette case with olive green and black lacquer. (Private Collection)

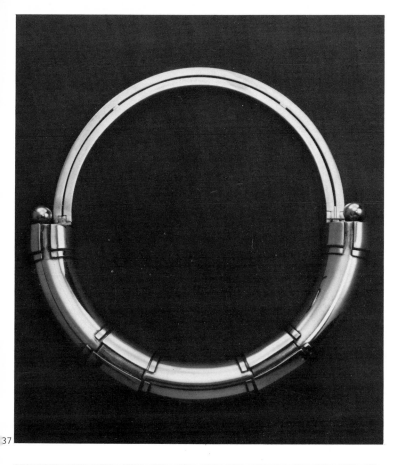

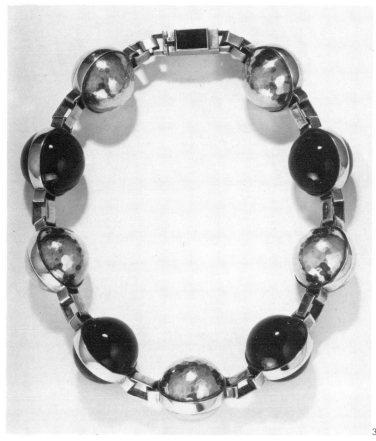

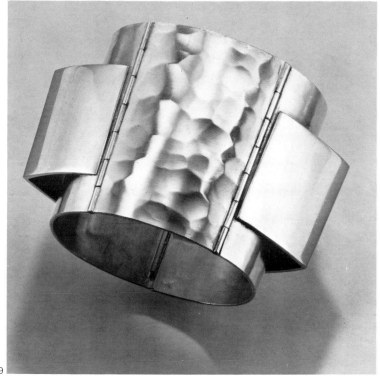

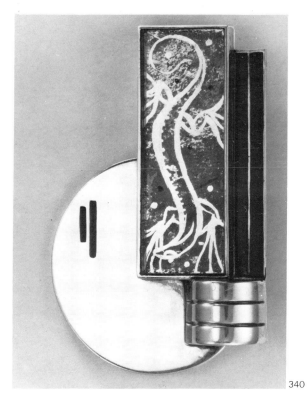

337 JEAN DESPRES Gold and silver choker.

338 JEAN DESPRES Silver, gold and black lacquer necklace.

339 JEAN DESPRES Silver bracelet based on an aeronautical design.

340 JEAN DESPRES Silver and black lacquer brooch with ornamentation by Etienne Cournault. (Private Collection)

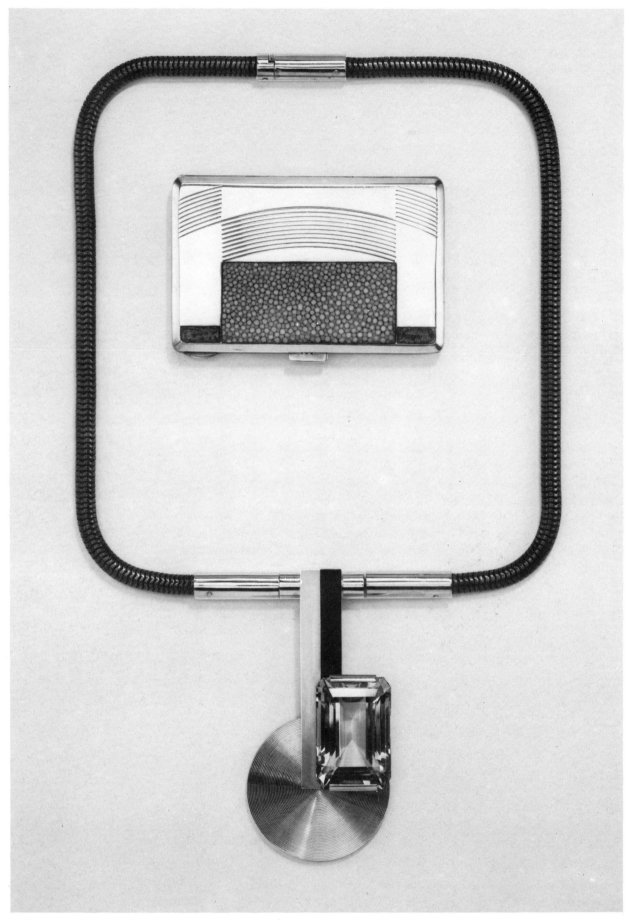

341 GEORGES FOUQUET White gold, silver and black lacquer necklace with an aqua-marine. In the centre is a silver and shagreen cigarette case. (Private Collection)

BOOKBINDING

Bookbinding in the 20s is associated with the patronage of the couturier, Jacques Doucet, a collector of manuscripts and first editions by contemporary authors. He turned to the young decorator Pierre Legrain who joined Paul Iribe in furnishing his apartment. The binding of a collection of poems by Francis Jammes, designed in 1917, was the beginning of a career as an innovator for which nothing had prepared him. Knowing nothing even of the technique of binding, he freely created a completely new style, independent of his predecessors' methods.

He made use of such unusual materials as sharkskin, exotic wood and mother-of-pearl and was the first to take letters as the starting point of the decoration, based most frequently on geometrical rhythm. For Legrain 'a binding has no apparent meaning; the cover of a book is merely a frontispiece which summarises its spirit and prepares for a reading of the text through the choice of a nuance or a sign'. His style triumphed at the 1925 Exhibition and set a fashion for a group of young women to which Rose Adler (1892-1959) belonged. She also worked for Jacques Doucet, from 1923 to 1929. Her style became progressively less bound up with that of Legrain in a series of works full of allusions in which the geometry is softened and the raw materials such as reptile skin and metallised leather are incrusted with precious stones.

With François-Louis Schmied (1873-1941), a painter born in Geneva and a friend of Jean Dunand, lacquer made its appearance in bookbinding at the same time as the influence of Negro art. For Robert Bonfils, colour mattered more than the design. This was also the case with André Mare who treated book covers through the eyes of a painter or illuminator. His floral or animated compositions were painted in bright or transparent colours on a parchment background.

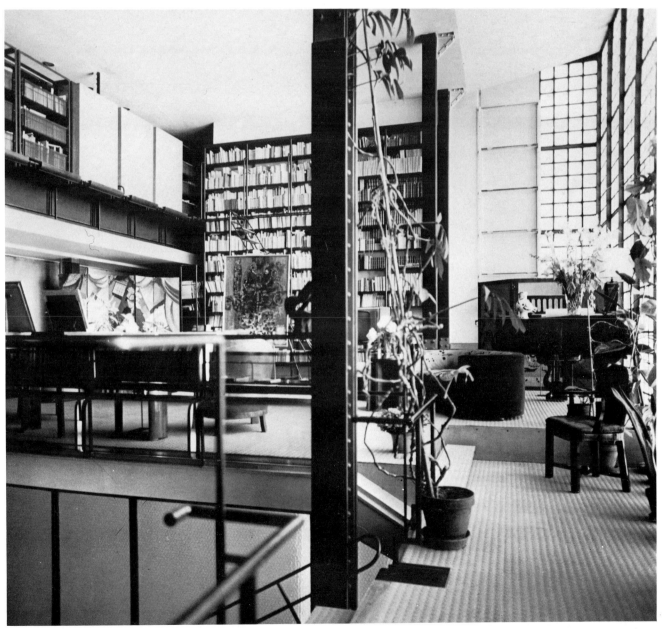

342 PIERRE CHAREAU Study of the Maison de Verre for Dr and Mme Dalsace, 1928-1931.

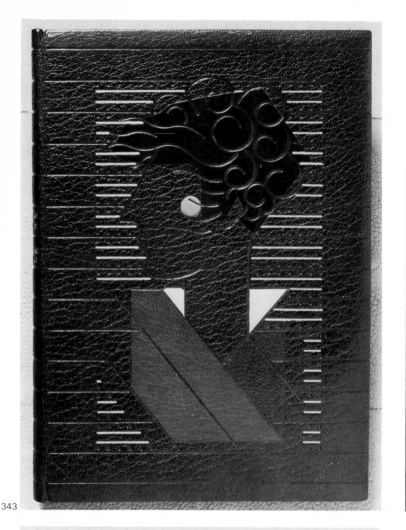

343

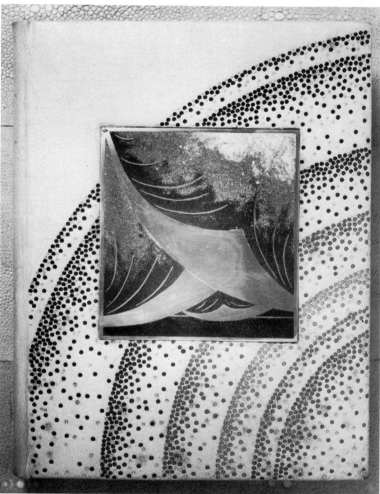

3

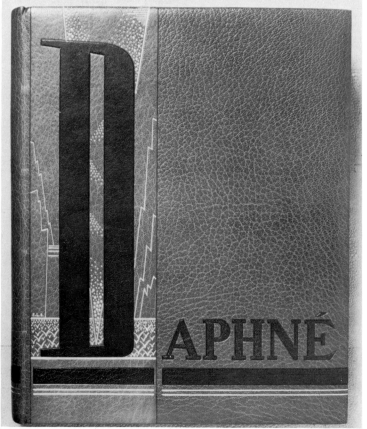

345

343 ROBERT BONFILS Binding in embossed and inlaid morocco leather for *Campagne romaine* by René de Chateaubriand, 1919. (Collection Félix Marcilhac, Paris)

344 FRANCOIS-LOUIS SCHMIED Morocco binding with a rainbow of coloured dots and inlaid metal plaque by Jean Dunand for *Les Ballades françaises* by Paul Faure, 1927. (Collection Félix Marcilhac, Paris)

345 GEORGES CRETTE Morocco and black leather binding embossed in gold for *Daphne* by Alfred de Vigny, 1924. (Collection Félix Marcilhac, Paris)

346 ROBERT BONFILS Inlaid morocco leather binding for *Eugénie Grandet* by Honoré de Balzac. (Collection Félix Marcilhac, Paris)

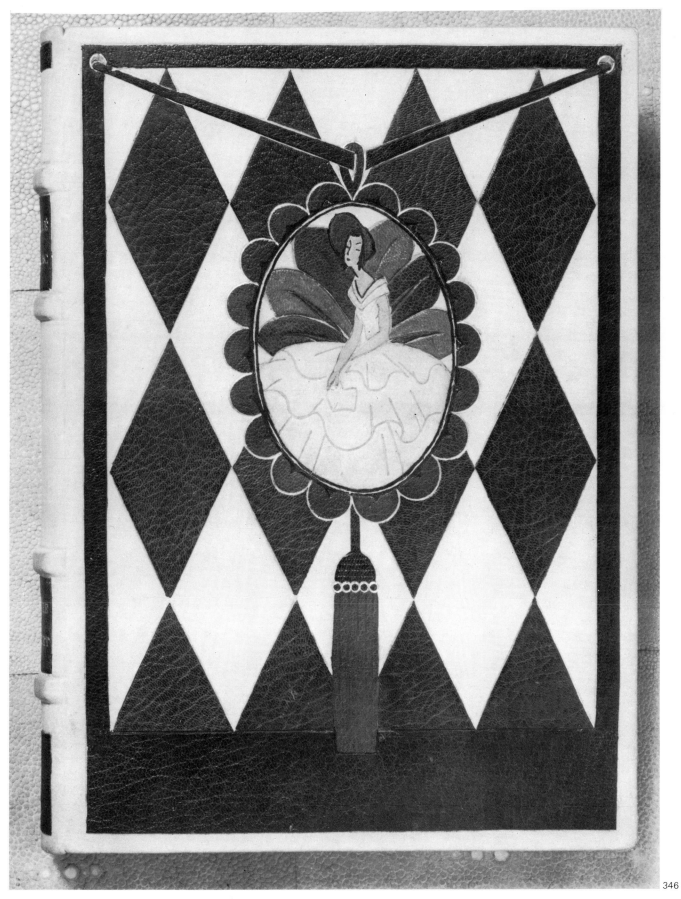

346

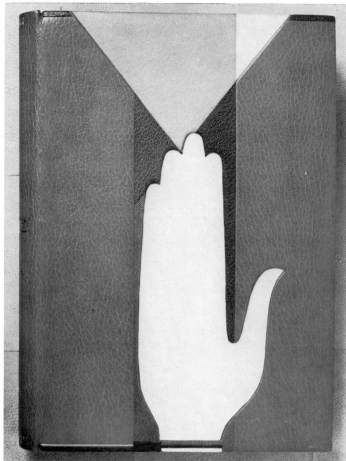

347

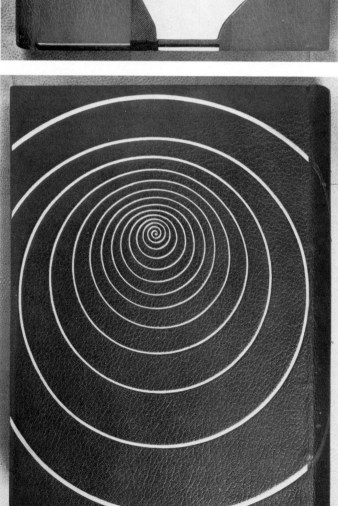

348

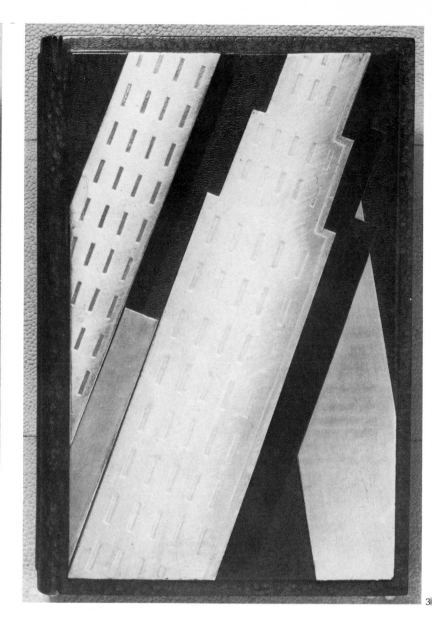

347 LOUIS CREUZEVAULT Morocco leather binding with inlaid plastic hand for *Le Livre de la verité de parole* by Dr Mardrus, 1929. (Collection Félix Marcilhac, Paris)

348 LOUIS CREUZEVAULT Silver embossed morocco leather binding with silver inlay for *La Création*, 1928.

349 LOUIS CREUZEVAULT Morocco leather binding with silver inlay for *Scènes de la vie future* by Georges Duhamel, 1930.

350 ANDRE MARE Painted parchment binding for *La Nuit vénitienne* by Alfred de Musset, 1920. (Collection Pierre Bérès, Paris)

351 ANDRE MARE White vellum binding for *Les Plus beaux contes* by Rudyard Kipling, 1920. (Collection Pierre Bérès, Paris)

352 White painted and engraved vellum binding for *Cette heure qui est entre le printemps et l'été* by Paul Claudel, 1913.

353 Binding in white painted vellum for *Les Croix de bois* by Dorgelès, 1921. (Collection Pierre Bérès, Paris)

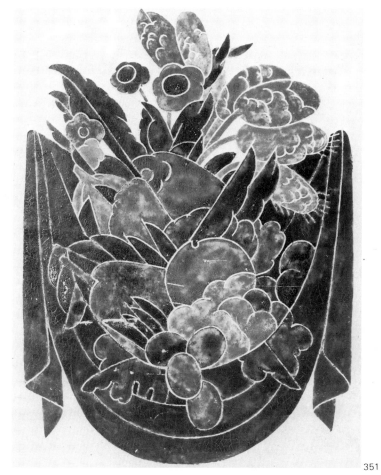

350

351

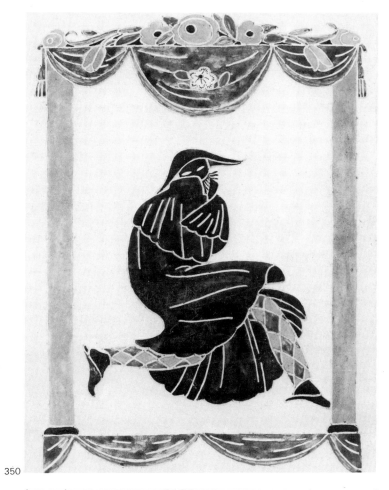

352

353

LIGHTING

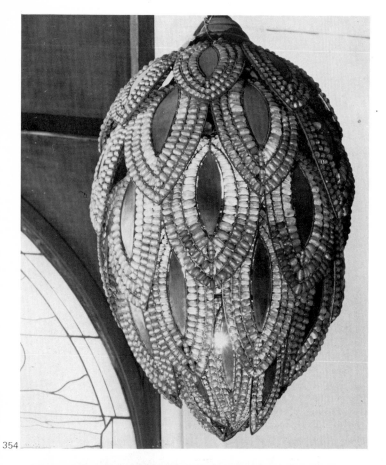

354

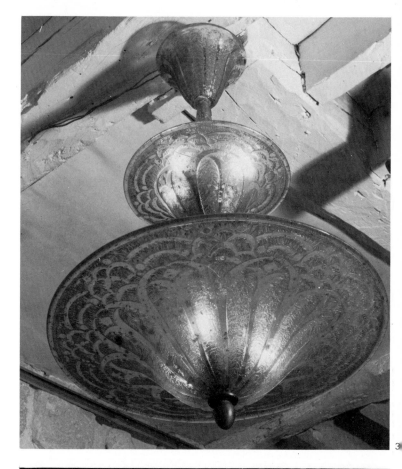

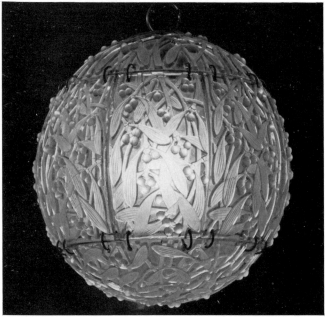

356

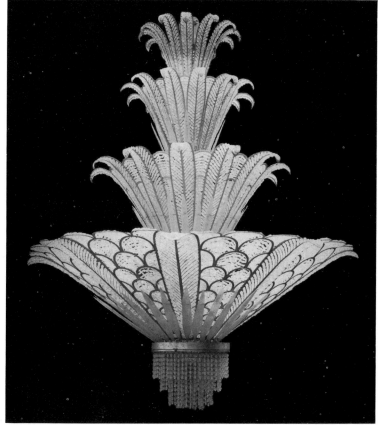

354 BAGUES Hanging lamp in the shape of a pine-cone in metal and crystal, exhibited in the Pavillon de l'Elégance at the 1925 Exhibition. (Musée des Arts Décoratifs, Paris)

355 DAUM Thick etched glass chandelier made in Nancy, c.1925.(Collection Jean-Pierre Badet)

356 RENE LALIQUE Glass chandelier with mistletoe design. (Collection Félix Marcilhac, Paris)

357 BAGUES Metal, Venetian glass and crystal chandelier.

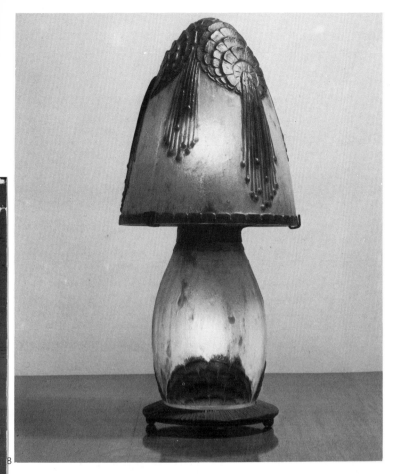

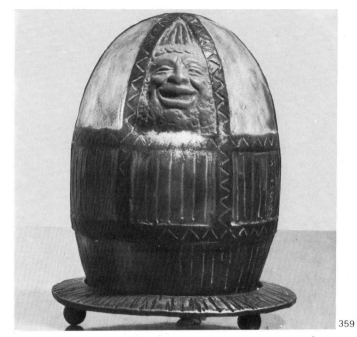

358-359 GABRIEL ARGY-ROUSSEAU Lamp and night-light. (Collection Andrée Vyncke)

360 RENE LALIQUE Lamp in a metal frame. (Private Collection)

361 JEAN LAMBERT-RUCKI Carved wooden lamp, lacquered by Jean Dunand with a black perforated metal base and grey lacquered wooden lampshade. The screen entitled *Le Cirque* in the background in polychrome lacquer and eggshell on a black ground is based on a design by Lambert-Rucki. (Galerie du Luxembourg, Paris)

362 JEAN GOULDEN Bedside lamp in silvered bronze and enamel, c.1929. (Collection Sydney Lewis, Richmond)

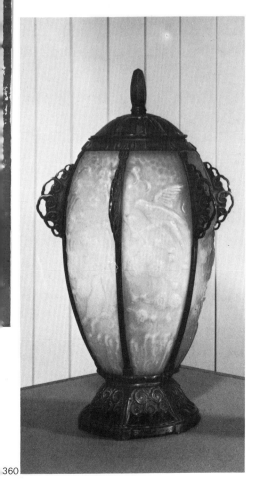

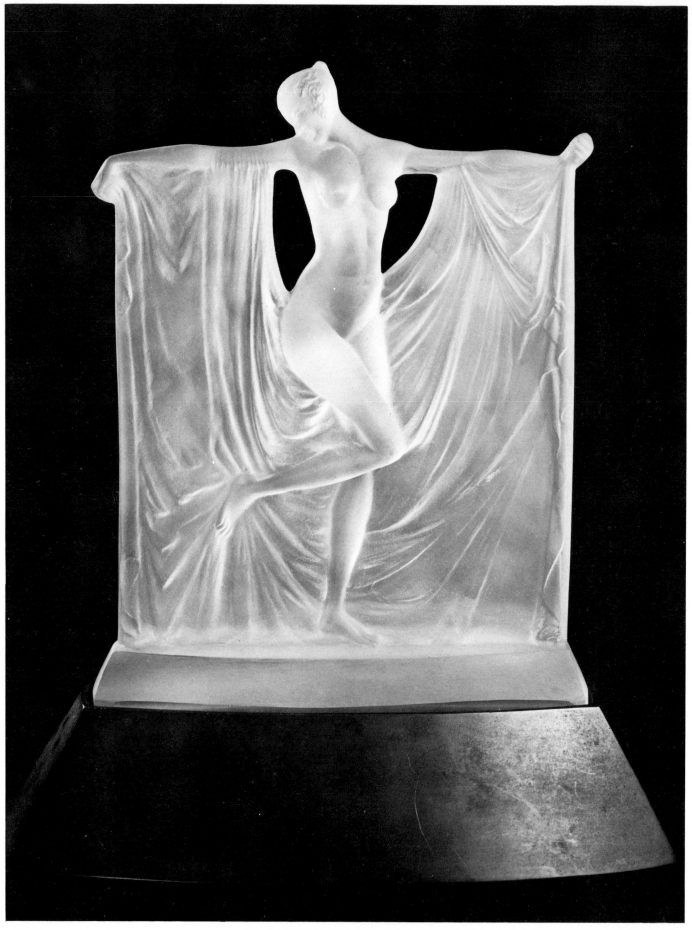

363 RENE LALIQUE Moulded glass lamp. (Private Collection)

64

366

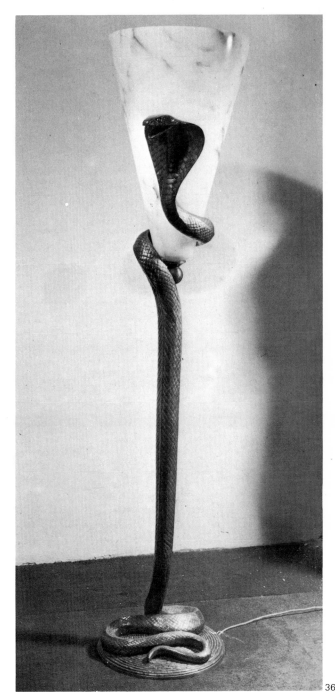

367

365

364 PIERRE LEGRAIN Standard lamp in frosted glass covered in parchment, originally part of Doucet's collection. (Musée des Arts Décoratifs, Paris)

365 Aluminium standard lamp. (Collection Félix Marcilhac, Paris)

366 ARMAND ALBERT RATEAU Green patinated bronze standard lamp designed for Jeanne Lanvin, early 1920s. (Collection Alain Lesieutre, Paris)

367 EDGAR BRANDT Patinated bronze lamp with etched glass bowl by Daum. (Collection Jean-Pierre Badet)

JEAN PERZEL

On his arrival in Paris in 1910, Perzel (b. 1892) who had studied the craft of painter and glassworker at Munich, underwent an apprenticeship in several workshops including Grüber's. He specialised in lighting from 1923 onwards and approached it from a point of view that was new in France. He concerned himself, in fact, with the nature of electricity itself, with its uses and impact on the environment and then with the rational form which should be given to the piece of equipment which bears the light source. In addition, Perzel gave much thought to the good and ill effects of light and found ways to correct them.

The shapes of Perzel's lamps are principally geometric and the medium generally metallic with the additional use of optical glass.

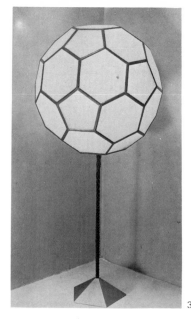

368-370 JEAN PERZEL Three of Perzel's earlier lights, made between 1923 and 1927, at which time he was using lead with enamelled, frosted or etched glass.

371-377 JEAN PERZEL: His second period during which he used brass with white frosted glass.

368

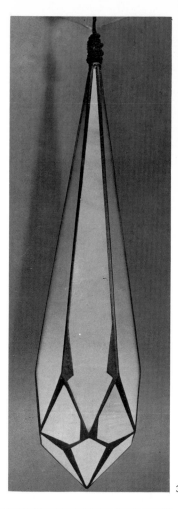

3

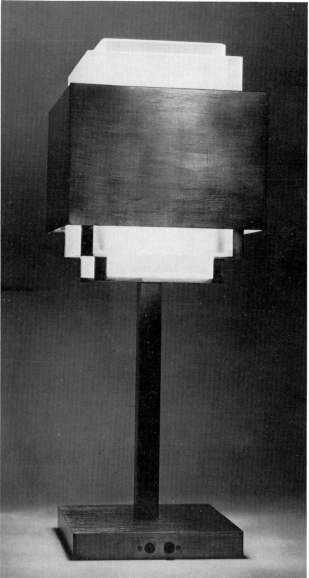

371

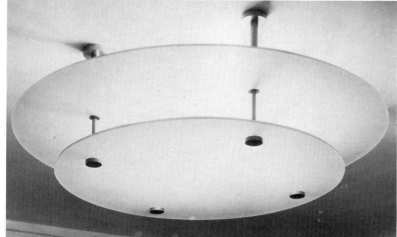

3

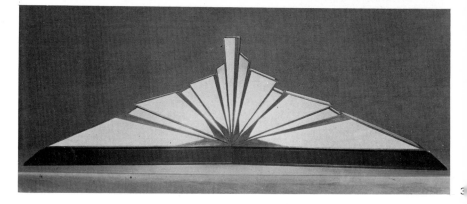

3

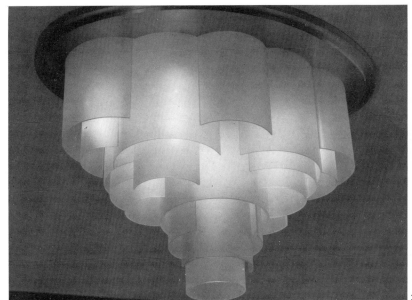

3

374

375

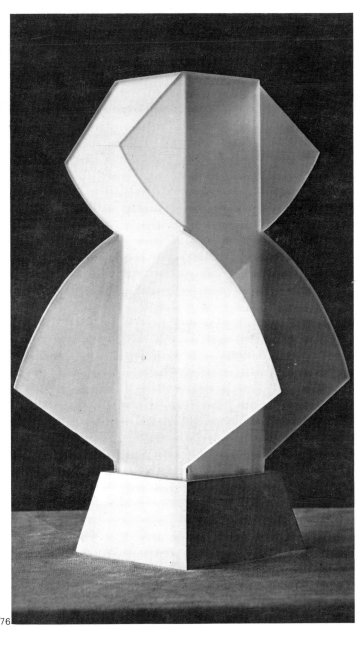

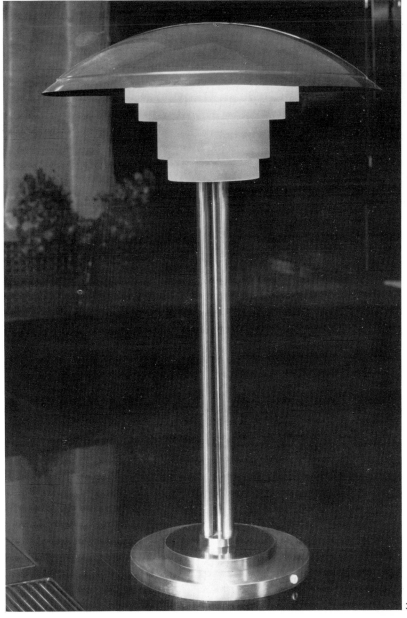

76

377

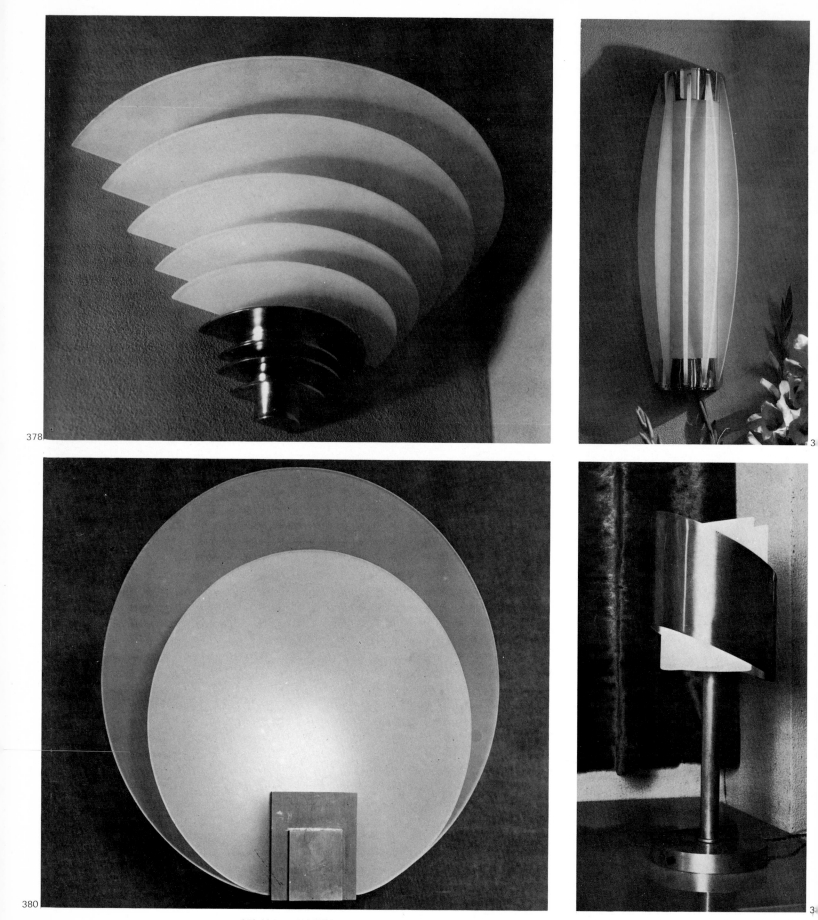

378

380

378-384 JEAN PERZEL Ceiling and bracket-lamps, early 1930s, showing Perzel's increasing use of geometric and simplified lines and white frosted glass with white or pink enamelled glass.

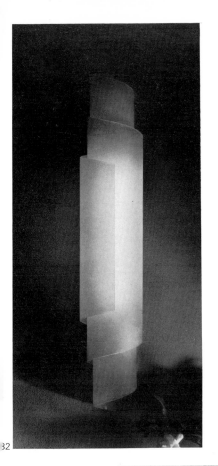

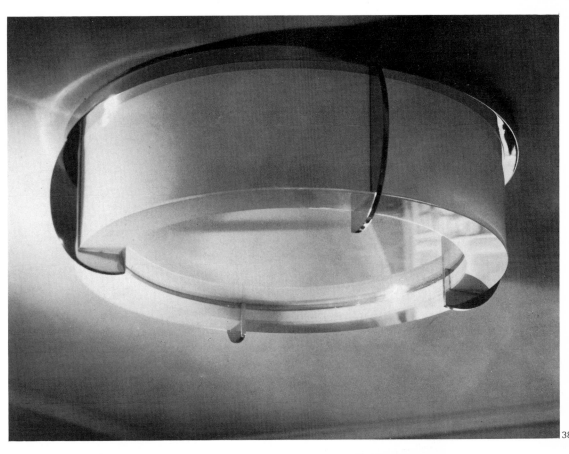

382

383

384

INDEX